IMAGES
of America

HISTORIC
ROSWELL
GEORGIA

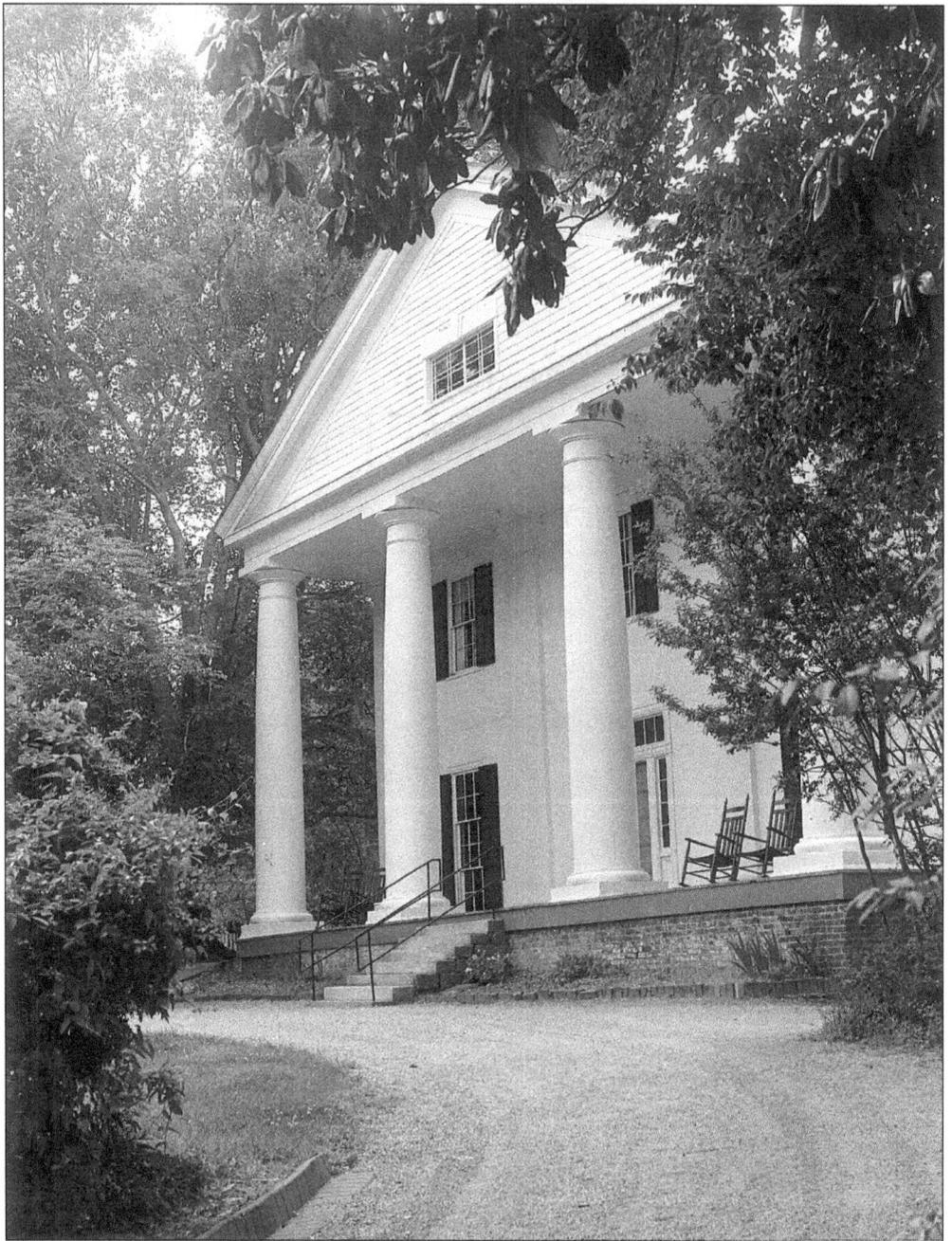

Stately Bulloch Hall was built in 1840 for James Stephens Bulloch. His daughter Mittie married Theodore Roosevelt there in 1853. (Photo by Joe McTyre.)

Cover photo: see page 108.

IMAGES
of America

HISTORIC
ROSWELL
GEORGIA

Rebecca Nash Paden and Joe McTyre

ARCADIA
PUBLISHING

Published by Arcadia Publishing
Charleston, South Carolina

Library of Congress Catalog Card Number: 2001090829

For all general information contact Arcadia Publishing at:
Telephone 843-853-2070
Fax 843-853-0044
E-Mail sales@arcadiapublishing.com
For customer service and orders:
Toll-Free 1-888-313-2665

Visit us on the Internet at www.arcadiapublishing.com

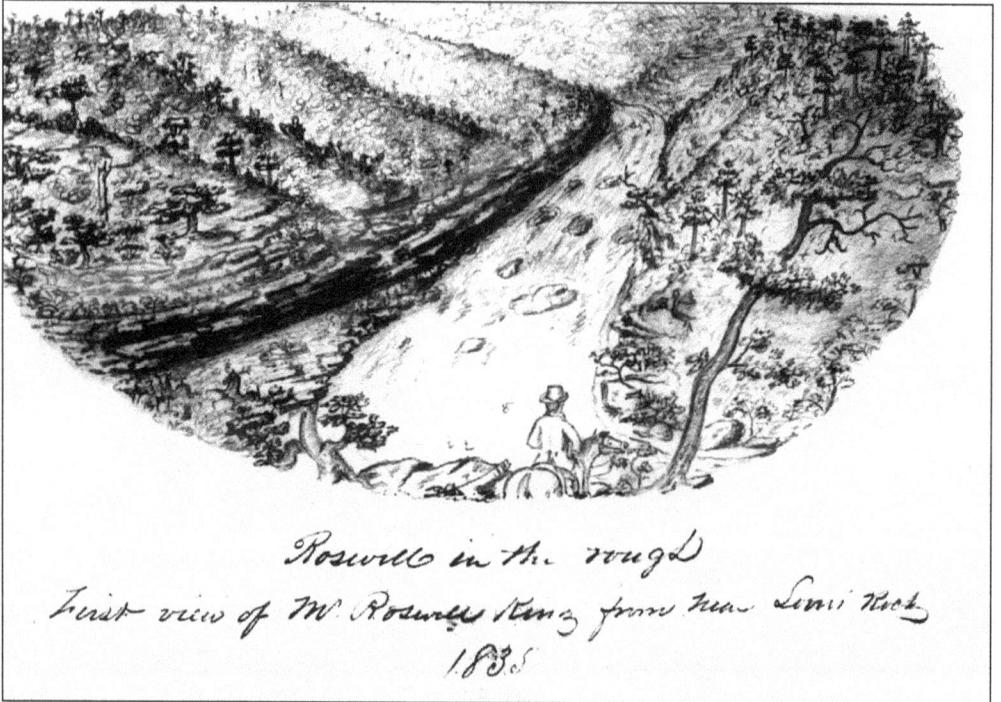

Roswell in the rough, First view of Mr. Roswell King from near 'Lover's Rock' (1835) was the first of six pencil sketches of early Roswell life by Henry Merrell. The sketches were found among the Archibald Smith family papers by Dr. James L. Skinner III, who originally published them in *The Autobiography of Henry Merrell*. (Courtesy of James L. Skinner III.)

CONTENTS

Acknowledgments 6

Introduction 7

1. The Mills 9

2. The Colony 23

3. Town and Buildings 37

4. Civil War and Reconstruction 71

5. The 1900s 91

6. From Small Town to Major Suburb 113

Endnotes 127

References 128

ACKNOWLEDGMENTS

The authors wish to thank many people for their interest and assistance in assembling the information, photographs, and other materials for this book. A complete list follows. We particularly thank the following individuals for their invaluable help:

Dr. James Lister Skinner III, professor, Presbyterian College, Clinton, South Carolina

Michael Hitt, historian and Roswell Police Department officer

Dotty Etris, executive director, Roswell Convention & Visitors Bureau

Pam Billingsley, executive administrator, Bulloch Hall

Lois King Simpson, Barrington Hall owner

Polly A. Payne, membership director, Roswell Presbyterian Church

Others who made important contributions include the following:

Roswell: Mary Wright Hawkins; Janice Metzler; Louise DeLong; W.L. "Pug" Mabry; Chuck Douglas, historic site coordinator, Archibald Smith Plantation Home; Emily Dolvin-Visscher; Sylvia and Edward Hansell; Nancy and Lew Gray; Todd Chancey; Ira Humphries; First Baptist Church; Frances McGahee; Margaret DeLong Thompson; Fulton County Public Library (Roswell Branch); Jacque Coxe, curator, Teaching Museum North, Fulton County School System; Henry Wing; Ann Miller; Lisa Senn; Melanie Chen; Keri MacDonald; and Elwyn Gaissert.

Marietta: Carolyn McFatridge Crawford, director, Georgia Room, Cobb County Public Library; Martha Wright Mangum; Janice Wright Hill; Daniel O. Cox, director, Marietta Museum of History; Russell D. King; William R. Paden; James B. Glover V; Sandra R. Stephens; Connie Cox; George and Elizabeth Kendley; John R. Nash; Mary Berry Terrell; and Nancy Hancock.

Others include Dr. Marian E. Dabney; Rachel F. Dabney, Smyrna; Joann Clark, curator, Midway Museum; Museum of Coastal History, St. Simons Island; and Mills Lane, Savannah.

INTRODUCTION

The story of Roswell, Georgia, is a story of a group of low country planters who relocated to a wilderness recently inhabited by Native Americans, and the Presbyterian community and textile industry they established between the 1830s and the 1850s. Roswell King discovered the area's potential during travels between his coastal home in Darien, Georgia, and the North Georgia mountains about 1828. From the start, he envisioned more than a common mill village. King's plan was for a town similar to those in his native Connecticut with a school, churches, stores, town square, workers' dwellings, and fine houses for his family and friends. Well-to-do coastal area plantation owners migrated to the North Georgia settlement to begin new lives and escape the heat and disease associated with the southern low country. When King died in 1844, Roswell was thriving and considered by many as the most important town in Cobb County. Located 20 miles north of Atlanta, Roswell was carved out of former Cherokee Indian lands acquired by the state of Georgia when Native Americans were removed to the west in 1838 along the infamous "Trail of Tears."

Today, the only reminders of Native American habitation are place names such as Chattahoochee, Willeo, and Etowah. Tangible evidence of Roswell's importance as a mill town includes Greek Revival mansions and buildings rivaling some of the best in the South. *Historic Roswell Georgia* tells the story—in pictures—of the town's place in the history of Georgia and the nation. This book provides an overview of Roswell from its establishment of a successful textile industry through its development as one of Atlanta's most desirable suburban locations. The volume contains more than 200 pictures, maps, drawings, and documents, many previously unpublished, from the area's beginnings to significant early 21st-century events. Images were gathered from private individuals, churches, newspapers, and museums. Contemporary photographs were made by one of Atlanta's outstanding photographers

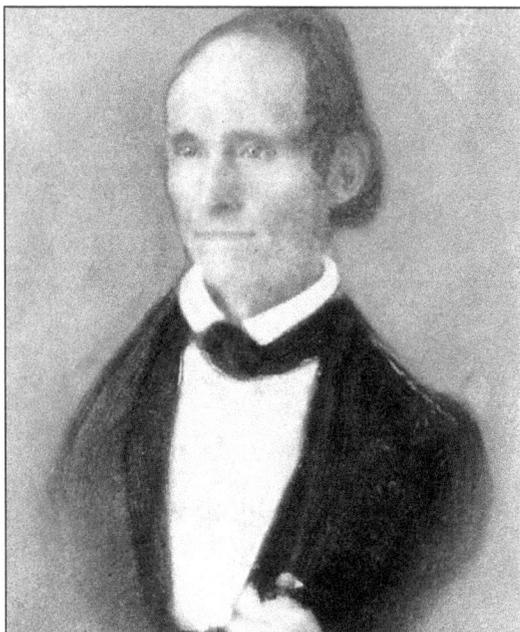

Roswell King (1765–1844) was one of the first Roswell pioneers to be buried in the Presbyterian (later Founders) Cemetery, carrying out his wish to be buried near the factory he built. The stone erected in his memory reads, "A man of great energy, industry, and perseverance, of rigid integrity, truth, and justice, he early earned and long enjoyed the esteem and confidence of his fellow men." (Courtesy of Roswell Presbyterian Church History Room.)

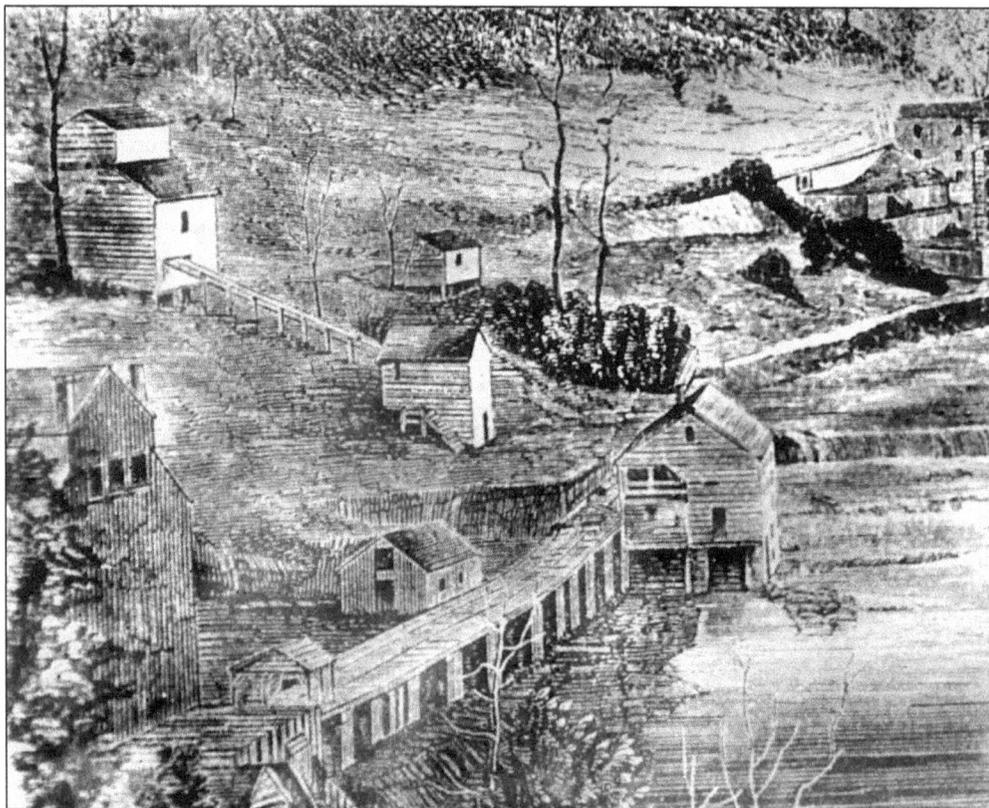

An 1860 drawing of the Roswell Manufacturing Co. is attributed to Ralph King. The cotton mills were at their peak prior to the Civil War. (Courtesy of Georgia Department of Archives and History.)

One

THE MILLS

Soon after arriving on the Georgia coast from his native Connecticut in 1789, Roswell King worked as a builder, surveyor, and justice of the peace. He was also commissioned as a lieutenant in the Georgia Militia in 1793 and served as a member of the Georgia House of Representatives from 1794 to 1795.[1] In the early 1800s, he was hired as supervisor of Pierce Butler's plantation on St. Simons and Butler's Islands on the Altamaha River. In 1819, King turned over many of his management duties to his son Roswell Jr. and began to develop his own business ventures. He bought rental property in Darien, built a steam-powered sawmill in McIntosh County, and owned a cotton factor firm in Savannah along with his son William.[2]

About 1828, King traveled to North Georgia and the Carolinas to investigate gold mining investment prospects for the Bank of Darien, in which he owned an interest. The trip turned out to be one of the most significant events in Roswell King's life.[3] His route from the coast took him inland through rugged, mountainous country to the present Roswell area, then occupied by Cherokee Indians. According to early accounts, the plentiful natural resources, including water and timber, sparked his interest in the land overlooking Cedar (now Vickery) Creek near the Chattahoochee River, about 20 miles north of the village of Standing Peachtree, later to become the city of Atlanta. While carrying out his commission for the bank, King discovered an ideal site for a textile mill and soon began acquiring title to hundreds of acres close to the creek. In 1835 and 1836, he purchased property from Fannin Brown and other tracts through courthouse sales.[4]

The nearby village of Lebanon had a flour mill, saw mill, general store, and post office. It soon became a principal trading center for early Roswell settlers. (The Lebanon community was situated about a half mile west of the present Georgia Highway 400 on Holcomb Bridge Road.) By 1837 Roswell King, his sons Barrington and Ralph, and their slaves had cleared land for a road to the mill site and built a dam to supply water power for the mill. In 1839, the Kings completed the first cotton mill, a three-story brick building, and incorporated the business as the Roswell Manufacturing Company. Roswell King designated his son Barrington to head the mill with the title of agent (later president). Commanding a view of the creek was the mill complex including a factory, machine shop, office, company store, and workers' houses.

In 1839, King hired Henry Merrell, a 23-year-old textile engineer from Utica, New York, to operate the new factory. Merrell supervised the installation of the mill machinery and, by 1841, had the cotton mill in full operation with 28 employees.[5] The mill enterprise also drew Merrell's cousin George Hull Camp of Utica, New York, who came to Roswell in 1842 to be the company storekeeper. Merrell supervised the mill until 1845 when he moved to Clarke County, Georgia, to set up his own cotton mill. By 1850, the mill employed 150 workers who turned out shirting, yarn, and osnaburg (a coarse heavy cloth for sacks and work clothes) for a growing market. When the company expanded with a second cotton mill in 1852, Roswell's mills were the largest in North Georgia.

At the beginning of the Civil War, Roswell had four mills operating on Cedar Creek—the two company-owned cotton factories and a flour mill nearby at Lebanon, along with the Ivy Woolen Mill, built in 1857 by Barrington King's sons James and Thomas, downstream from the cotton mills. That same year, the company built a covered bridge over the Chattahoochee River to improve transportation of its goods. By the late 1840s, the Roswell Manufacturing Company had a capitalization of $80,000 and 150 workers converting five bales of cotton into 1,100 yards of shirting and 1,500 yards of osnaburg a day. Orders for cloth, rope, and yarn were sent to several northern states as new product lines opened up. By 1854, the mills' production had increased and the two cotton mills, the woolen mill, and the Lebanon mill (acquired from Archibald and Clark Howell in exchange for company stock) were capitalized at $220,000. The Lebanon mill produced 300 barrels of flour a day.[6] Although the mills triggered the community's boom, a lack of rail transportation hampered the town and its industries. When the Western and Atlantic Railroad's Chattanooga to Atlanta line was constructed through Marietta in 1845, it gave Roswell's neighbor to the west an edge. The mill owners set out to build their own railroad from Roswell to Atlanta to facilitate moving their goods to markets. The company obtained a charter in 1863 and graded for the railway the next year but couldn't carry out the project during the Civil War. It was finally built 18 years later.[7]

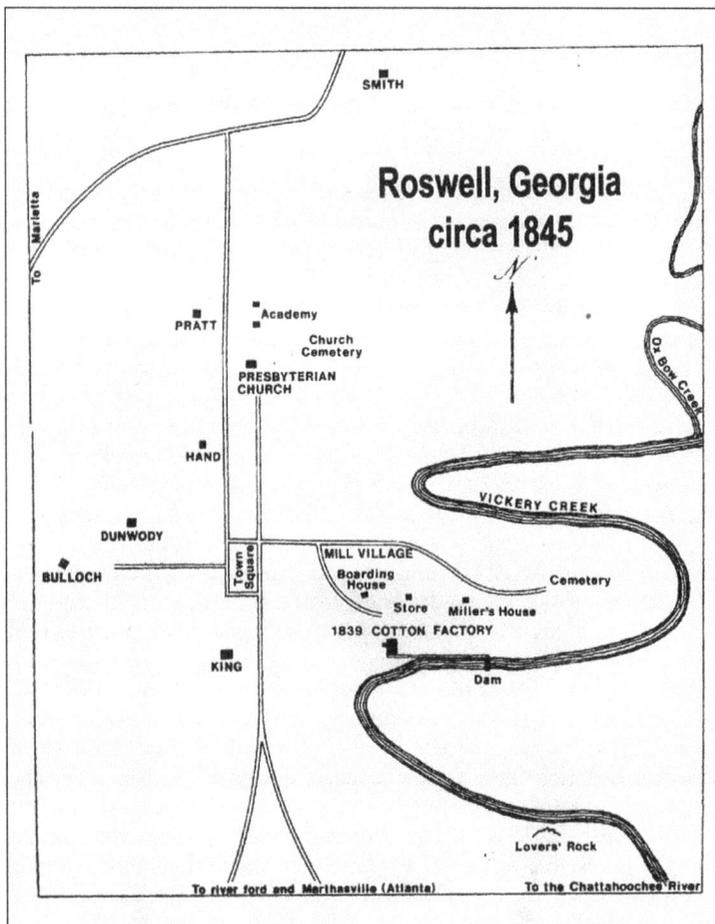

Seen here is Roswell, Georgia, according to an 1845 map researched by Arthur Skinner. (Courtesy of Arthur Skinner.)

Henry Merrell (1816–1883) was a young textile engineer from Utica, New York, who came to Roswell to run the cotton mills. He is pictured about 1850 when Merrell ran two textile mills in Greene County. Merrell's autobiography, edited by Dr. James L. Skinner III, provides a unique picture of life in Roswell in the early days of the Colony. (Courtesy of James L. Skinner III.)

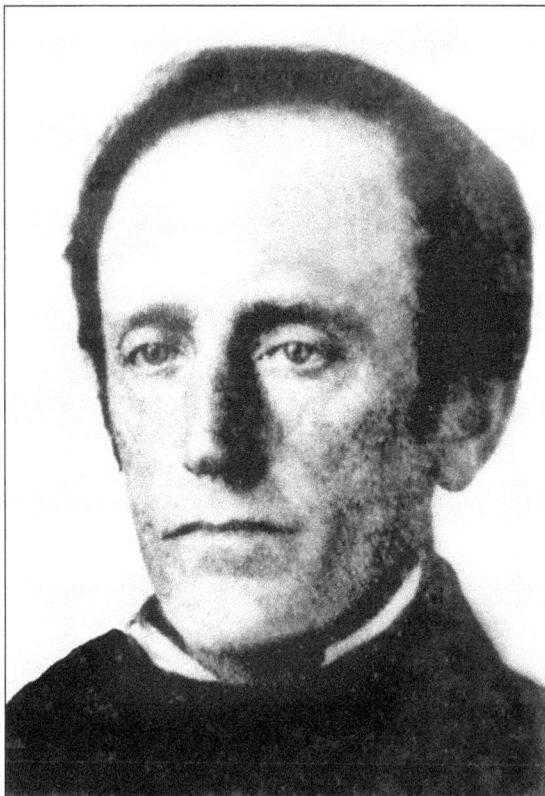

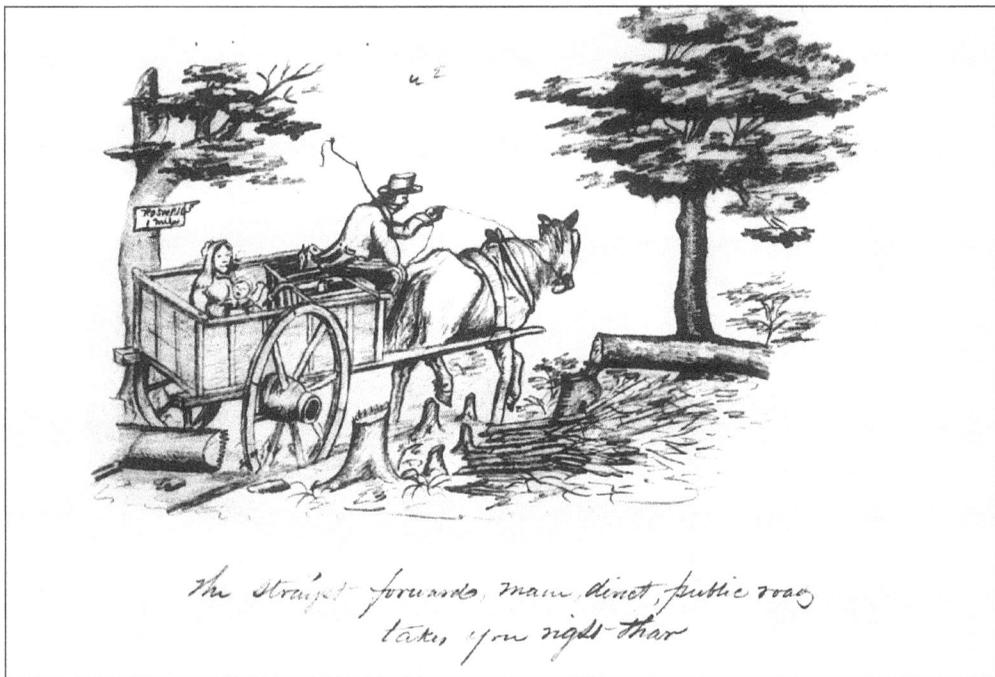

Henry Merrell's 1840 drawing is titled *Roswell, 1 mile, the straight forwards, main direct public road takes you right thar.* (Courtesy of James L. Skinner III.)

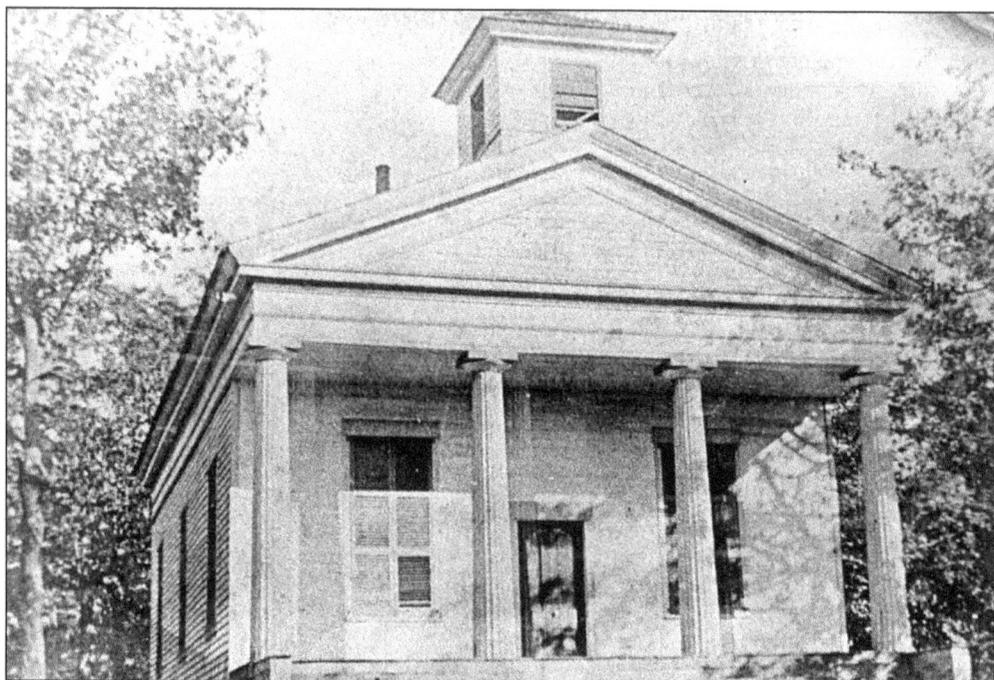

Roswell Presbyterian Church, organized in 1839, was the focal point for Roswell King's layout of the new town. He specified that the town limits would extend one mile in each direction from the Presbyterian Church on Main Street, later Mimosa Boulevard. King's plan included the town square with wide streets leading toward the founders' houses and the mills. (Courtesy of Henry Wing.)

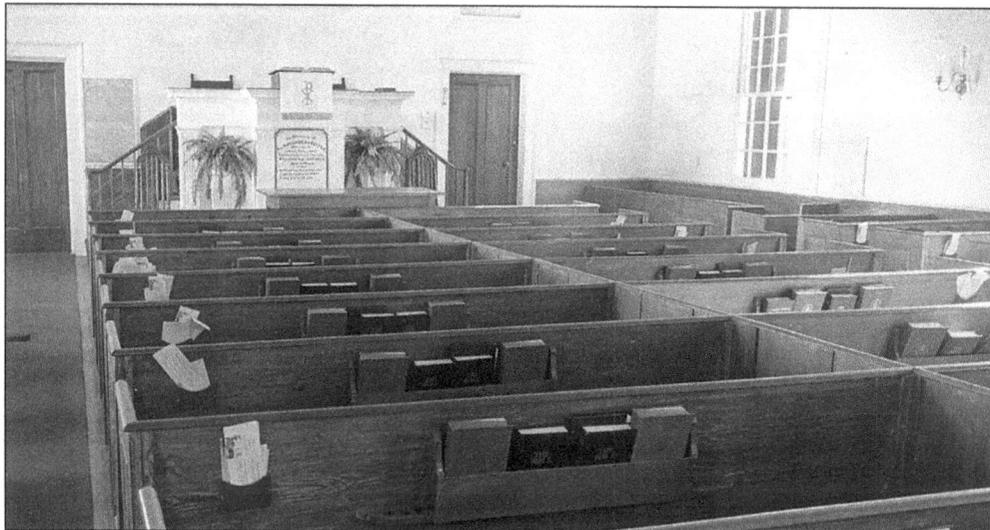

Roswell Presbyterian Church's original sanctuary has seen few changes since its congregation first worshipped there in 1840. Interior features include box pews with seating for 180, a raised pulpit, and a slave gallery. During the Civil War, Federal soldiers removed the pews and destroyed the pipe organ and hymnals. While regular services were briefly suspended, a Union army chaplain with the 72nd Mounted Indiana Infantry preached to a full house of soldiers in a service on July 9, 1864. (Photo by Joe McTyre.)

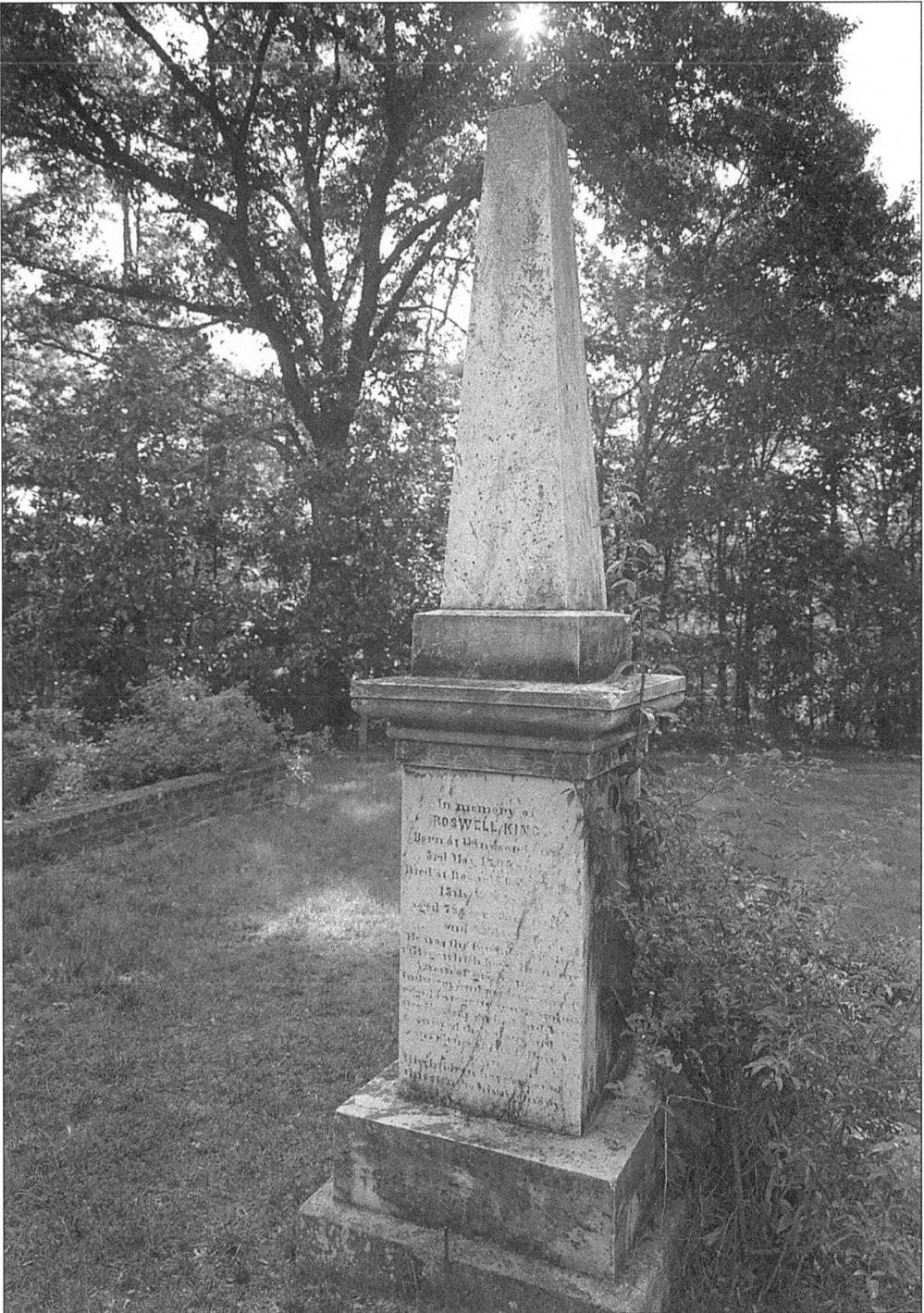

A monument was erected to honor Roswell King (1765–1844), the town's founder and namesake, by his children. Founders Cemetery, originally the Presbyterian Cemetery, also contains the graves of King's grandson Ralph King Hand, the three-year-old son of Eliza King Hand and Bayard E. Hand, and several slaves. (Photo by Joe McTyre.)

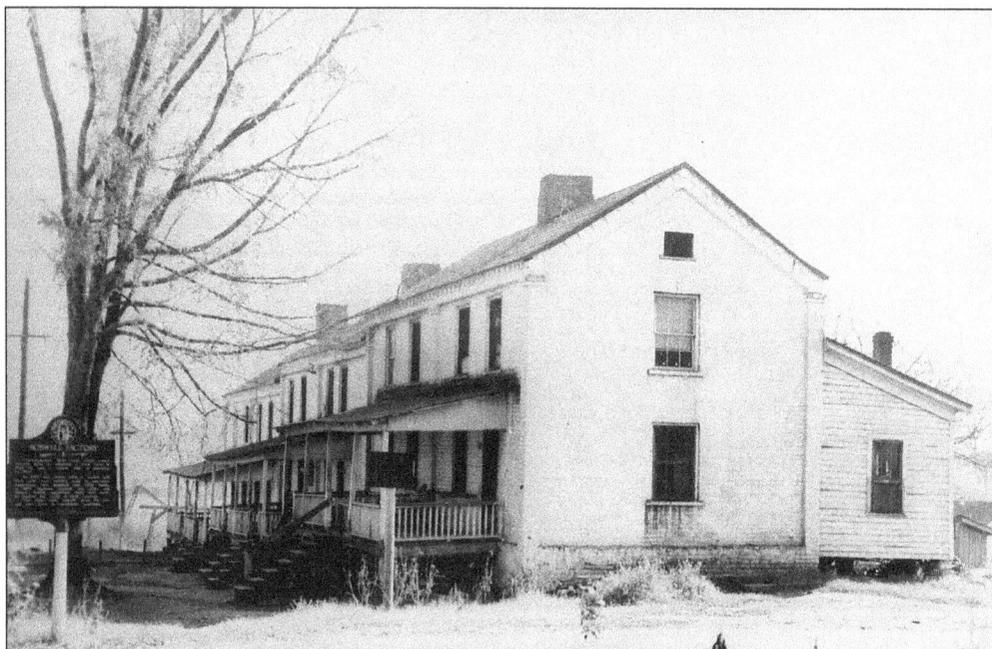

The Bricks, two apartment buildings built about 1840 by the Roswell Manufacturing Co., housed cotton mill workers and their families until the 1950s. According to the present owners, the apartments were used intermittently as residential and business space until the mid–1970s. The structures were renovated in the early 1980s and again more extensively in 1990. (Courtesy of Georgia Department of Archives and History.)

The Bricks, possibly the oldest apartment buildings in the United States, are pictured as the former dwellings look today. The two buildings contained a total of ten apartments for mill workers. An addition to the largest of the two structures was made in the 1990s to accommodate special events at the private Founders Club, located in the larger building. (Photo by Joe McTyre.)

A portrait of Barrington King (1798–1866) was probably painted in the 1840s and is displayed in a parlor of the mansion he built. King, the son of Roswell King and Catherine Barrington King, was born in Darien, Georgia, in 1798. He died at age 68. (Courtesy of Lois King Simpson.)

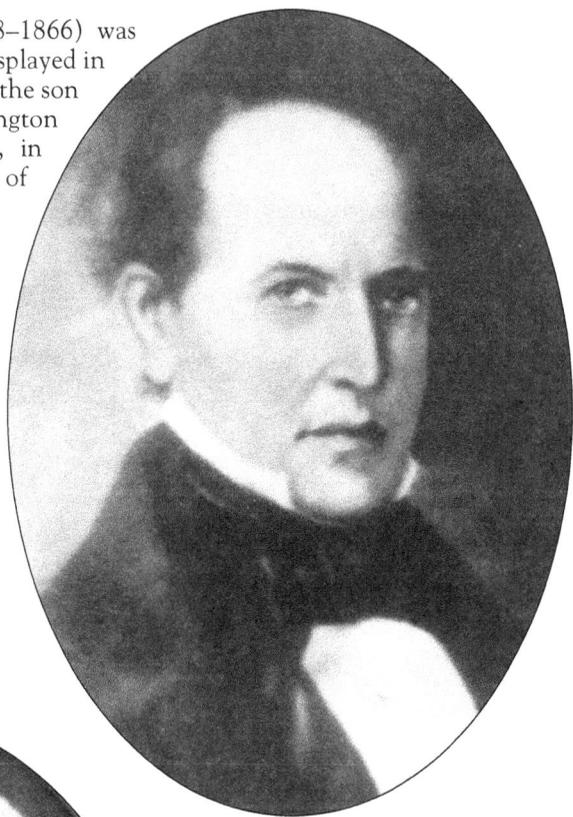

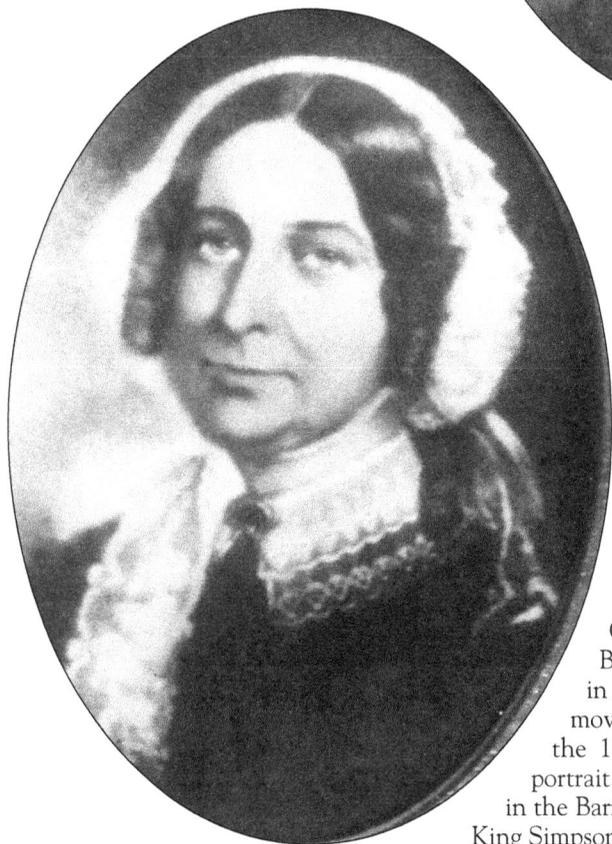

Catherine Margaret Nephew King (1804–1887), daughter of James Nephew and Mary Margaret Gignilliat Nephew, married Barrington King at Ceylon Plantation in McIntosh County, Georgia, in 1822, moved to Roswell with her husband in the 1830s, and died there in 1887. Her portrait, probably painted in the 1840s, hangs in the Barrington Hall parlor. (Courtesy of Lois King Simpson.)

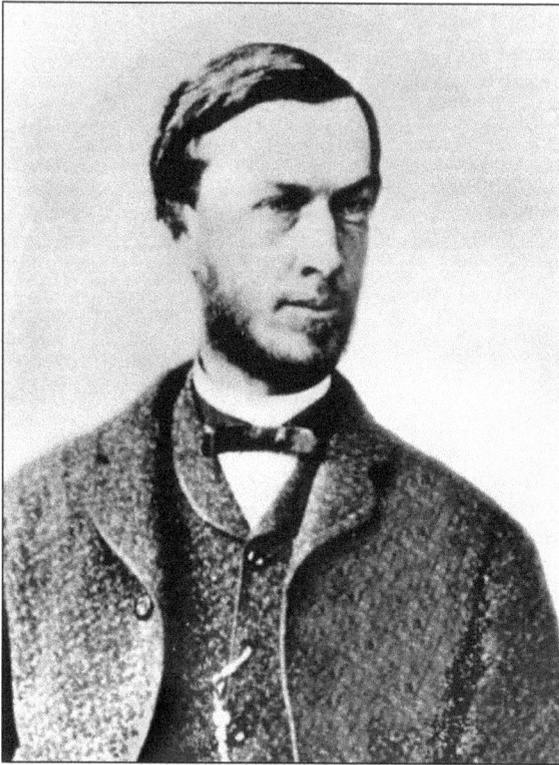

James Roswell King (1827–1897), son of Barrington and Catherine King, founded the Ivy Mill along with his brother Thomas Edward King. The woolen mill manufactured a special gray fabric for Confederate soldiers' uniforms. During the Civil War, James remained in Roswell running the woolen mill and serving as commander, with rank of captain, of the Roswell Battalion, which guarded the town. In July 1864, King and his unit burned the Chattahoochee River bridge and moved south as Federal troops invaded Roswell. The woolen mill was rebuilt after the war and sold to the Empire Manufacturing Co., which bought the original site. (Courtesy of Michael Hitt.)

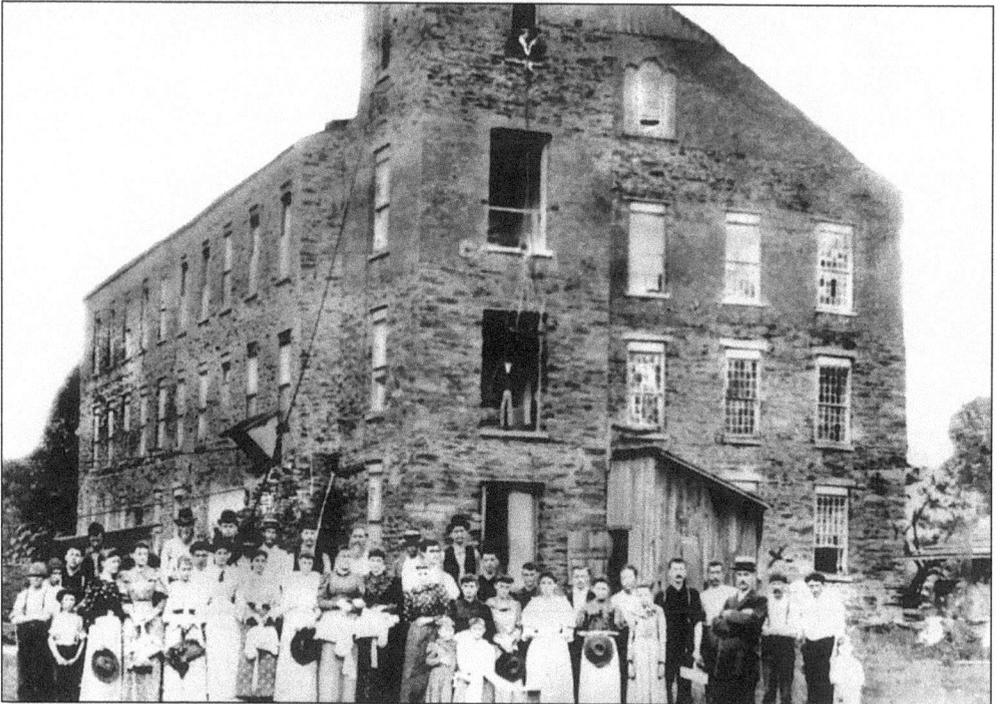

Laurel Woolen Mill (formerly the Ivy Mill) workers posed for this 1890s picture in front of the factory near Vickery Creek. (Courtesy of Georgia Department of Archives and History.)

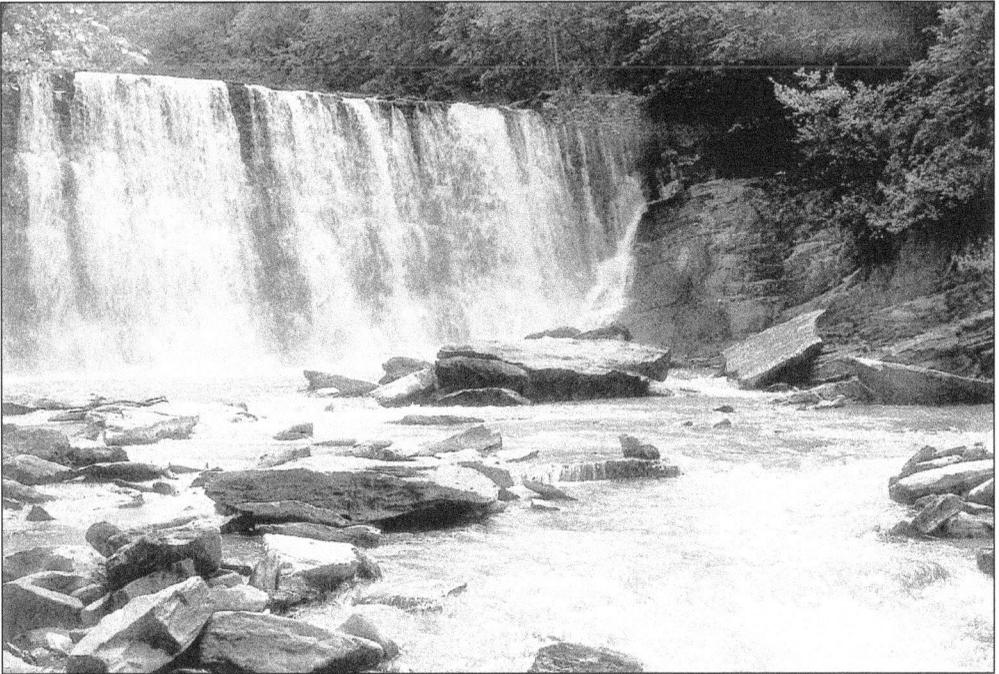

The Vickery Creek dam and waterfalls retain the natural beauty of the area as they might have appeared in the 1850s when the dam was built to provide waterpower for industrial development.(Photo by Robert Brown.)

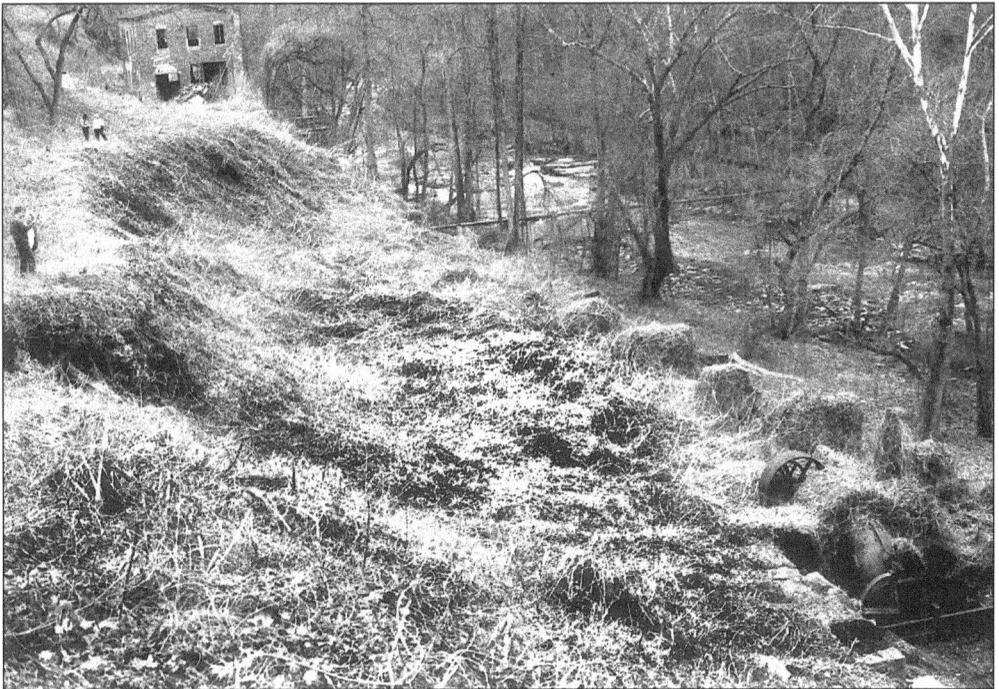

The pillars are all that remain of the 1839 Roswell Manufacturing Co. cotton mill sluiceway. (Courtesy of James L. Skinner III.)

17

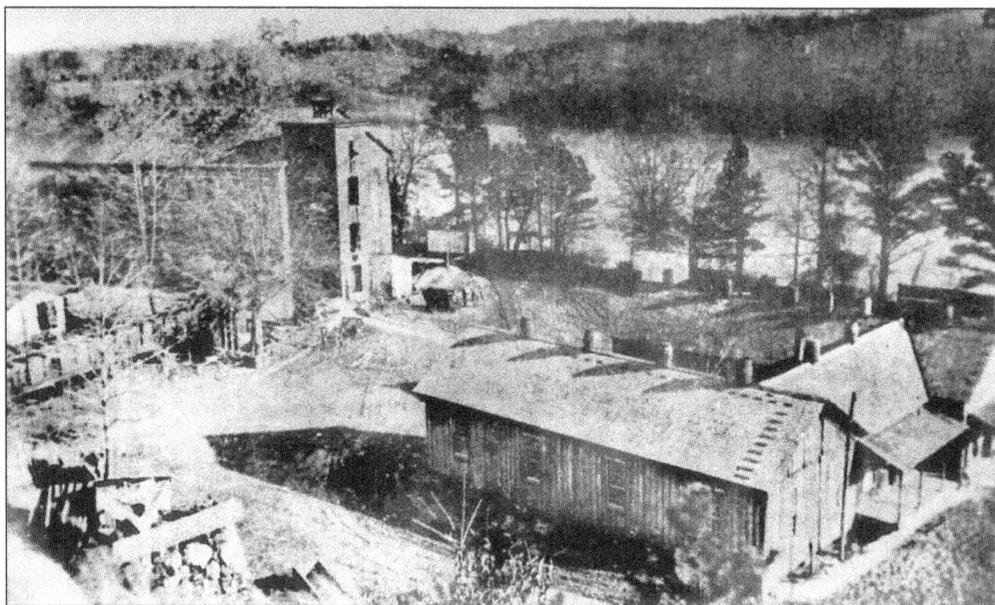

The Oxbo Falls Manufacturing Company (formerly Ivy Woolen Mill) was located close to the covered bridge on the north side of the Chattahoochee River. The original mill was burned in 1864 but its stonework saved it from total destruction. The machinery was thrown into the creek. (Courtesy of Michael Hitt.)

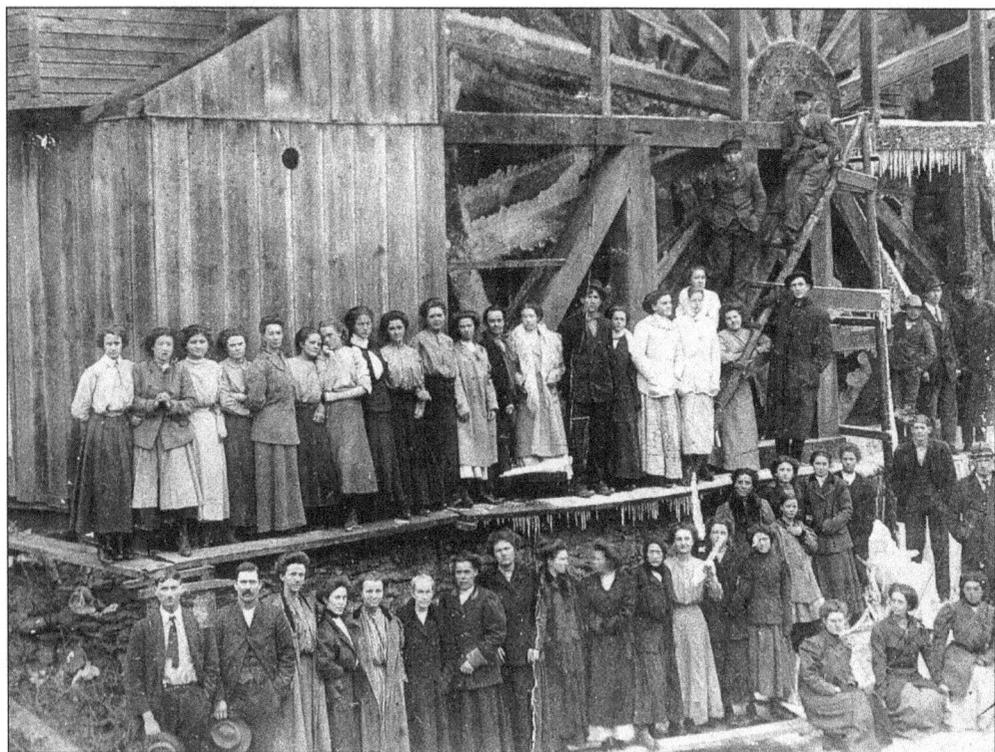

Employees at the Oxbo Falls Manufacturing Company stood in front of the water wheel covered with ice about 1900. (Courtesy of Nancy Hancock.)

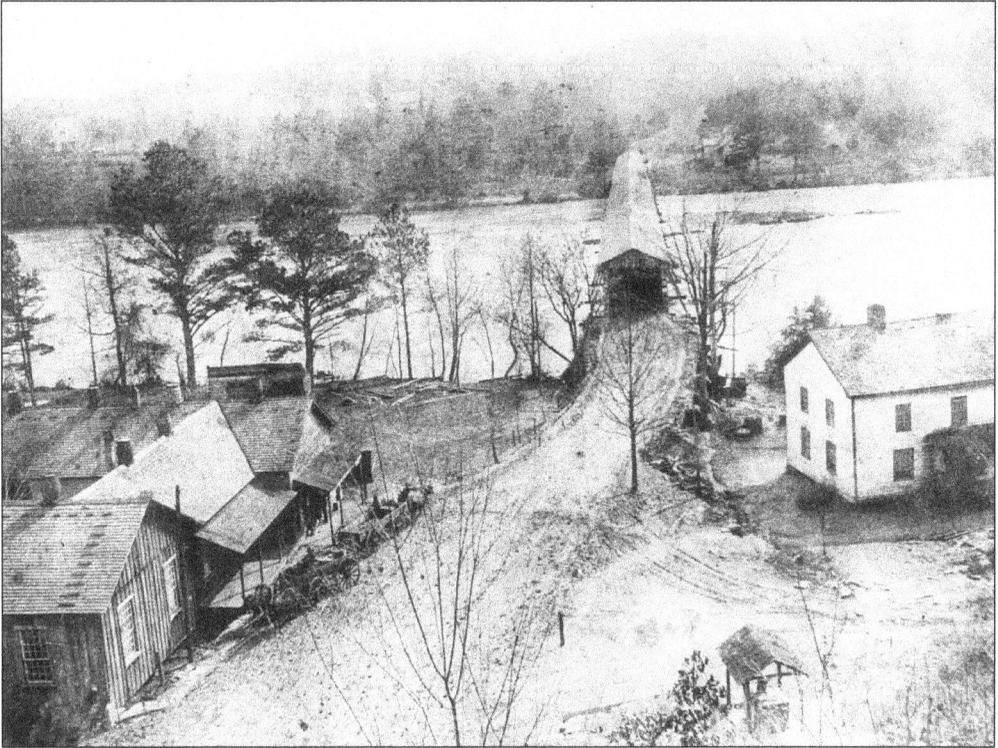

The covered bridge over the Chattahoochee River on Roswell Road is shown in approximately 1900. The building on the right was built as a boarding house. The structures on the left were part of the Roswell Manufacturing Co. complex. The bridge was replaced with a concrete bridge in 1925. (Courtesy of Georgia Department of Archives and History.)

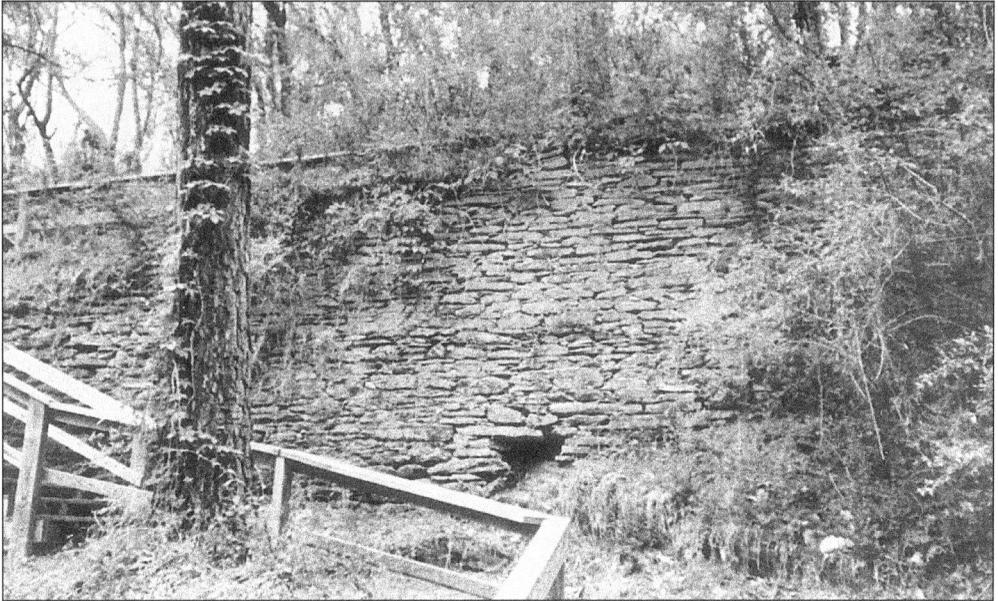

Ruins of the Roswell Manufacturing Company mills on Vickery Creek can be seen from nearby trails. (Photo by Charles Thon.)

19

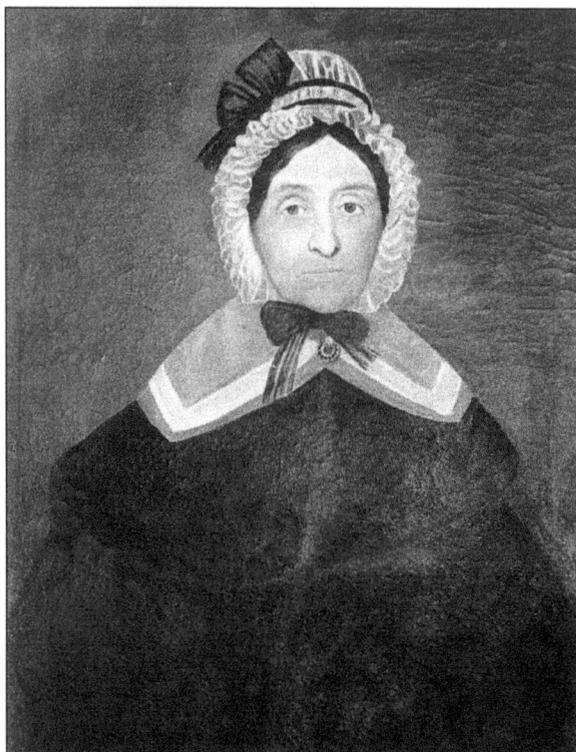

Catherine Barrington King (1776–1839) was the wife of Roswell King and daughter of Col. Josiah Barrington, who served under Gen. James Edward Oglethorpe. She married King in 1792 at the Barrington plantation near Darien. She never saw the fulfillment of her husband's work at Roswell because she did not join him in his move to the new settlement. Catherine is buried in St. Andrews Cemetery in Darien. (Courtesy of Lois King Simpson.)

Near the intersection of Mimosa Boulevard and Magnolia Street is Wachovia Bank, the site of Roswell King's first dwelling. Roswell and Barrington King and others shared the dwelling when they first arrived in the area until their permanent homes were completed. (Photo by Joe McTyre.)

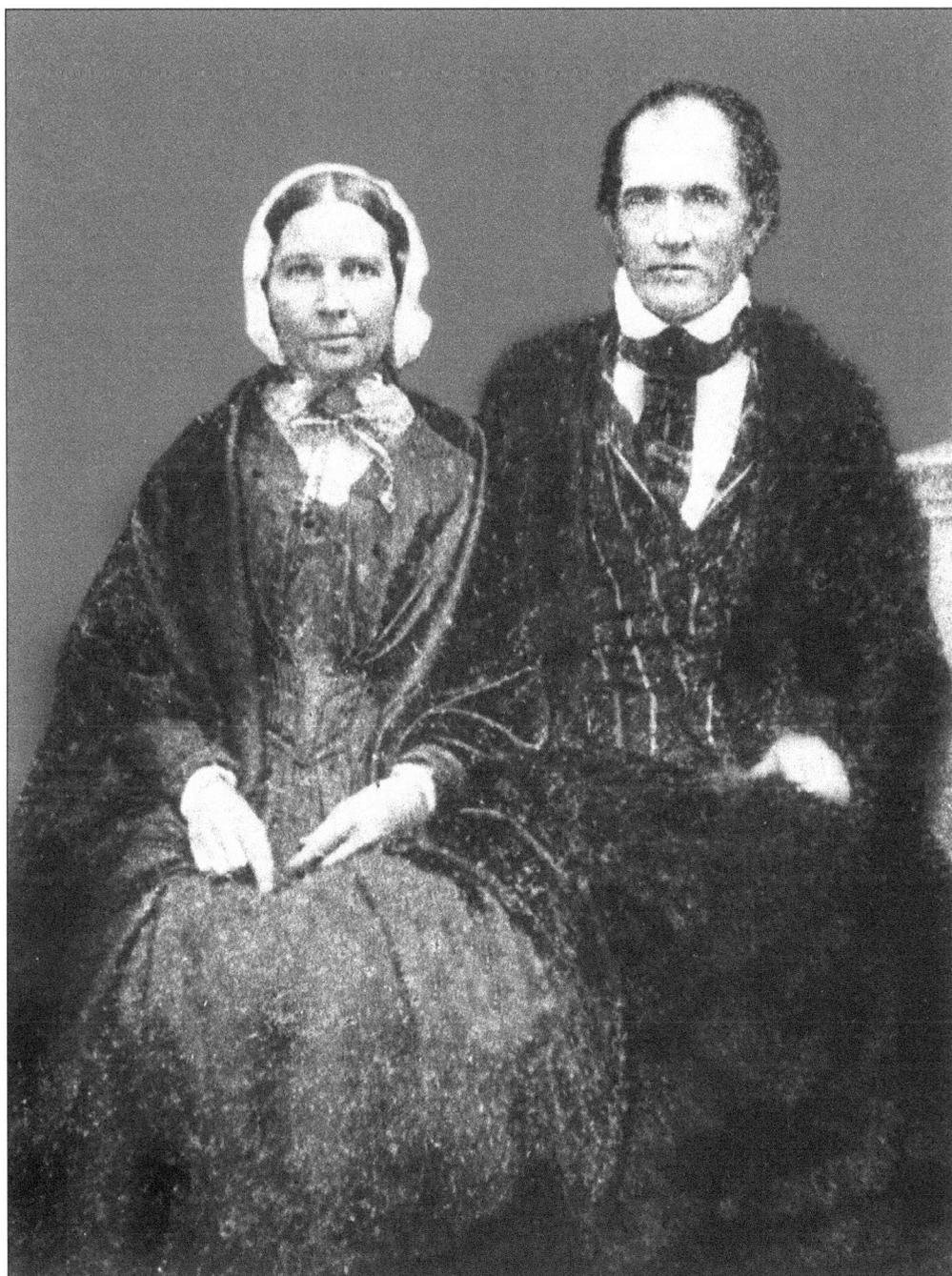

Barrington King and his wife, Catherine Nephew King, were natives of coastal Georgia. They were original Roswell settlers and built Barrington Hall, one of Roswell's outstanding temple form houses. (Courtesy of Roswell Presbyterian Church History Room.)

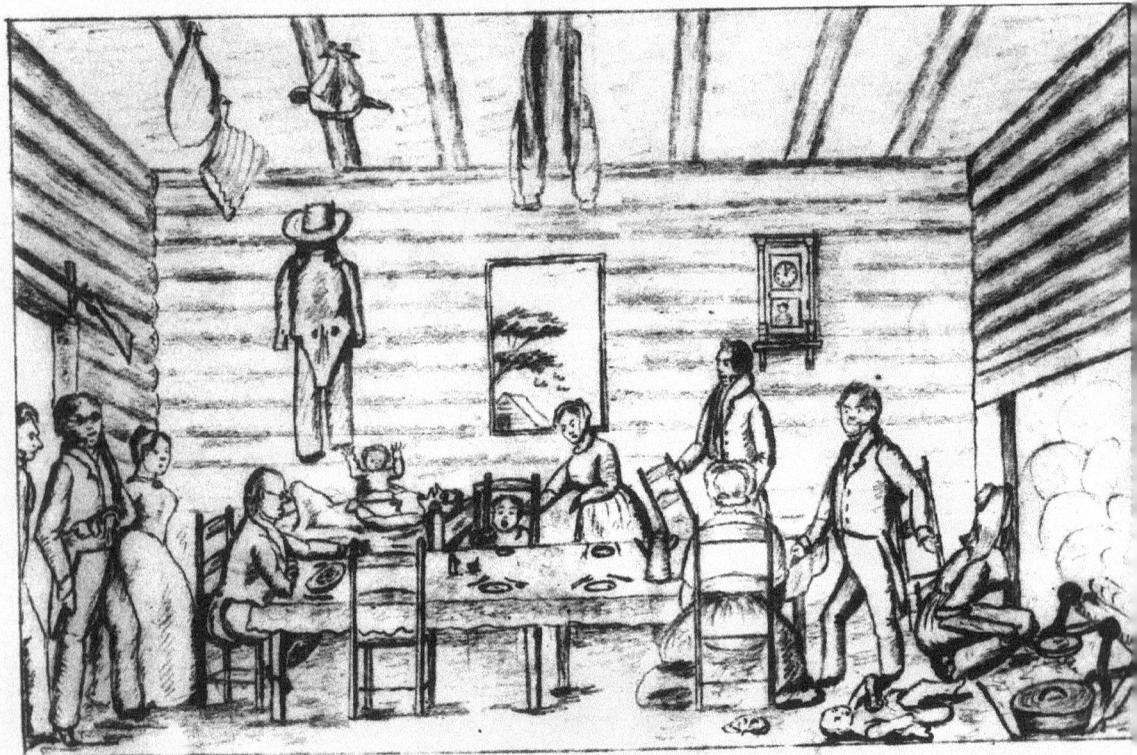

The first season at Roswell

Boarding Out.

Henry Merrell's drawing of early years in Roswell, *The first season at Roswell, Boarding out*, shows Roswell and Barrington King in the "Labyrinth" before homes for other family and friends were built. (Courtesy of James L. Skinner III.)

Two

THE COLONY

W hen word reached Roswell King's friends on the coast about his desirable new location, several well-to-do planters and businessmen couldn't resist the perfect inducement: free land for homesites and stock in the mill. In 1838, these pioneers from Darien, Savannah, and St. Marys began arriving and, by the early 1840s, the Hand, Bulloch, Dunwody, Pratt, and Smith clans were recorded as residents of Roswell. These founders called themselves "the Colony." Later, other visitors came in the summers and liked the small-town atmosphere and pleasant surroundings so much they also made Roswell their home.

As Roswell's "first family," the Kings were involved in all aspects of the community— managing the mills, supervising the workers, serving as church leaders, establishing the town government, and participating in the community's social life. Barrington and Roswell King laid out the town with wide streets, a park, and building sites they donated for the Presbyterian Church and a school. During their early years in Roswell, several founding families lived in rough log cabins or farmhouses until their permanent homes were completed. Soon after John Dunwody and his wife, Jane Bulloch Dunwody, came from Savannah in 1838, their son Charles started a shoe factory that became an important part of Roswell's industrial life. About 1840, they built Dunwody Hall next door to the property of James Stephens Bulloch, Mrs. Dunwody's brother and a prominent Savannah bank president. The Reverend Dr. Nathaniel Alpheus Pratt and his wife, Catherine King Pratt, another of Roswell King's daughters, and their family arrived in 1840. Dr. Pratt was called from his pastorate of the Darien Presbyterian Church to organize the new church at Roswell. Camden County plantation owner Archibald Smith and his wife, Anne Magill Smith, first settled in Lebanon but moved into Roswell in 1844. The Smiths built a plantation farmhouse on a large tract just north of the town square.

All the founding families brought their slaves, or servants, with them. In 1848, Cobb County records show Barrington King as the owner of 56 slaves. The Roswell Manufacturing Company had its own contingent of 10 slaves. The Bullochs owned 25 slaves, the Dunwodys 31, the Smiths 21, and the Pratt slaves were numbered as 11. Other early settlers, including mill workers, merchants, blacksmiths, carpenters, farmers, and others mostly came from North Georgia and North and South Carolina. In his autobiography, Merrell was pleased with the abundant labor of white "able–bodied men [paid] at eight dollars per month."[8]

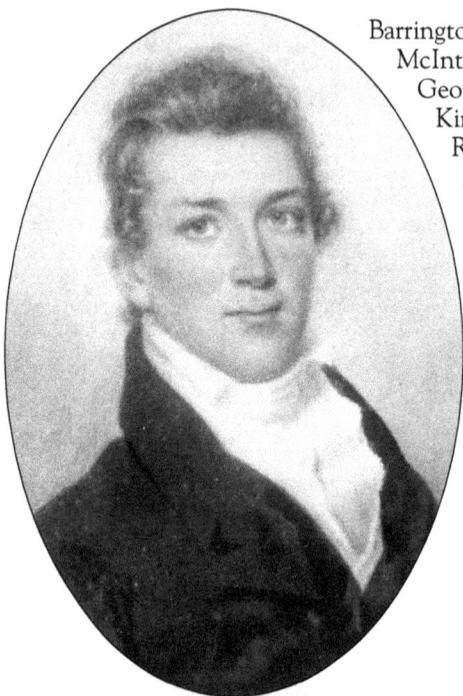

Barrington King sat for this rare portrait at age 19. Born in McIntosh County on the Georgia coast, he came to North Georgia in the late 1830s to help his father, Roswell King, clear land and build the first mill. He moved to Roswell permanently in 1838. (Courtesy of Roswell Presbyterian Church History Room.)

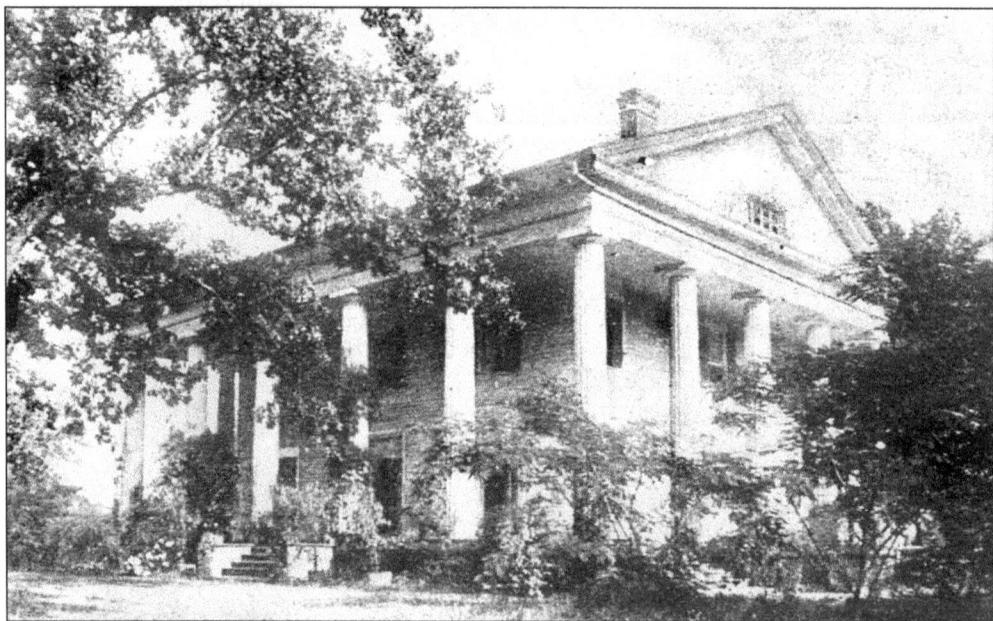

This early postcard photo of Barrington Hall shows the front and west porticoes of the outstanding Greek Revival house, the largest of the temple-form dwellings built in Roswell. The 11-room house was completed in 1842 after two years of construction. Connecticut carpenter Willis Ball built the house for Barrington King, which probably explains the addition of a captain's walk, a New England house feature. Barrington Hall is now owned by Lois King Simpson, adopted daughter of Katherine Baker Simpson, great–great–granddaughter of Roswell King. (Courtesy of Lois King Simpson.)

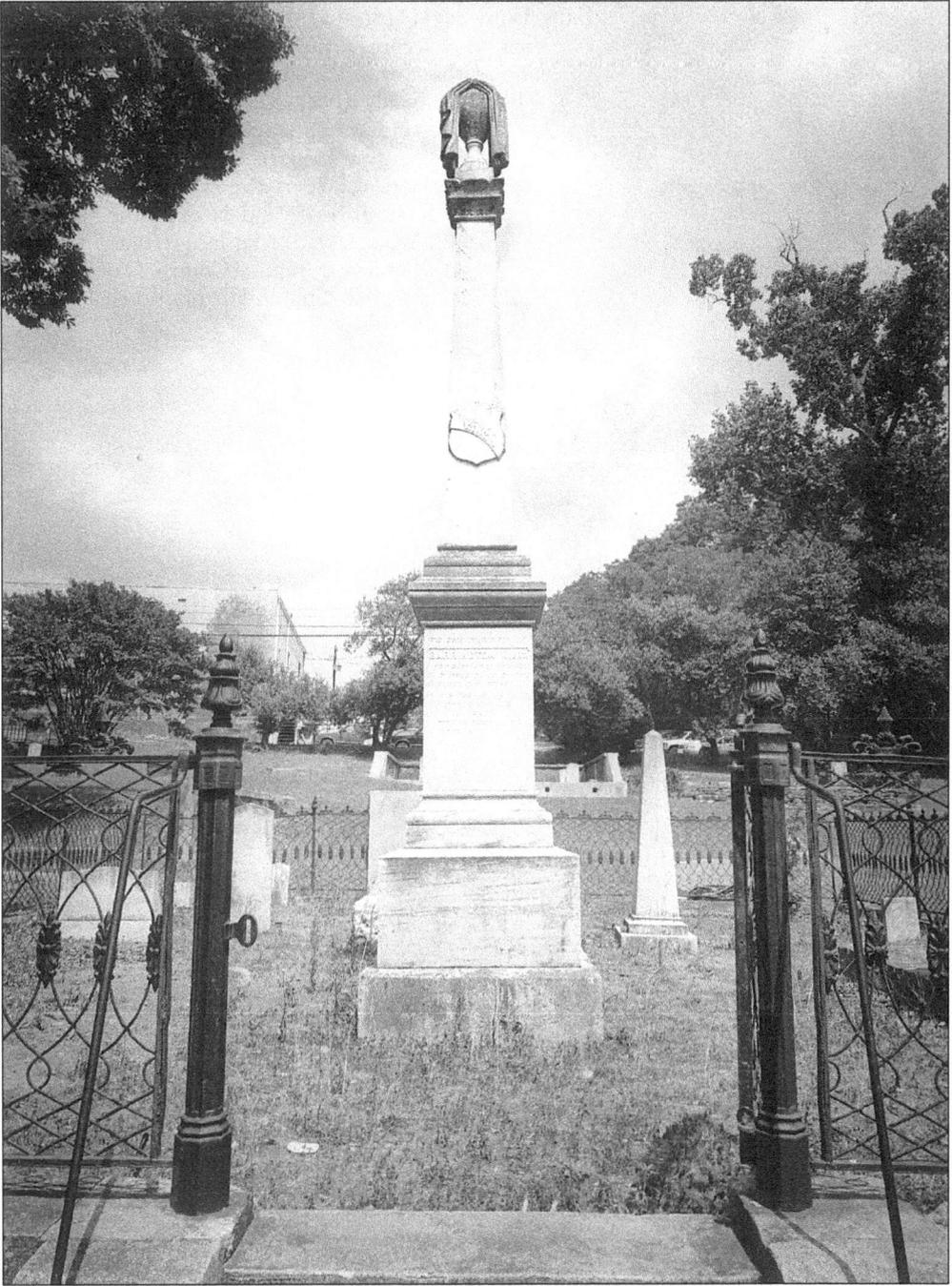

Barrington King was honored by his family with a monument erected in the Presbyterian Cemetery on Atlanta Street. King died in 1866. (Photo by Joe McTyre.)

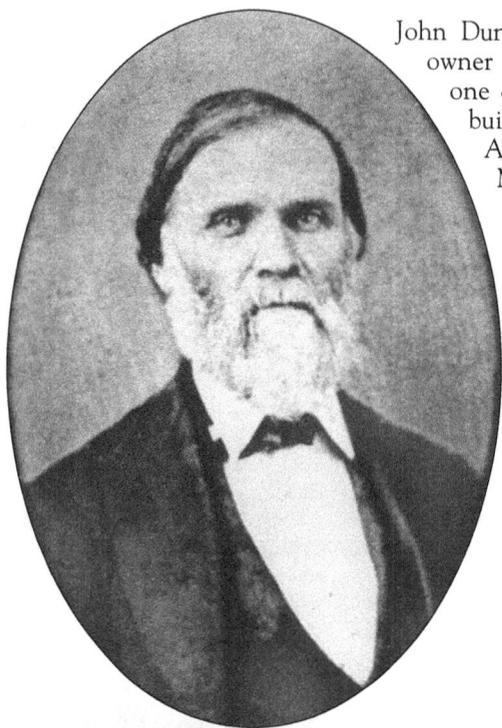

John Dunwody (1786–1858) was a Savannah business owner who accepted Roswell King's offer to become one of the Roswell founders in the late 1830s. He built Dunwody (later Mimosa) Hall on Bulloch Avenue and was a stockholder in the Roswell Manufacturing Co. His son Charles operated a shoe factory first in the downtown area near the Roswell Store and later in the two-story building occupied today by a restaurant, Pastis, on Canton Street. (Courtesy of Roswell Presbyterian Church History Room.)

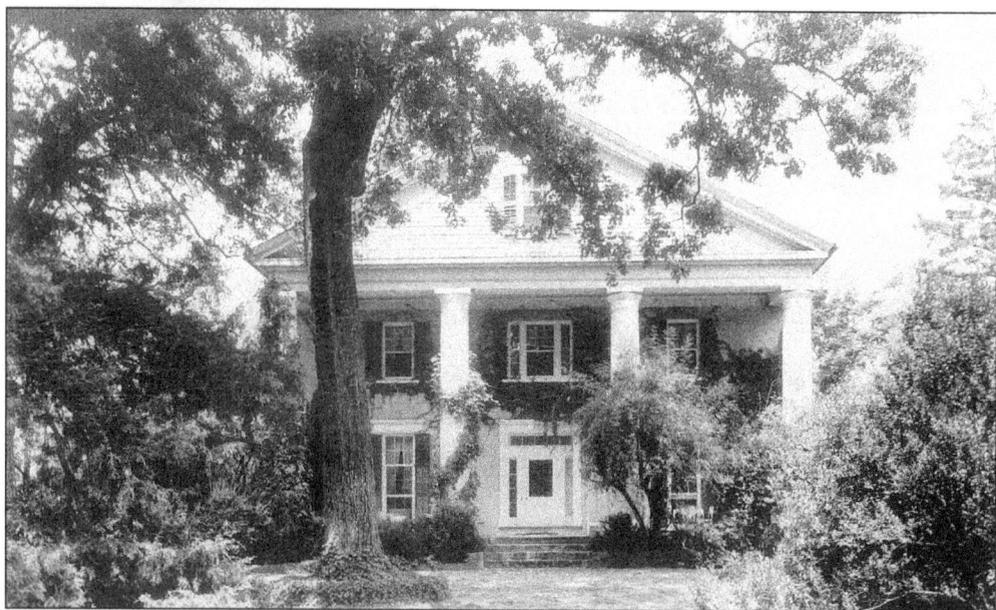

Mimosa Hall, a Greek Revival house built for John Dunwody, has impressive Doric columns that are among the largest in the area. Pictured here in the 1950s, Mimosa Hall is occupied by the Hansell family, which has owned it twice. Gen. Andrew J. Hansell purchased the Bulloch Avenue house in 1869 and sold it 30 years later. Hansell's great-grandson Granger Hansell reacquired it in 1947 and Granger's son Edward and Edward's wife, Sylvia Hansell, reside there now. Mimosa Hall's 37 acres of grounds are one of the outstanding examples of antebellum landscape settings remaining in Georgia. (Courtesy of Mary Wright Hawkins.)

James Stephens Bulloch (1793–1849) was born in Savannah to James Bulloch and Anne Irvine Bulloch. He first married Hester Amarinthia Elliott (1797–1827) in 1817, and they were parents of a son, James Dunwody Bulloch (1823–1901). After his wife died, James S. Bulloch married Martha Stewart Elliott, a widow and the stepmother of Bulloch's first wife, Hester. James and Martha Bulloch had four children: Anna, Martha, Charles, and Irvine. (Courtesy of Roswell Presbyterian Church History Room.)

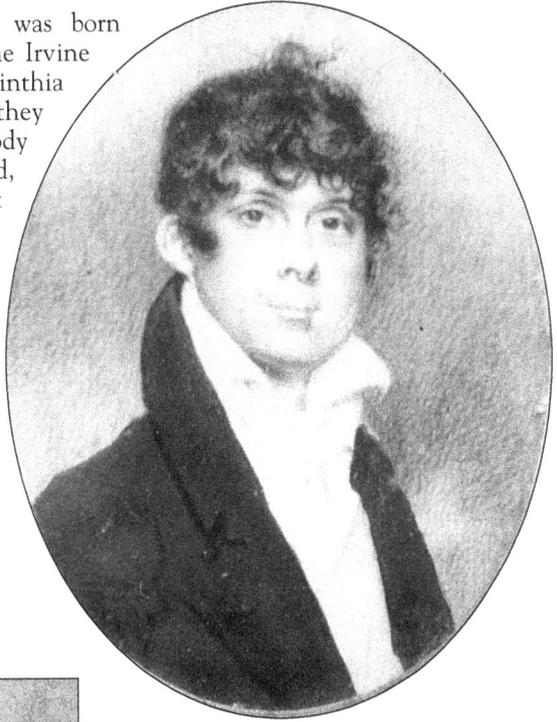

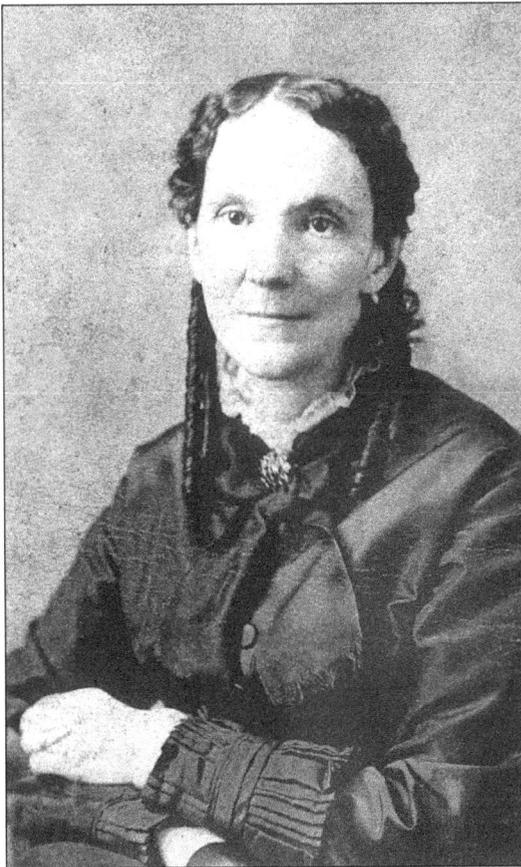

Jane Bulloch Dunwody (1788–1856) was the granddaughter of Archibald Bulloch, Georgia's Executive Council president and commander-in-chief prior to the colonies' independence from England. She married John Dunwody, son of early Sunbury, Georgia settlers, in 1808. (Courtesy of James B. Glover V.)

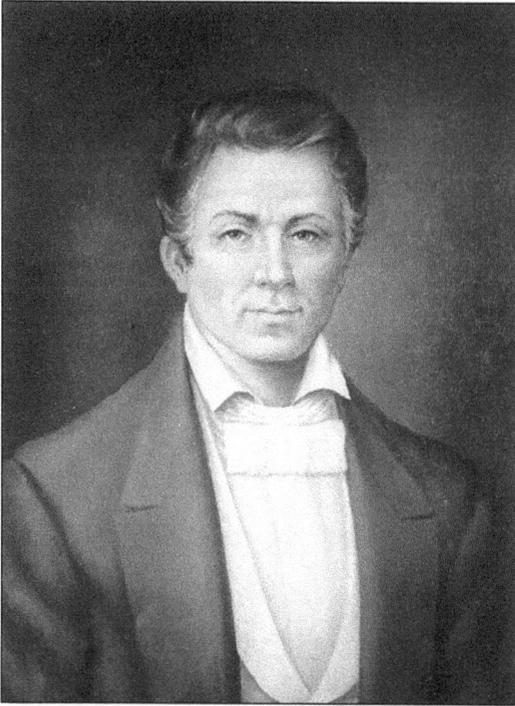

Artist Ernest DeVane painted Roswell pioneer James Stephens Bulloch as he conceived Bulloch in his middle years. Bulloch was the grandfather of Pres. Theodore Roosevelt and great-grandfather of Anna Eleanor Roosevelt, wife of President Franklin D. Roosevelt. (Courtesy of Marie B. DeVane.)

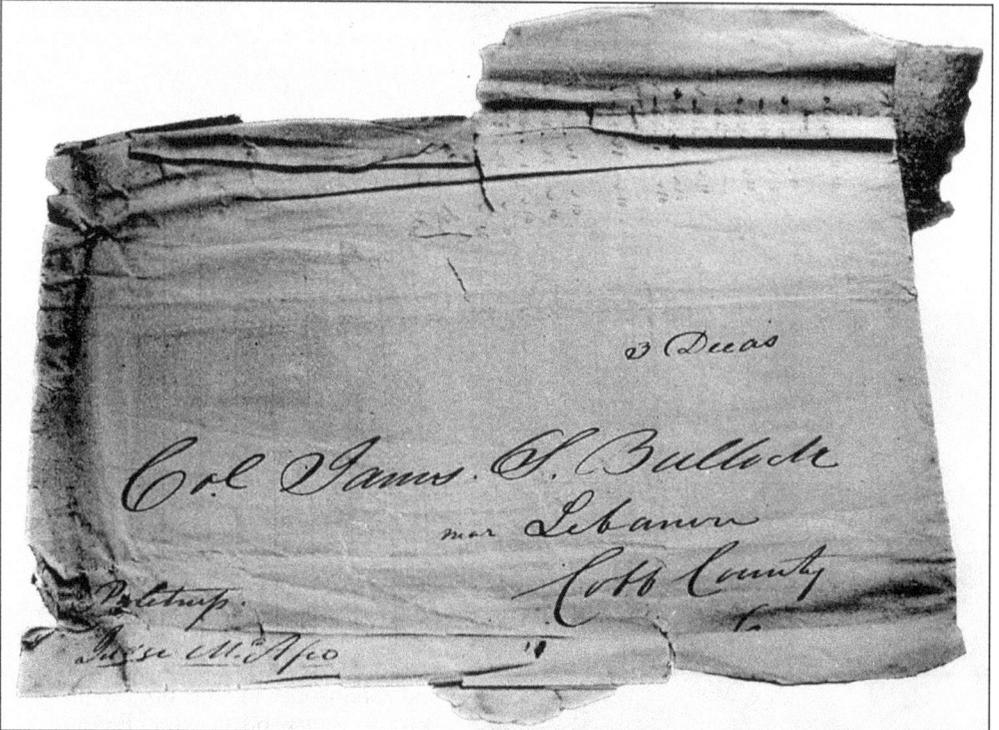

A letter addressed to Col. James Stephens Bulloch near "Lebanon, Cobb County" before Roswell had its own post office was hand-delivered by Judge McAfee. (Courtesy of Marietta Museum of History.)

Martha Stewart Elliott Bulloch (1799–1864) was the second wife of James Stephens Bulloch, whom she married in 1832. The daughter of Revolutionary War hero Gen. Daniel Stewart of Midway, she was previously married to Sen. John Elliott (she was his second wife) of Savannah. She was the mother of Susan, Georgia, and Daniel Elliott, as well as Anna, Martha (Mittie), Charles, and Irvine Bulloch. In 1856, she rented Bulloch Hall to Thomas King and moved with two of her younger children to Philadelphia. A year later, she moved to New York City to live with Martha and her husband, Theodore Roosevelt. (Courtesy of Bulloch Hall.)

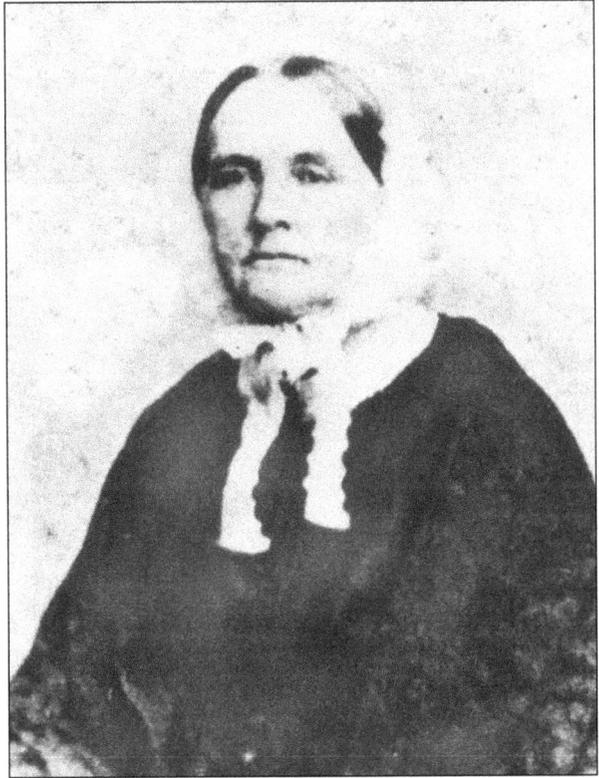

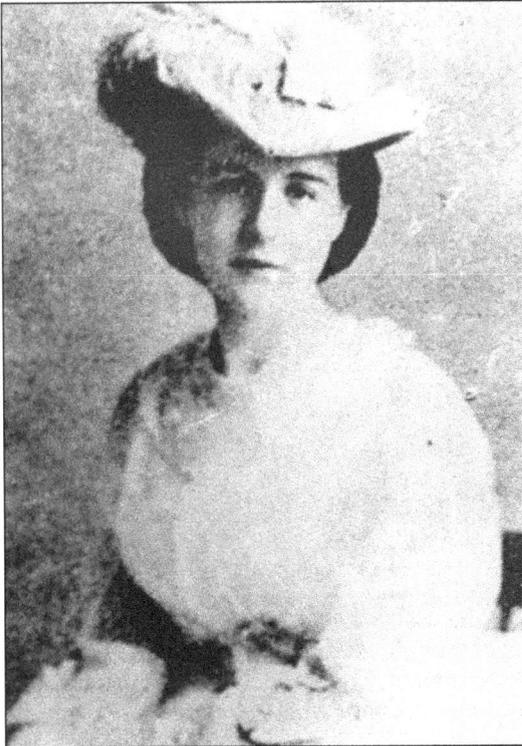

Martha (Mittie) Bulloch Roosevelt was 19 when she married Theodore Roosevelt of New York at her family home in 1853 after a four-month engagement. She returned twice to visit Roswell but spent the remainder of her life in New York where she gave birth to four children including Theodore Roosevelt Jr., 26th president of the United States. She was the grandmother of Anna Eleanor Roosevelt, wife of President Franklin D. Roosevelt. Mittie died of typhoid fever in 1864 at 49. That same day, Alice Roosevelt, wife of Theodore Jr., also died. (Courtesy of Roswell Presbyterian Church History Room.)

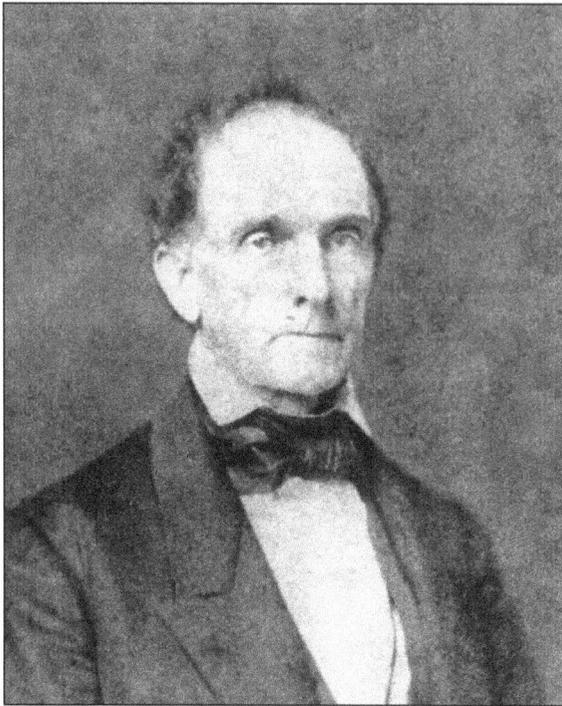

Dr. Nathaniel Alpheus Pratt (1796–1879) was the founding pastor and longtime minister (from 1840 to 1879) of Roswell Presbyterian Church. (Courtesy Roswell Presbyterian Church History Room.)

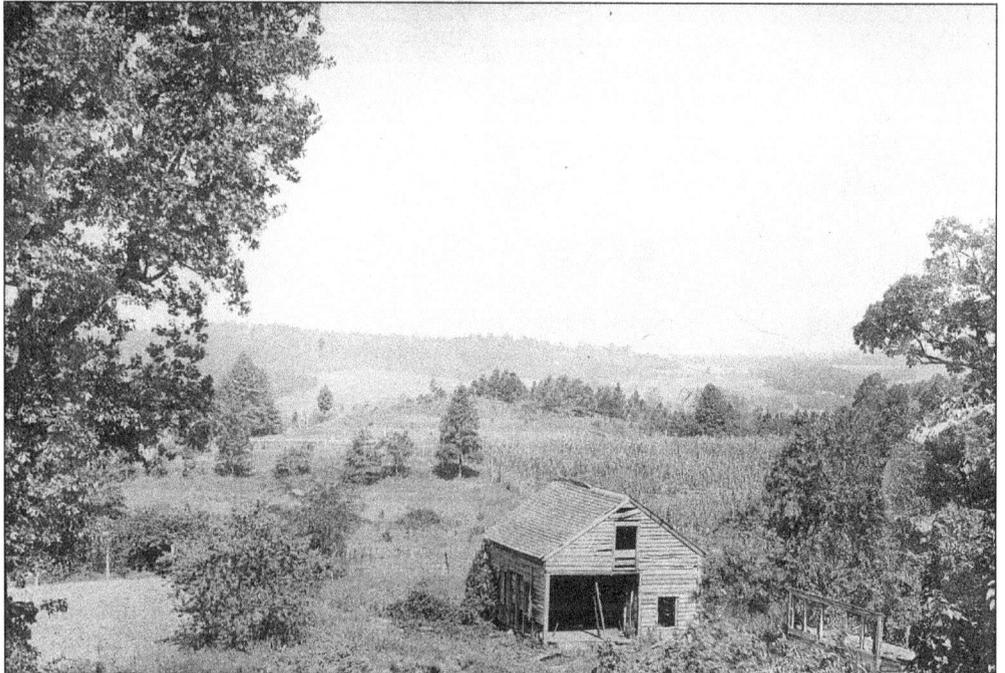

A scenic view, looking west, in 1921 from the back of the Great Oaks property on Mimosa Boulevard includes the barn with Sweat Mountain in the background. The house was occupied for generations by original owner Dr. Nathaniel A. Pratt and his direct descendants including the Heath, Merrill, and Rushin families. (Courtesy of Georgia Department of Archives and History.)

Catherine Barrington King Pratt (1810–1894), daughter of Roswell and Catherine Barrington King, was the wife of Rev. Nathaniel A. Pratt. She remained with her husband during the occupation of Roswell in July 1864. (Courtesy of Roswell Presbyterian Church History Room.)

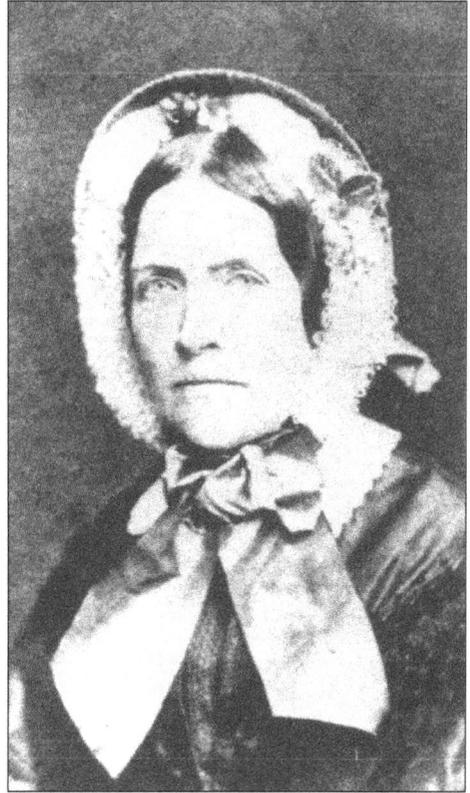

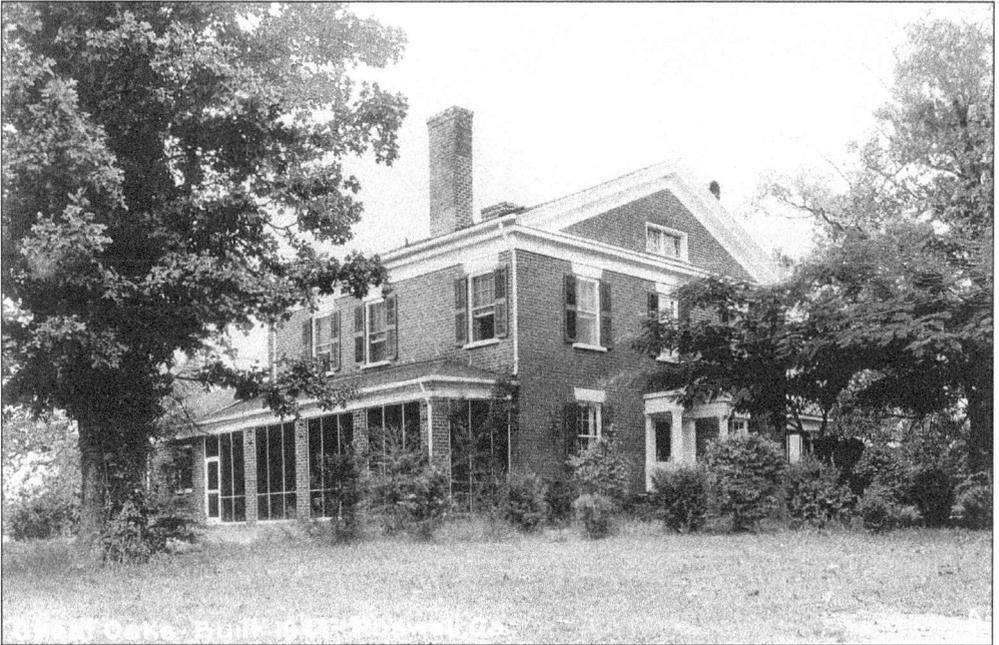

One of Roswell's impressive antebellum houses, Great Oaks, is pictured in the 1950s. The Pratt family owned the house for generations. Among its original features are a rare attached kitchen with a warming hearth and a well house. (Courtesy of Mary Wright Hawkins.)

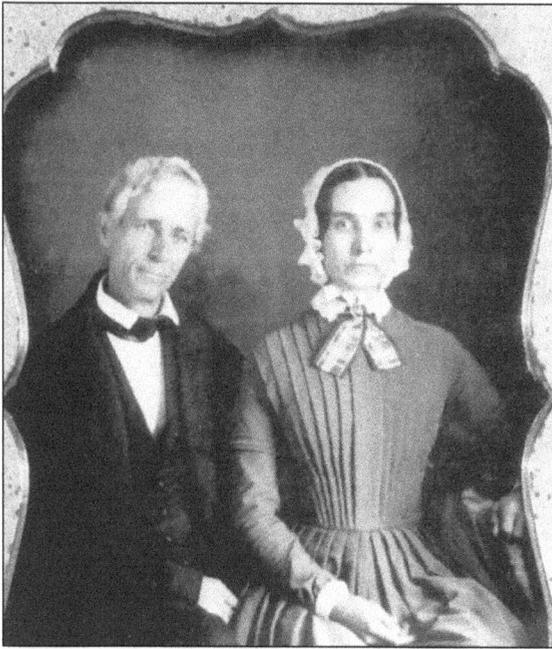

Archibald Smith (1801–1886) and Anne Magill Smith (1807–1887) arrived in the Roswell area with the first of the colony residents and were among the charter members of the Roswell Presbyterian Church. They first lived on a rented farm near Lebanon on the current site of North Fulton Regional Hospital and, in 1844, purchased a tract from a man who won it in the original Cherokee land lottery. On his 200-acre property Smith built a large cotton plantation, plantation house, and outbuildings in 1845. (Courtesy of James L. Skinner III.)

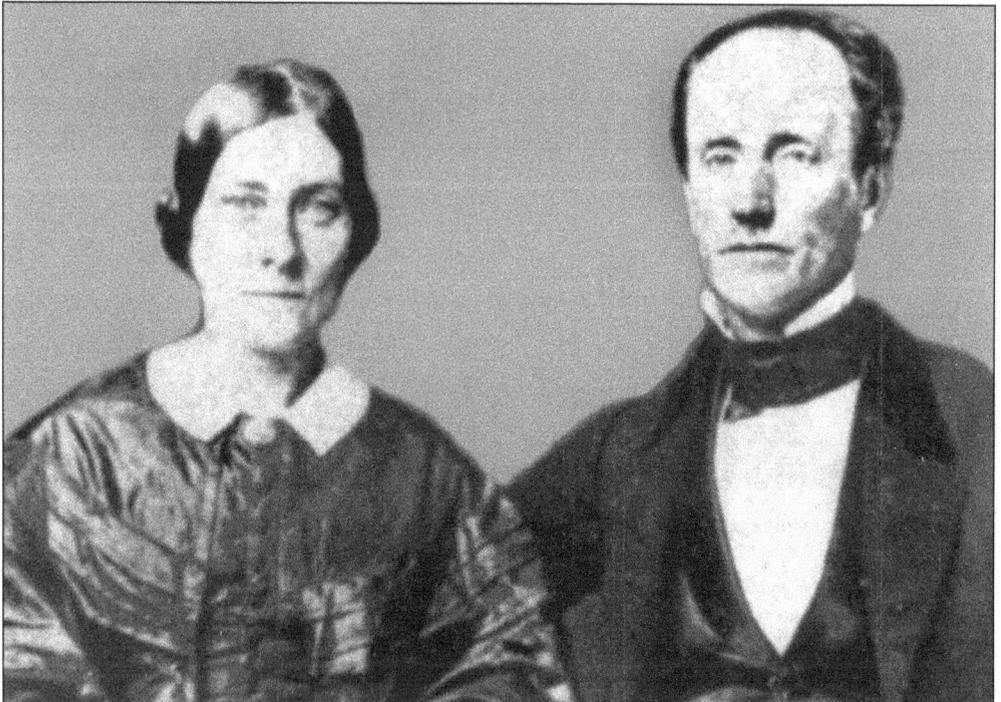

Henry Merrell and Elizabeth Magill married in Roswell in 1841 and lived there until 1845 when they moved to Greene County, Georgia. Merrell managed two factories near Athens and Greensboro until 1855 when they moved to Arkansas and he established mills that manufactured Confederate supplies during the Civil War. Elizabeth was the sister of Anne Magill Smith, wife of prominent Roswell settler Archibald Smith. (Courtesy of Roswell Presbyterian Church History Room.)

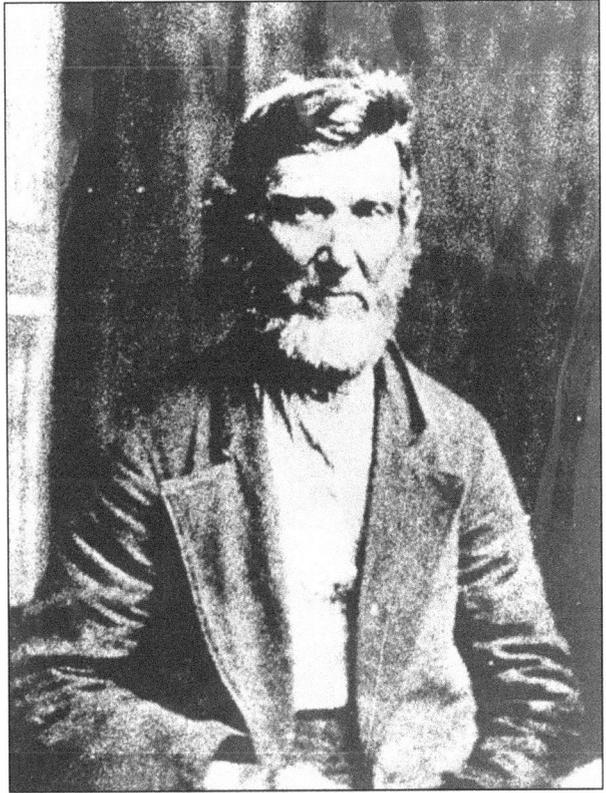

Valentine Coleman (1812–1890) was one of Roswell's earliest settlers and the son of Richard Coleman. Valentine married Nancy Campbell, a Cherokee Indian, in 1837. Many of their descendants still reside in the area today. (Courtesy of Dorcas Coleman McDonald.)

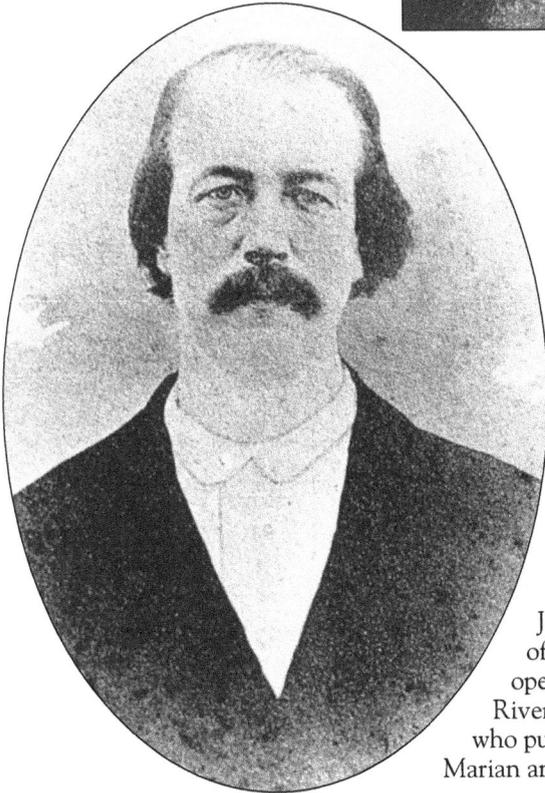

Jehu Lowery Wing (1823–1877) was one of Roswell's early settlers. In the 1850s he operated a ferry across the Chattahoochee River. He was the father of Jehu Bartow Wing who purchased Bulloch Hall in 1907. (Courtesy of Marian and Rachel Dabney.)

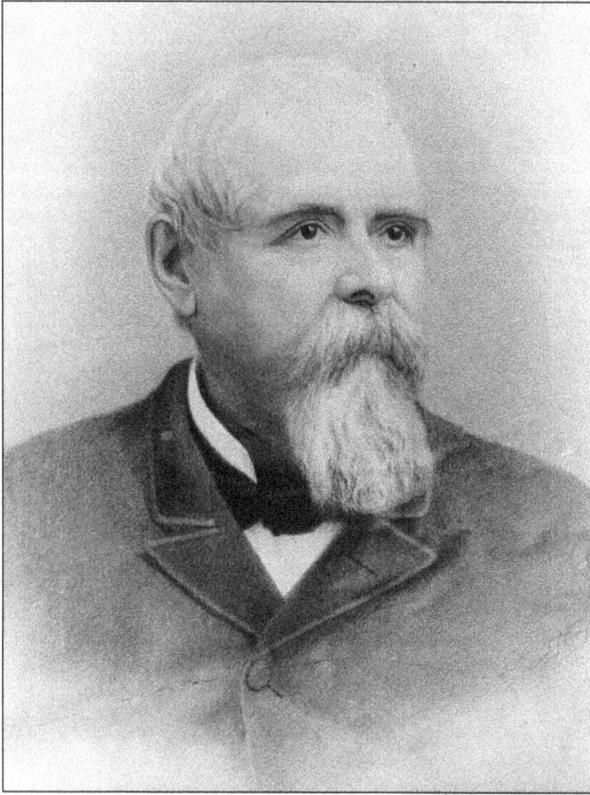

George Hull Camp (1817–1907) moved to Roswell from New York in the 1840s to work for the cotton mill owners. Later he became agent, then president of the Roswell Manufacturing Co. He first married his cousin Lucretia Merrell, who died in childbirth in 1845 in Roswell. In 1870 he acquired Tranquilla, an antebellum mansion in Marietta where Camp and his second wife, Jane Margaret Atwood, lived the remainder of their days. (Courtesy of Anne Torry.)

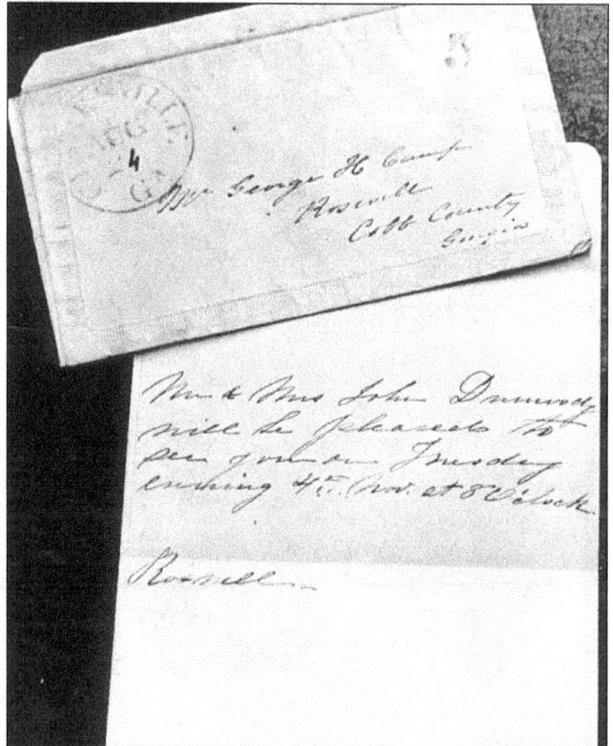

An invitation sent to George Camp by Mr. And Mrs. John Dunwody in Roswell in the late 1840s is postmarked Clarksville, Georgia, August 24. (Courtesy of Marietta Museum of History.)

Jane Atwood Camp (1830–1911), daughter of a prominent Darien cotton planter, married George Camp, whom she met while visiting friends in Roswell during the summers. After their marriage in 1850, the Camps lived in Roswell until the Civil War when they fled to Greensboro, Georgia, as the Union army invaded Roswell. (Courtesy of Anne Torry.)

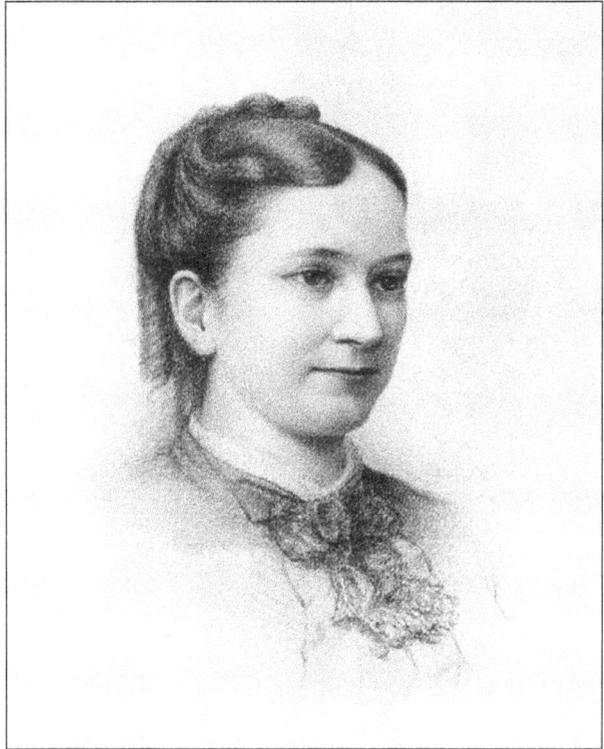

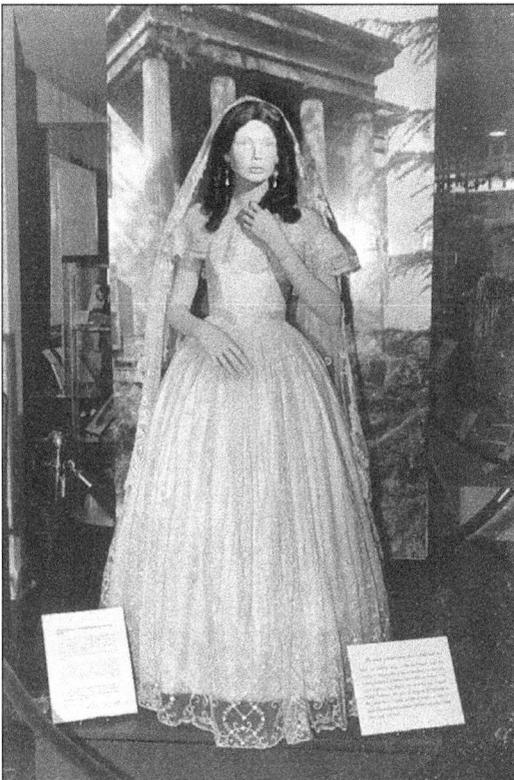

Jane Atwood Camp's wedding dress, worn to the Roosevelt-Bulloch wedding in 1853, is displayed at the Marietta Museum of History. In 1850, Jane married George Hull Camp. After the Civil War, the Camps moved to Marietta where they and their descendants owned Tranquilla, the 1849 mansion built by Gen. Andrew J. Hansell, for 124 years. (Photo by Joe McTyre.)

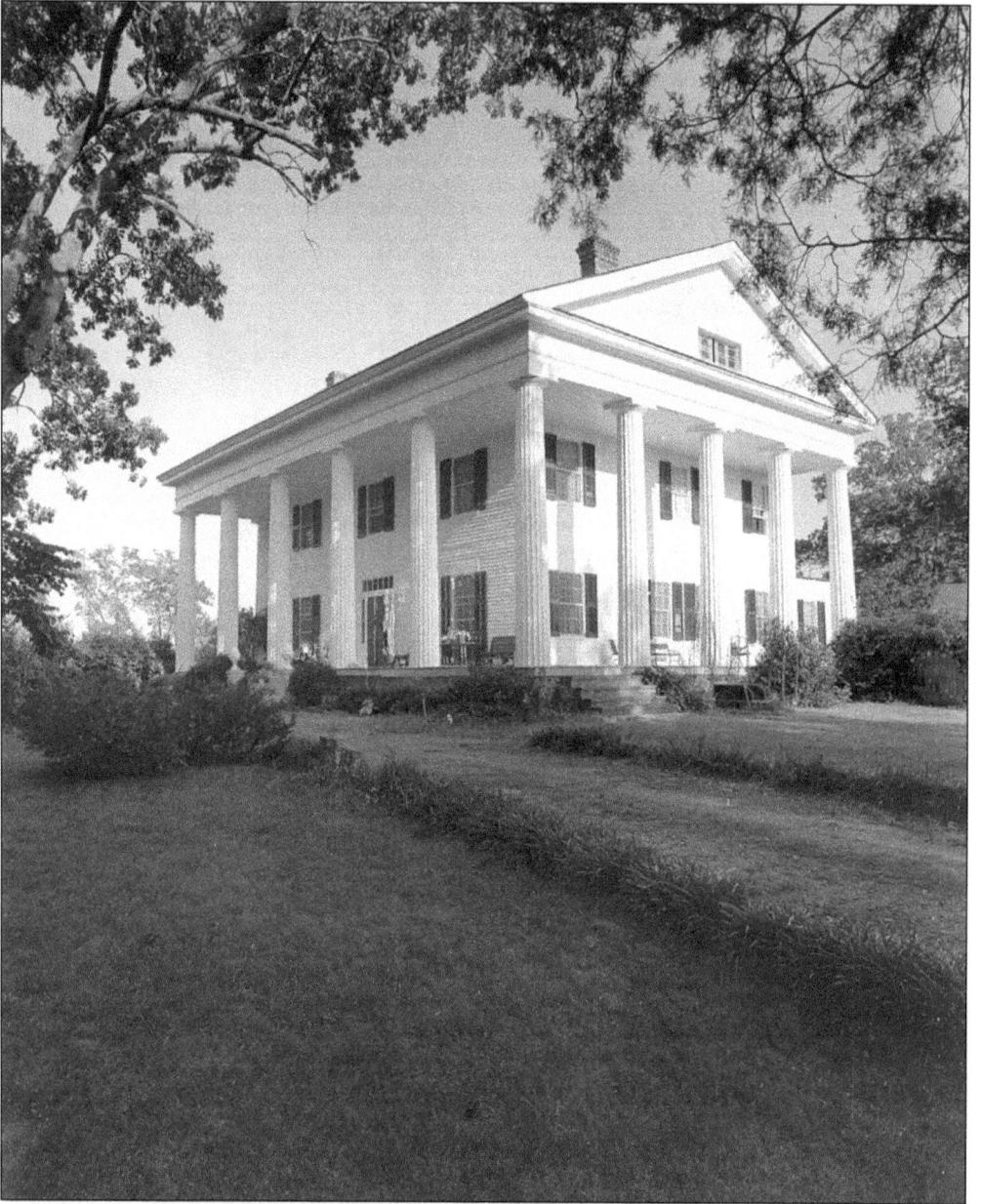

Barrington Hall's front and west sides catch the late evening sun on a summer day. Its massive Doric columns and porticoes cover three sides of the building. The house is atypical among temple-form houses because it is wider than its length with its gables and pediments facing to the sides. Barrington Hall is now owned by the city of Roswell and is used as a house museum. (Photo by Joe McTyre.)

Three

TOWN AND BUILDINGS

At first, Roswell King and Barrington King and his family occupied a double log cabin, nicknamed the "Castle" or the "Labyrinth" because many rooms were added to accommodate new arrivals until their homes were completed.[9] After the cotton mill was in operation, the major construction priorities were a Presbyterian church, a commissary, housing for mill workers, a school, and other dwellings.

Among the earliest structures was the first private house, Primrose Cottage, built in 1839 for Roswell King's widowed daughter Eliza King Hand of Darien. The original company store, or commissary, and two apartment buildings—called "The Bricks"—for mill workers and their families were built about 1840 near the mill site, an area called "Factory Hill." In 1854, a new company store east of the town park replaced two earlier commissary structures that were razed or used for other purposes.

Barrington King and his wife, Catherine Nephew (probably Neveu originally) King, built Barrington Hall in 1842 for their large family—9 of their 12 children lived to maturity. Timber for the striking Greek Revival house was cut and cured on the property, which now overlooks the busy intersection of Atlanta Street and Georgia Highway 120. The design for the mantelpieces was copied from Asher Benjamin's book, *The Practical House Carpenter*.[10] Many historical accounts credit Connecticut architect-builder Willis Ball with designing and overseeing construction of the Barrington, Bulloch, and Dunwody mansions.

The Bulloch family moved into their fine home in 1840. One of the most romantic and significant events that took place at Bulloch Hall was the 1853 marriage of the Bullochs' daughter, Martha (Mittie), to Theodore Roosevelt of New York. The couple later became parents of Theodore Roosevelt Jr., 26th president of the United States.

Set amid trees of many varieties was Dunwody Hall, an impressive frame house built early in the 1840s by John Dunwody and similar to its neighbor Bulloch Hall. Unfortunately the new structure burned to the ground on the night of its owners' housewarming party. When the second construction was completed about 1847, the great house was christened Phoenix Hall to signify the legendary bird rising from the ashes. Later owners, the Hansells, renamed the house Mimosa Hall and, in the 1930s, it was one of the Southern mansions used as a model for the Tara and Twelve Oaks facades in *Gone with the Wind*.[11]

Among other notable antebellum homes are the Archibald Smith plantation house, Great Oaks, and Holly Hill. Archibald Smith, a South Georgia plantation owner, built a plantation farmhouse on his 200-acre property where he grew much of the cotton used for the first mill.[12] Dr. Pratt planned to build a new home similar to Bulloch Hall but fire destroyed the materials before construction could begin. In 1842, the Pratt family moved into Great Oaks, a two-story Greek Revival-style brick house that still stands across from the Presbyterian Church on Mimosa Boulevard. Holly Hill, a Greek Revival raised cottage-style house, was built as a summer home about 1845 for Robert Adams Lewis, a prominent Savannah businessman.

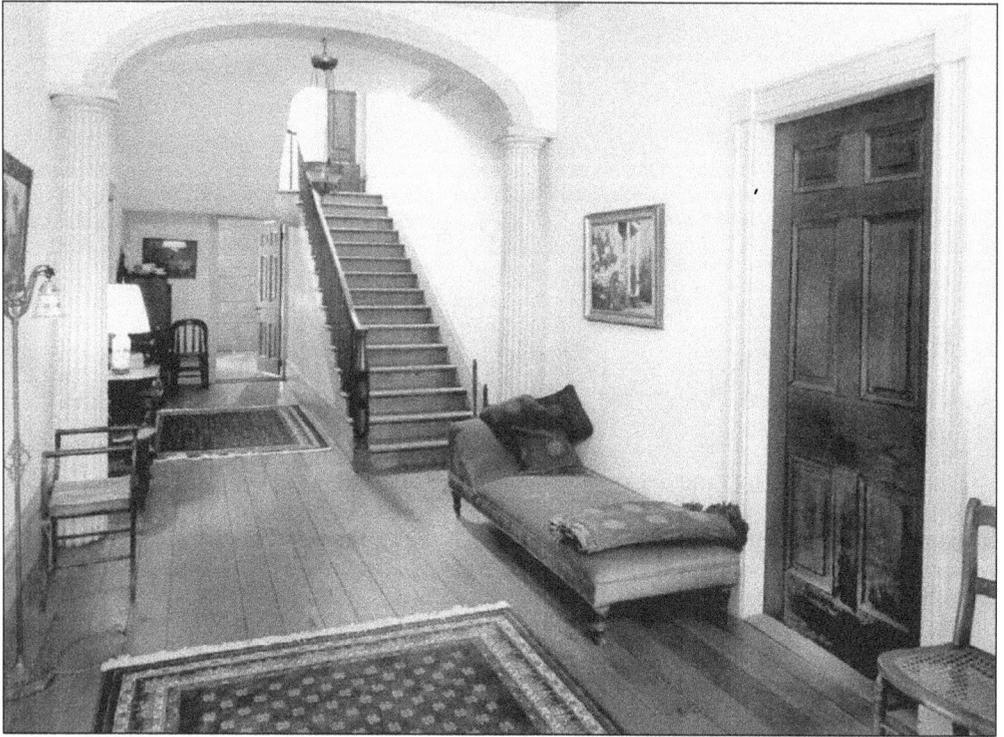

Among Barrington Hall's striking features are the entrance hallway, stairs, and wide archway with Doric columns. The west parlor door is shown on the right. (Photo by Joe McTyre.)

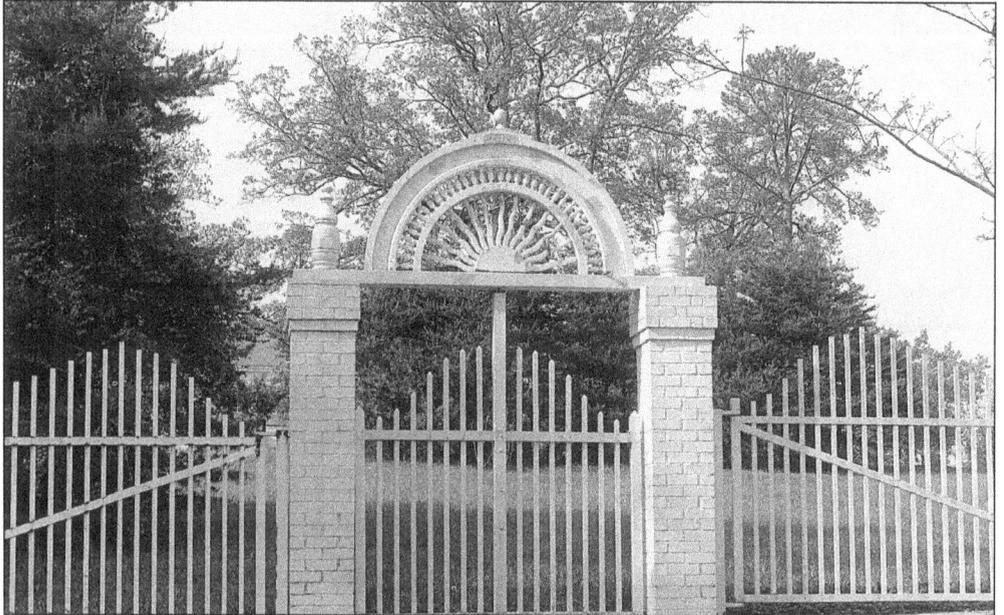

For several decades, the distinctive gates at Barrington Hall opened for family members and guests as they arrived at the front entrance. When the Marietta Highway was widened, a retaining wall was necessary and the gates were moved to the back of the property facing King Street. (Photo by Joe McTyre.)

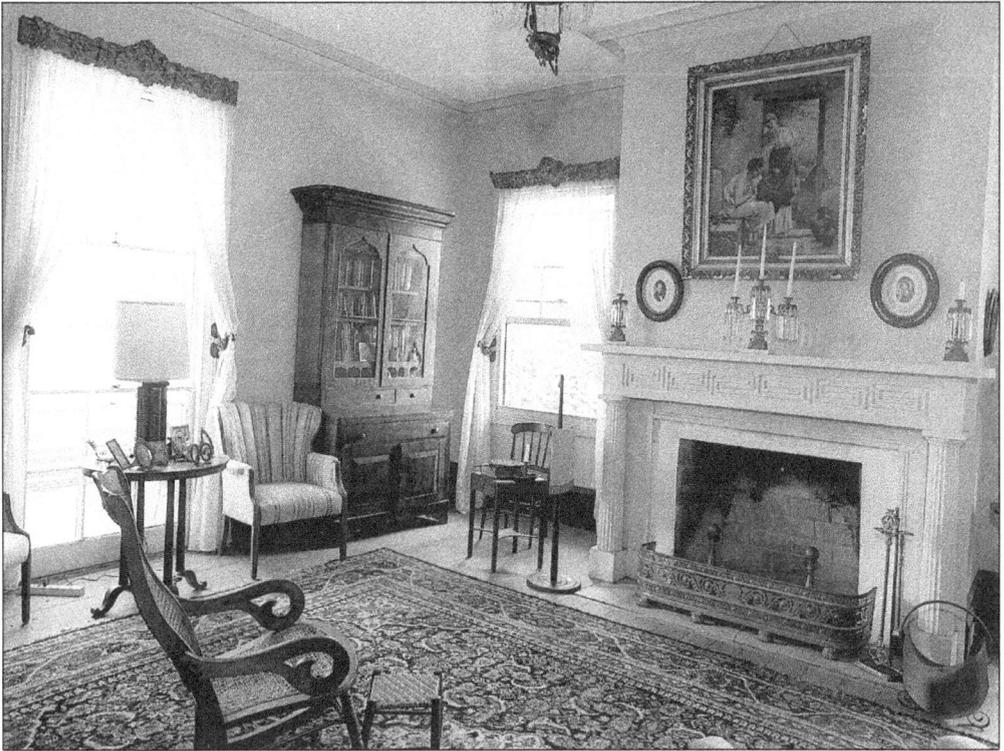

With only a few modern conveniences, including electricity, added through the years, Barrington Hall's parlor is shown as it looks today. The outstanding mantel detailing was copied by the builder from Asher Benjamin's 1830 designs. (Photo by Joe McTyre.)

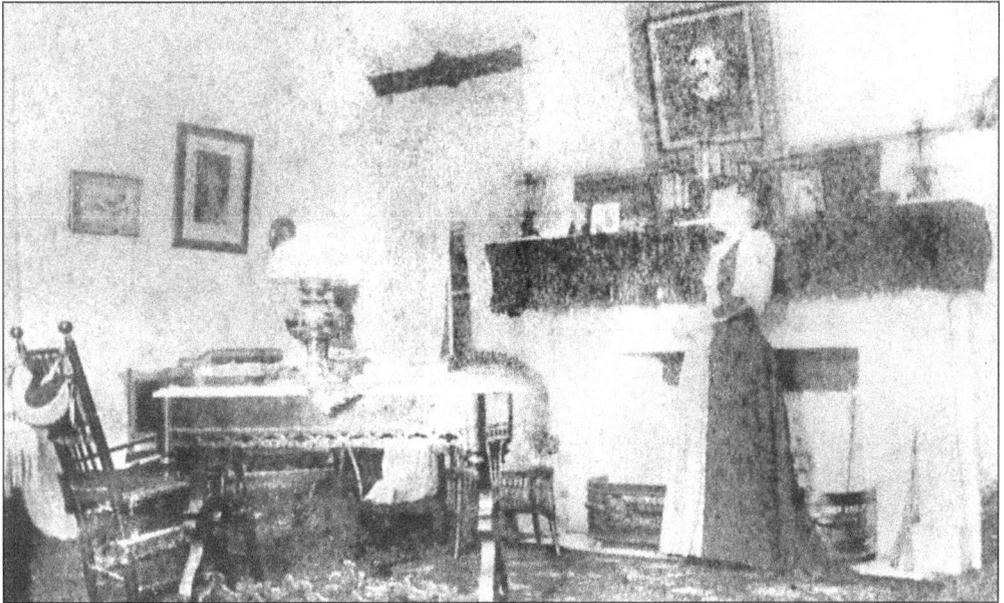

Sarah Clifford Baker stood at the mantel in the Barrington Hall parlor about 1900. Sarah was the daughter of Rev. William E. Baker and Catherine Evelyn King Baker and the granddaughter of Barrington and Catherine King. (Courtesy of Lois King Simpson.)

Section of facing full size

Scale of feet & inches

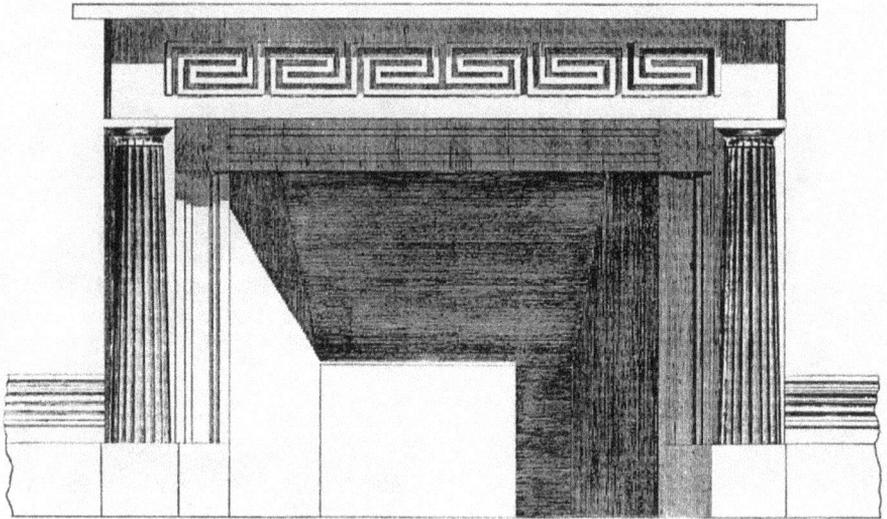

Drawings of chimneypiece artwork by Asher Benjamin were published in his *Practical House Carpenter*. This drawing from the 1830 book is identical to the parlor fireplace design at Barrington Hall believed to have been copied by carpenter Willis Ball of Connecticut.

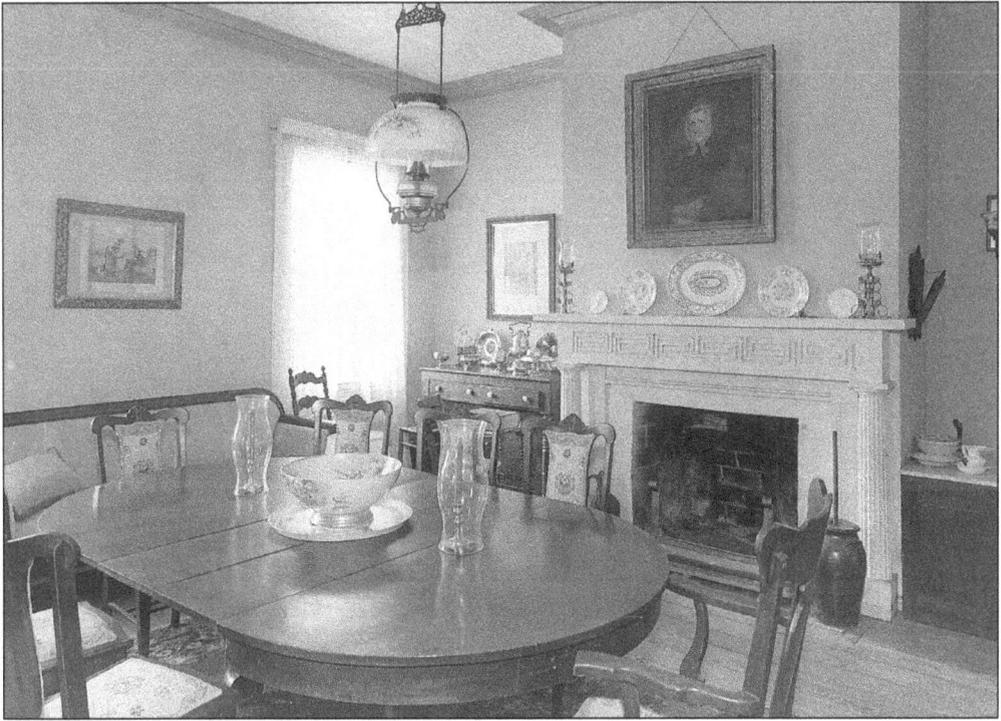

The dining room at Barrington Hall has seen few changes from its original 19th-century appearance. An oil-burning light fixture still hangs from the ceiling. Original heart-pine floors, the chimneypiece, and cornices are important features. (Photo by Joe McTyre.)

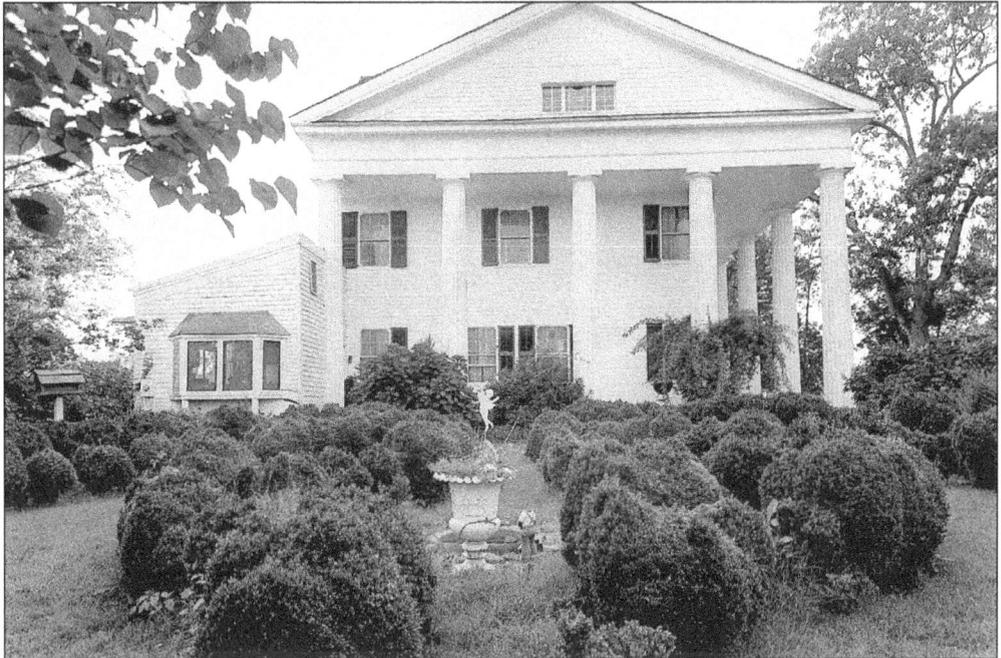

This view of the east side of Barrington Hall shows the English boxwoods and other remaining features of the formal gardens established in the 1840s. (Photo by Joe McTyre.)

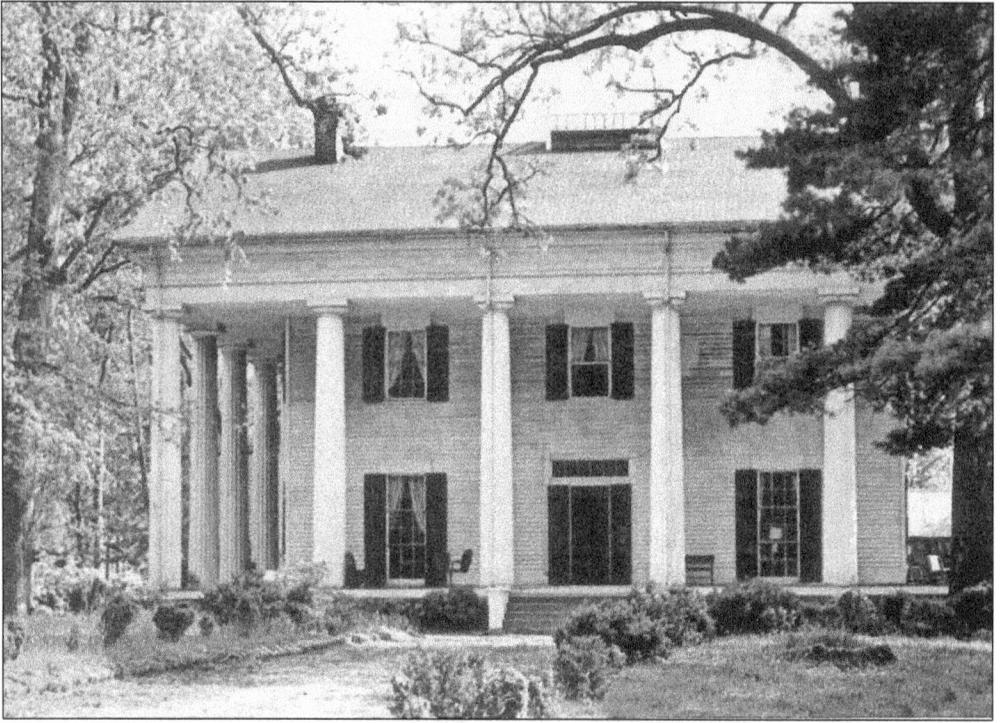
Barrington Hall was featured in a 1950s postcard. (Courtesy of Mary Wright Hawkins.)

Antique china used through the years by the King, Baker, and Simpson families at Barrington Hall decorates the cabinet top in the entrance hall. (Photo by Joe McTyre.)

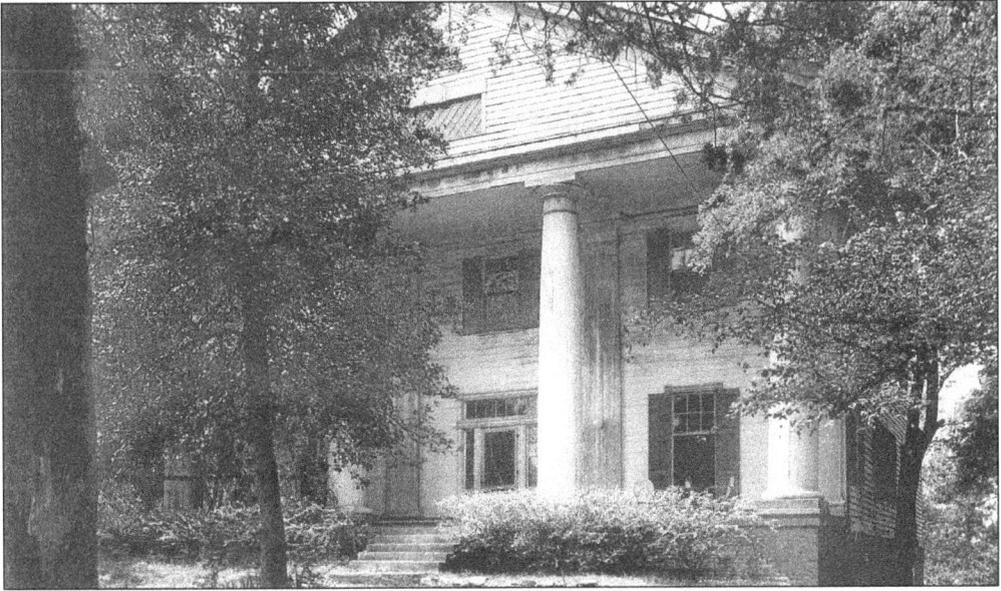

The unchanged beauty of Bulloch Hall is seen in this 1950s postcard. During construction of the house in 1840, special materials, woods, and furniture were hauled from the coast by boat to Augusta, then by oxcart and ferry to Roswell. (Courtesy of Mary Wright Hawkins.)

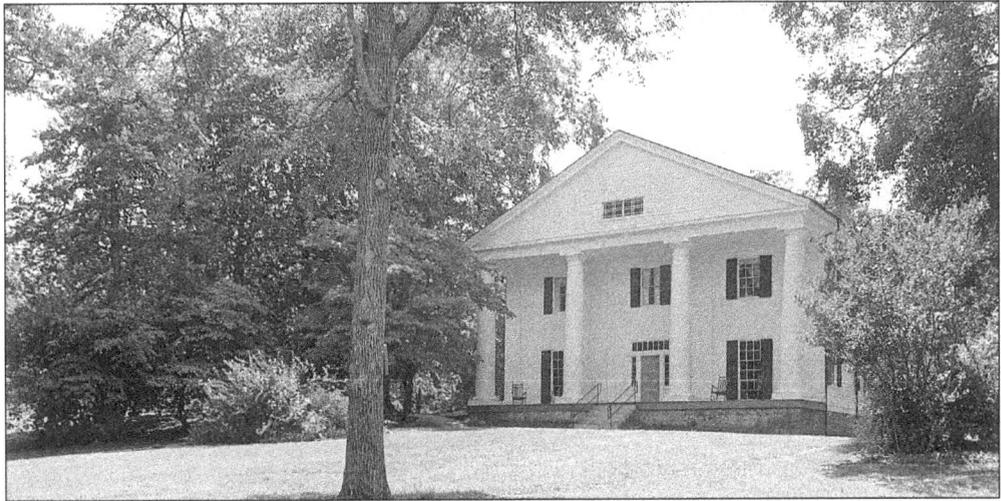

Bulloch Hall, built for James Stephens Bulloch in 1840, has a "four-square" floor plan typical of the period. Along with flowering shrubs, the grounds still have some original trees, including Osage orange, cedar, and walnut. Other important features are four large chimneys and Doric columns measuring 113 inches around the base. Original outbuildings (none survive today) included a summerhouse, a privy, two wells, a carriage house, a barn, two slave houses, and a smokehouse. Bulloch Hall was occupied by Thomas E. King's family after the Bullochs left Roswell in 1856. When King died in battle in 1863, his widow, Mary Clemons King, and family remained there until forced to leave Roswell in 1864. In an attempt to save the house and the woolen mill from destruction by Union troops, a mill employee raised French flags from Bulloch Hall and the Ivy Mill. The house was spared but the mill was burned. The house was vacant from 1956 until 1972. Today Bulloch Hall is owned by the city of Roswell and is open for tours seven days a week with a small admission fee. (Photo by Joe McTyre.)

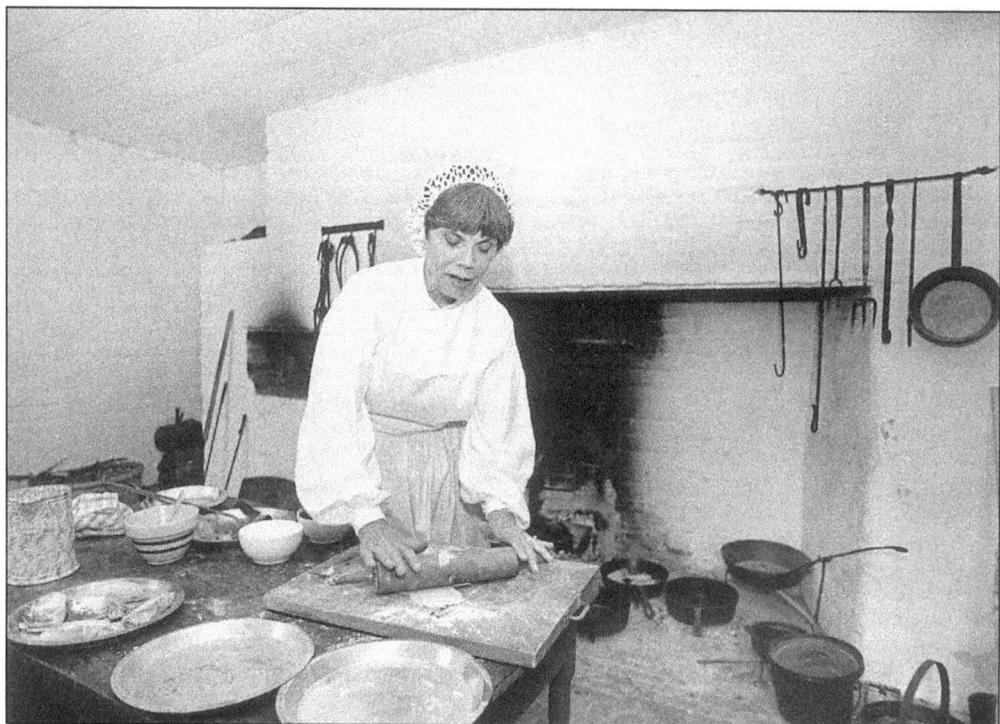

Bulloch Hall docent Jackie Collopy rolls dough for cooking in the open hearth oven in the original downstairs kitchen during a tour of the 1840 mansion. (Photo by Joe McTyre.)

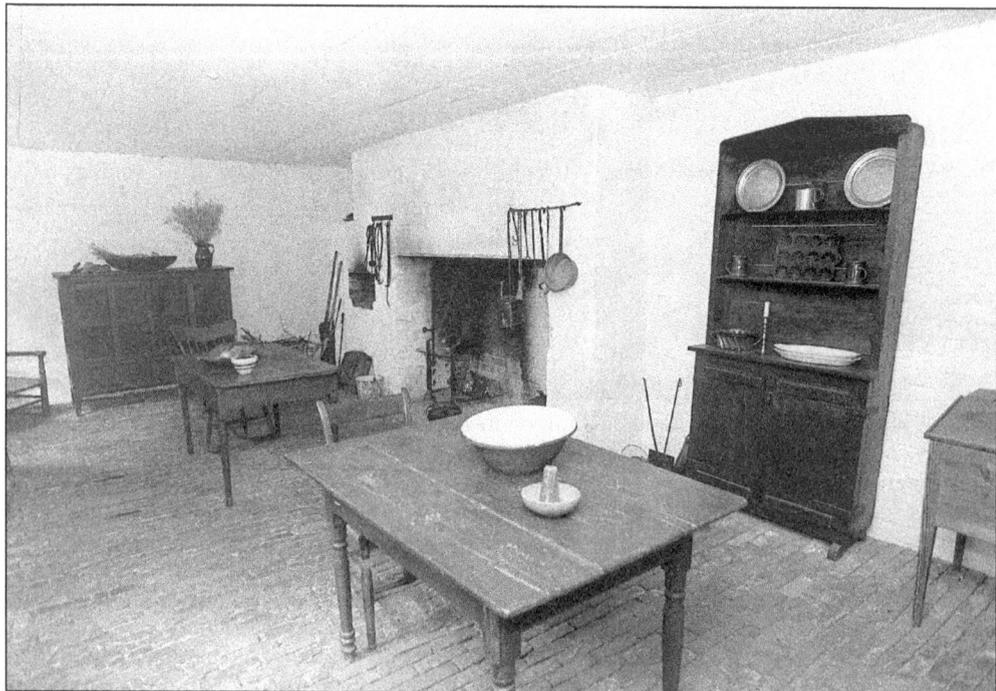

Bulloch Hall, owned by the city of Roswell and open for public tours since 1972, still has its original kitchen on the basement level. (Photo by Joe McTyre.)

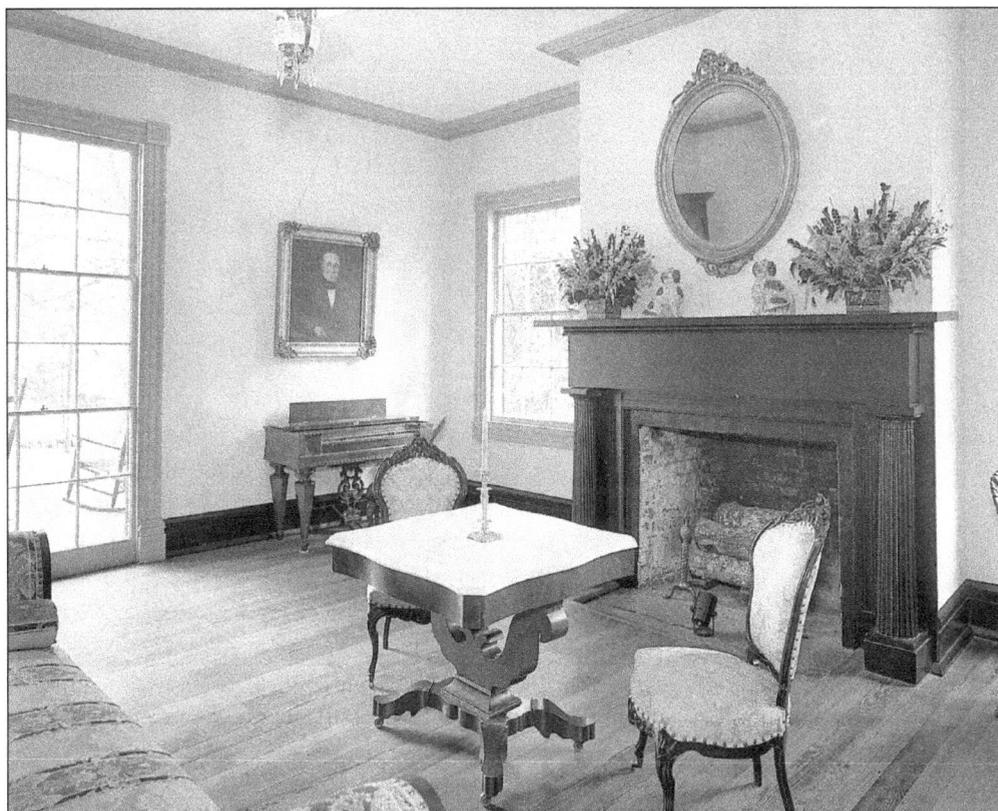

The front triple-hung window on the left is in the library at Bulloch Hall. Among the furniture in the room is an original Barrington Hall secretary (not shown), donated by Barrington King III to Bulloch Hall. (Photo by Joe McTyre.)

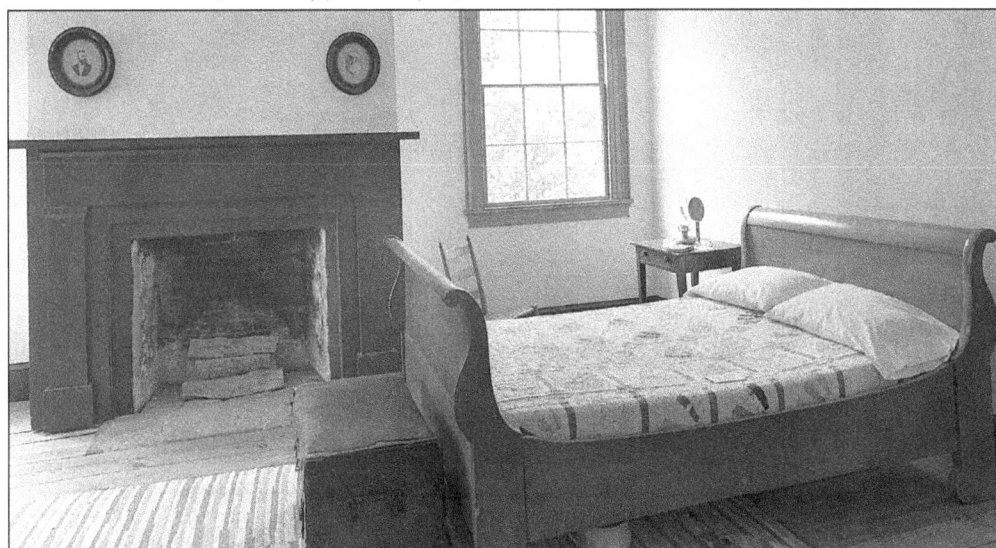

Among the antique furniture in the children's bedroom at Bulloch Hall is a sleigh bed. Hanging above the mantel are portraits of Theodore Roosevelt (left) and Mittie Bulloch Roosevelt. (Photo by Joe McTyre.)

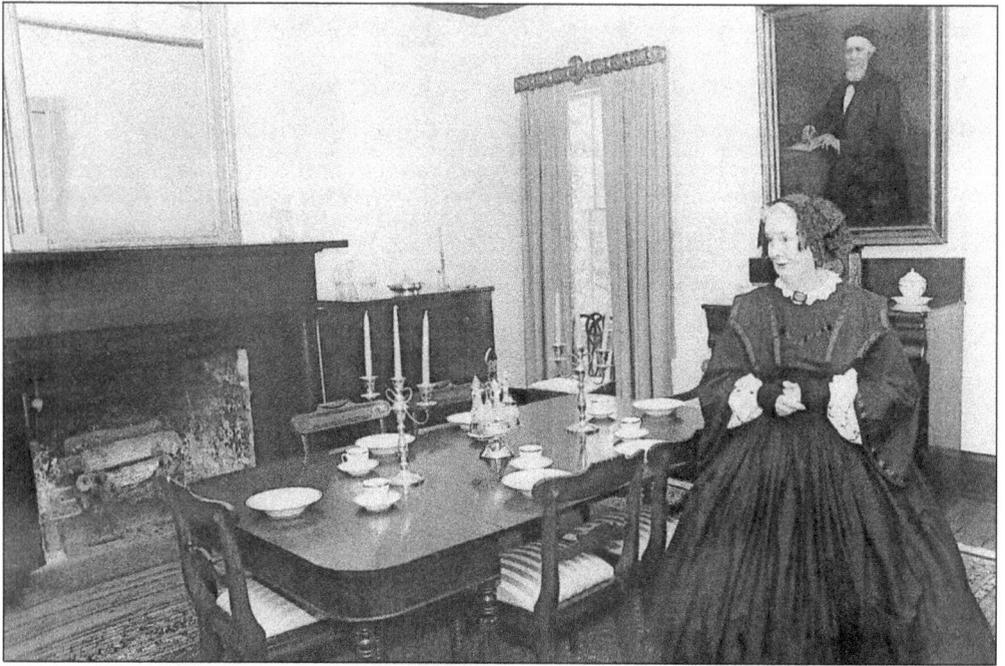

Docent Mary Nixon plays the part of Martha Stewart Bulloch while giving a tour at Bulloch Hall. She stands in the dining room where the Roosevelt-Bulloch wedding ceremony took place. (Photo by Joe McTyre.)

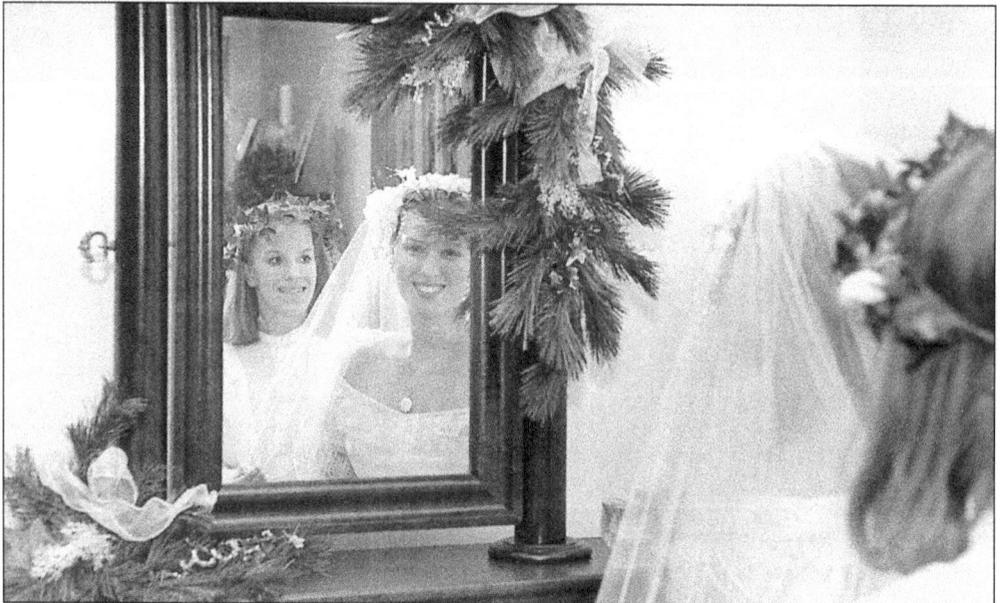

The reenactment of "Mittie's Wedding," a Christmas event at Bulloch Hall, draws large crowds each year throughout December. Participating in the 2000 pageant were Jennifer Winegal as Mittie (in wedding dress) and Jenna Mersfelder as a bridesmaid. In the real 1853 wedding, the officiating minister, Dr. Nathaniel Pratt, wouldn't allow his daughter Fannie to be a bridesmaid because he thought the attendants' white muslin dresses with ruffles were not suitable for a minister's daughter. (Photo by Joe McTyre.)

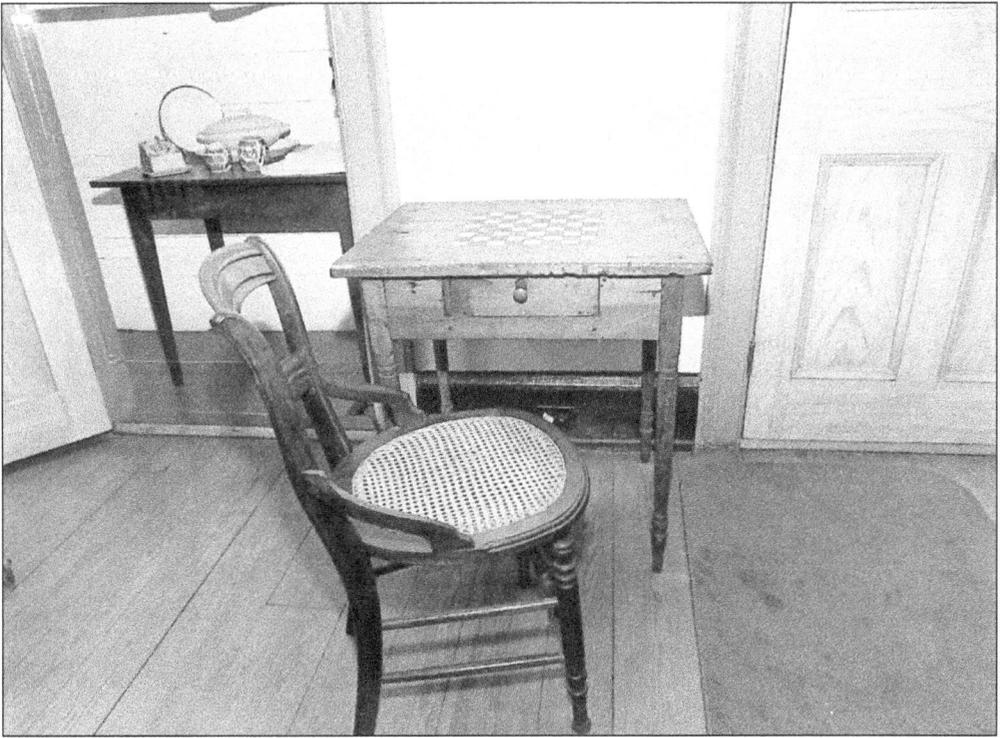

A checkerboard table and two cane-bottom chairs are believed to be the only pieces of furniture original to Bulloch Hall. (Photo by Joe McTyre.)

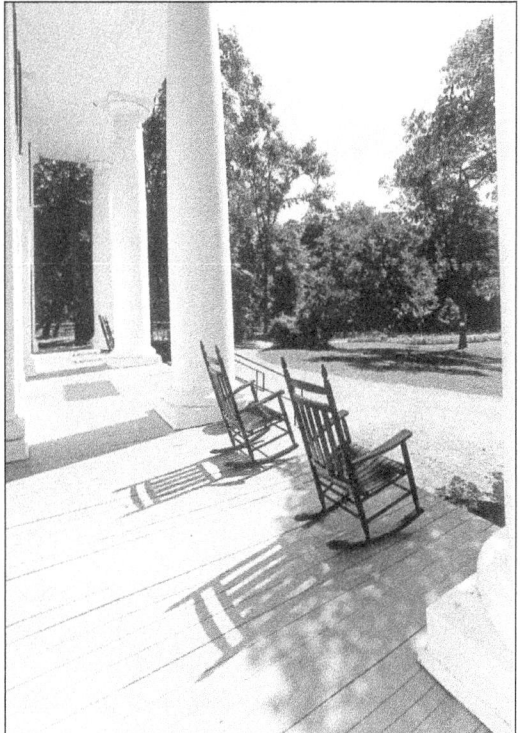

Rocking chairs on Bulloch Hall's front portico have invited guests to sit and savor the picturesque scene since the house was completed more than 160 years ago. (Photo by Joe McTyre.)

Mimosa Hall, completed in 1847 by John Dunwody, is one of the outstanding temple-form houses in Roswell. This view shows the front portico. (Photo by Joe McTyre.)

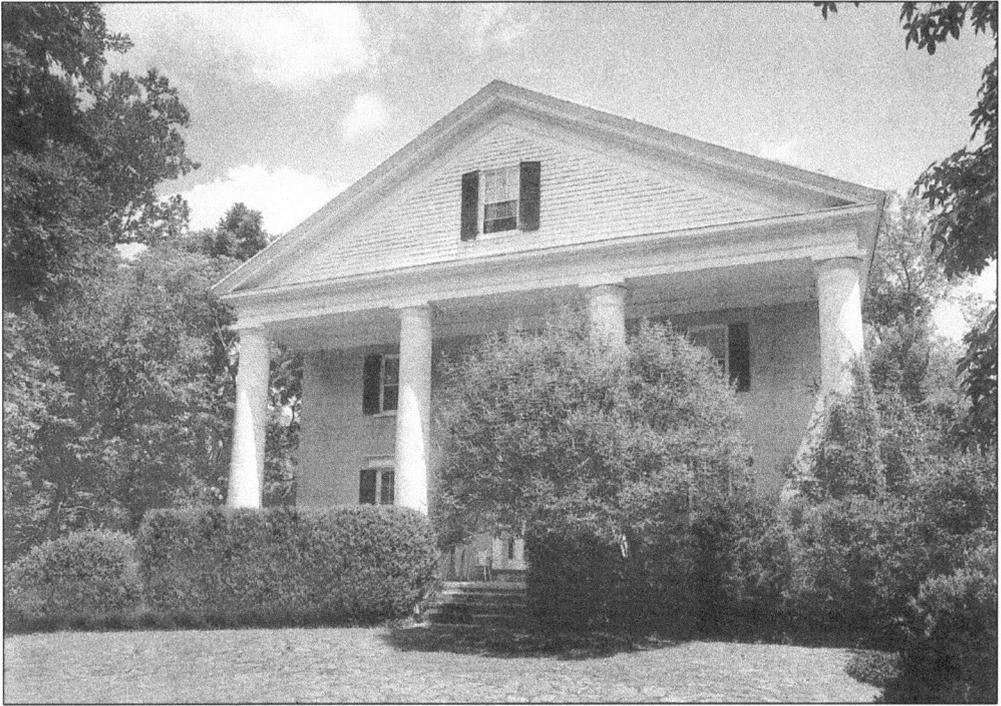

Mimosa Hall's massive columns add to its distinctive appearance and its 37 acres of grounds are one of the outstanding examples of antebellum settings remaining in Georgia. Among the many rare varieties of trees are Osage orange, deciduous oriental magnolia, and yellowwood. Atlanta architect Neil Reid bought the house in 1916 and combined the twin parlors into one large drawing room and reestablished the gardens and courtyard. (Photo by Joe McTyre.)

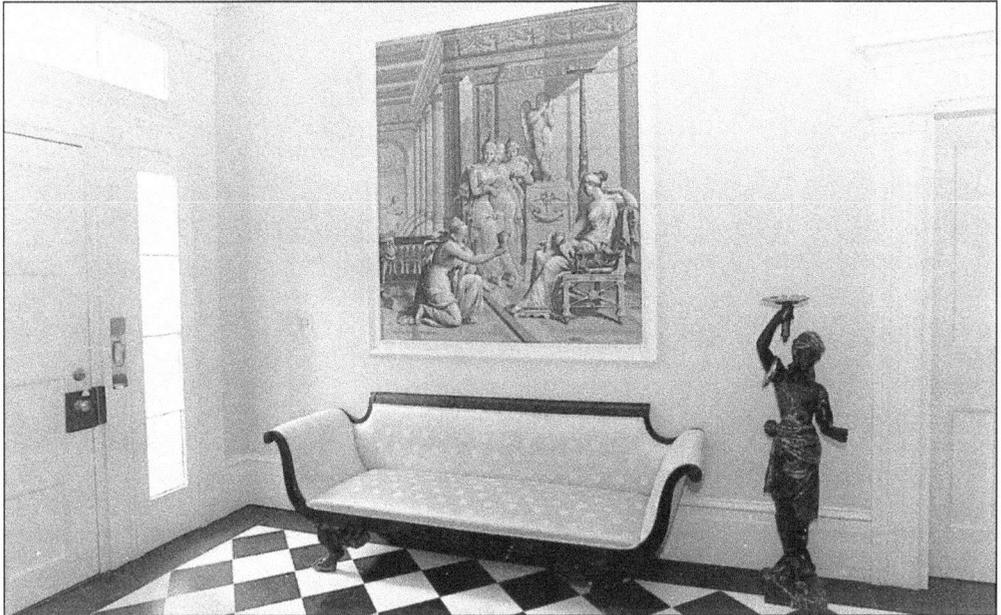

Three rare panels painted in 1881 adorn the entrance hallway at Mimosa Hall. Shown are the *Three Graces—Cupid, Psyche and Venus*. (Photo by Joe McTyre.)

This rare photo shows the Archibald Smith plantation house as it looked before renovation in 1940. (Courtesy of James L. Skinner III.)

Most of the Archibald Smith plantation's original outbuildings, including the smokehouse, survive today as well as many artifacts and most of the furniture. (Courtesy of James L. Skinner III.)

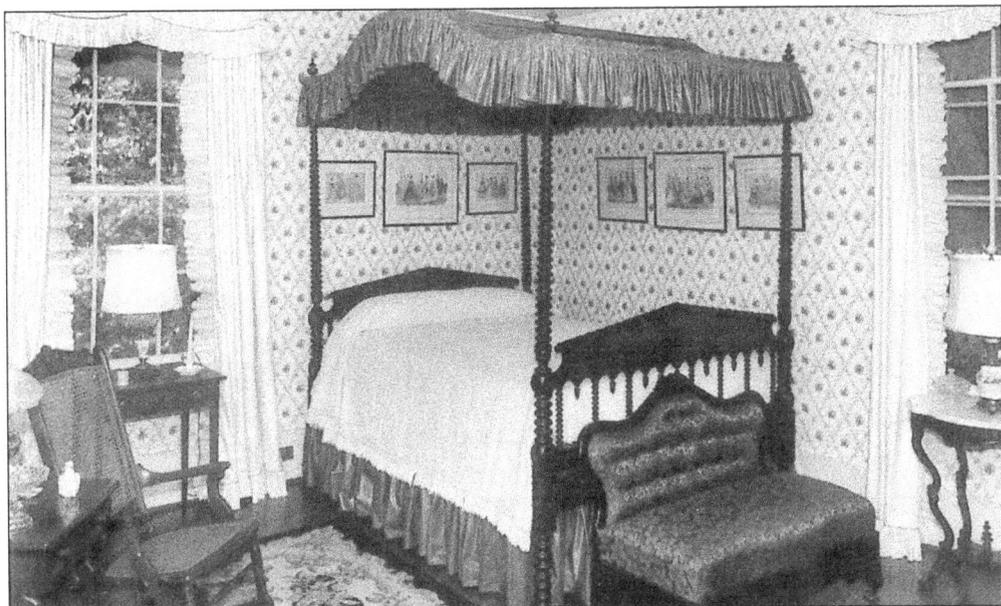

A guest bedroom of the Archibald Smith Plantation Home contains many original furnishings. Throughout the house, many artifacts and the furniture on display provide visitors with a unique glimpse of how a wealthy 19th-century plantation family lived. The Skinner family inherited the house and retains control of the furniture and artifacts. The Archibald Smith Plantation Home Preservationists Inc., conducts year-round tours and administers the site. (Courtesy of James L. Skinner III.)

Arthur Smith and his sister Frances Maner Smith (front, on steps) posed for a snapshot with Smith plantation house caretakers at the back of the house c. 1934. Arthur (1881–1960) was the last direct Smith descendant to occupy the house. In 1940, he and his wife, Mary Norvell Smith (1890–1981), restored the house and raised the one-story front porch to two stories. In the 1980s, Mary's heirs, Josephine Fry Skinner and James L. Skinner Jr., sold 32 acres of the Smith property to the city of Roswell for a municipal complex at a price much less than that offered by developers. (Courtesy of James L. Skinner III.)

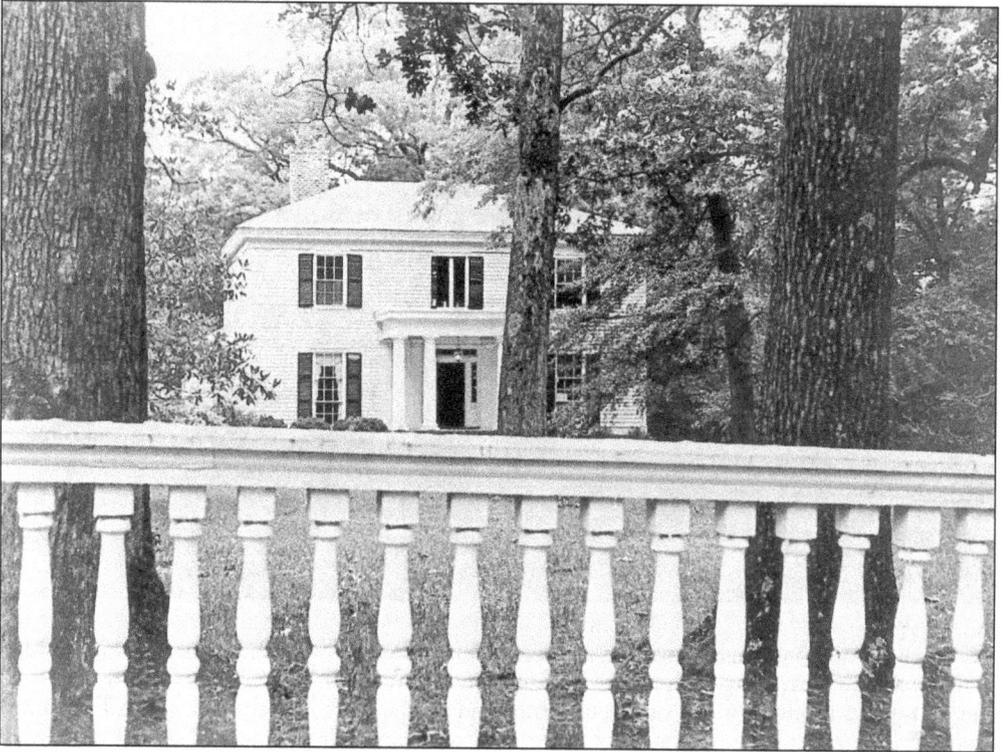

The house now known as Primrose Cottage was the first permanent dwelling built in Roswell. Roswell King joined his daughter Eliza King Hand and her young children soon after they moved into their new home in 1839. The handcrafted fence has been replaced through the years but was an original feature of the house. (Photo by Jo Ann Browne.)

The parlor at Primrose Cottage was the setting for a group of 15 early Roswell residents who organized the Presbyterian Church in 1839. (Photo by Joe McTyre.)

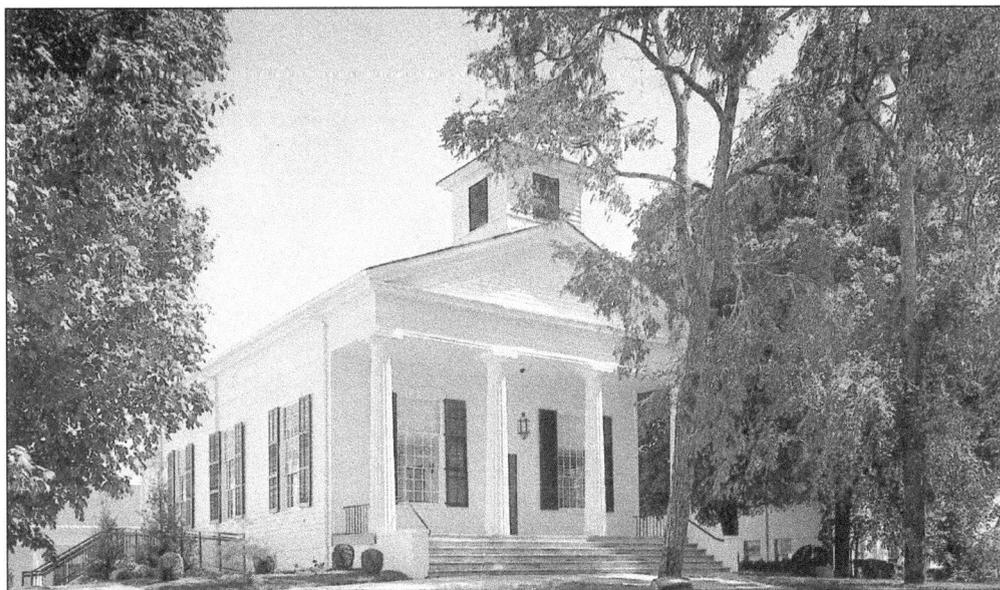

The first church built in Roswell and the first to be incorporated in Cobb County was the Presbyterian Church, now more than 160 years old. When Roswell King laid out the village, he described the town limits as one mile in each direction from the Presbyterian Church site, which he donated. He hired carpenter Willis Ball to oversee construction of the building. The church has features typical of a New England meetinghouse including a white clapboard exterior, a short square bell tower, and fluted Doric columns. (Photo by Joe McTyre.)

The original leather-bound pulpit Bible of Roswell Presbyterian, displayed in the church's History Room, disappeared from the sanctuary during the Federal army's use of the building as a hospital in 1864. The Bible was replaced following the war but 90 years after its disappearance, it was found in Louisiana and returned. A year later, in 1958, it survived a fire in the sanctuary annex that destroyed 400 other books. The inside cover still has a message left by a Union soldier: "Run Johnny run, the Yankees will catch you." (Photo by Joe McTyre.)

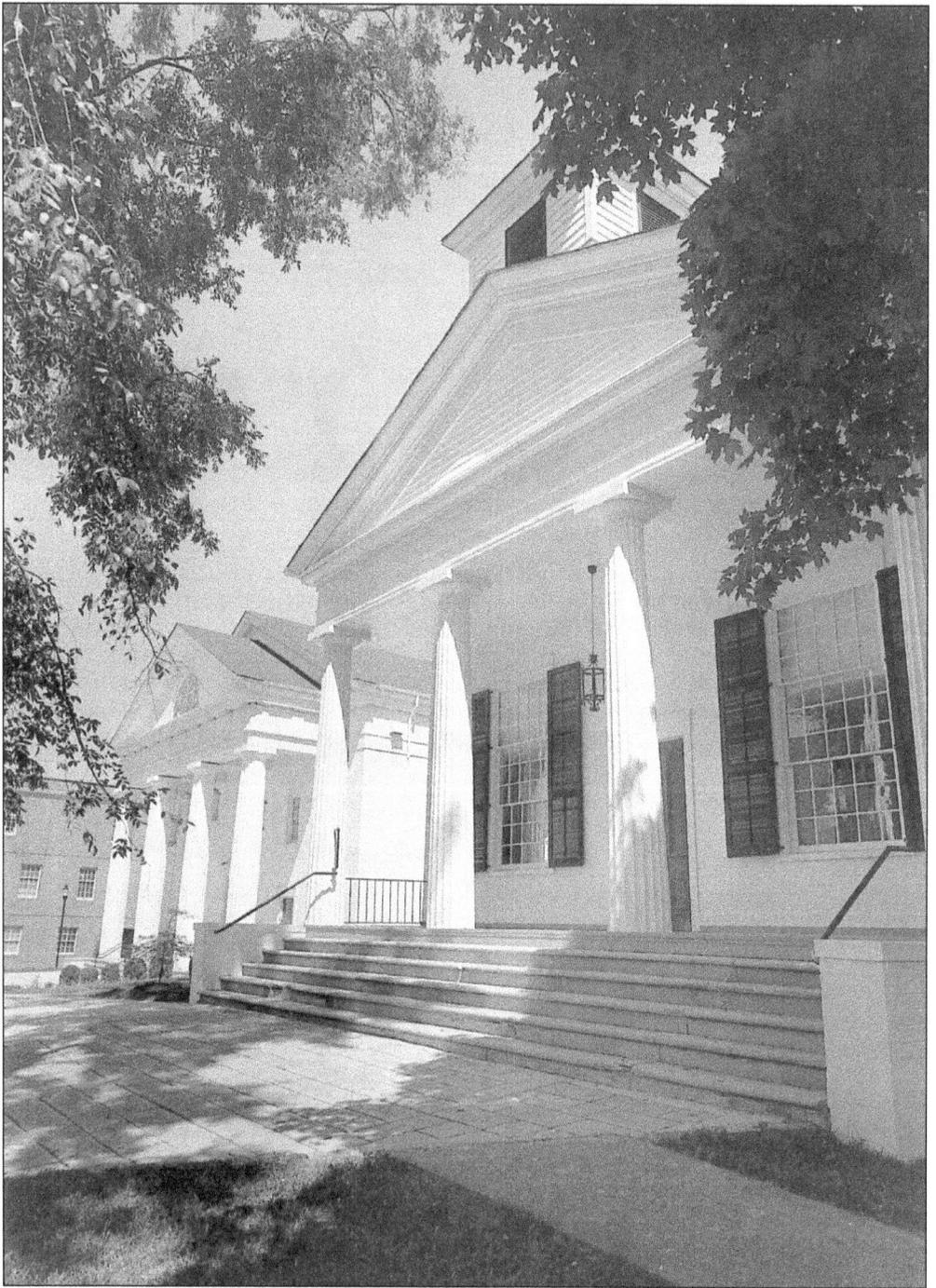

The contrasts and similarities between the old and the new Presbyterian Church buildings are emphasized in this striking photo made in September 2000. (Photo by Joe McTyre.)

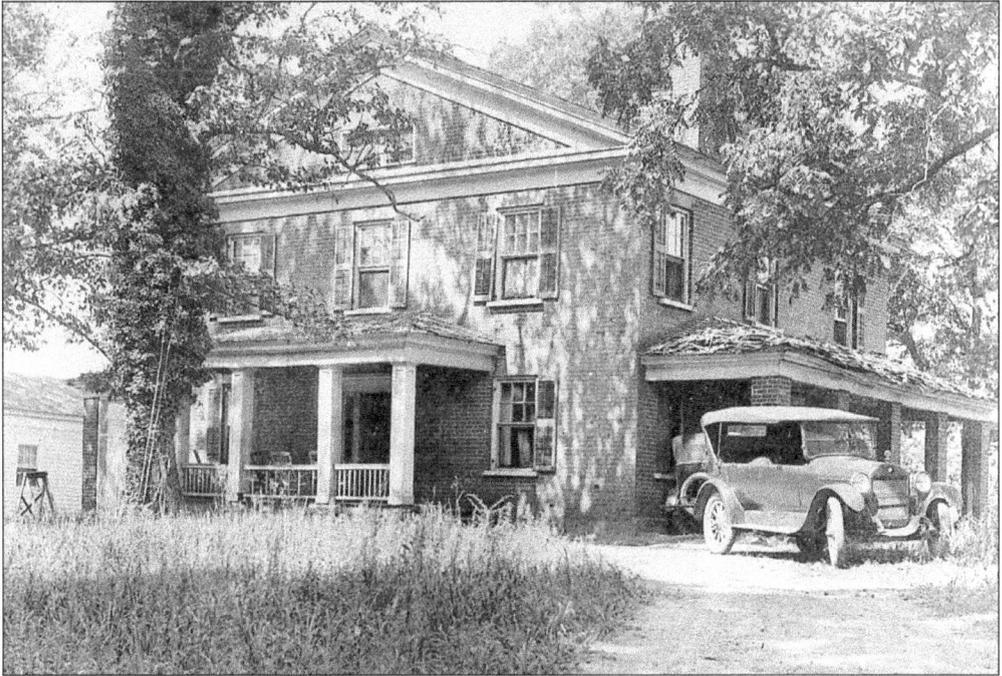

Great Oaks, built in 1842 by Dr. Nathaniel Pratt, survived the Civil War and the many changes that have come to Roswell in nearly 160 years since it was built. (Courtesy of Georgia Department of Archives and History.)

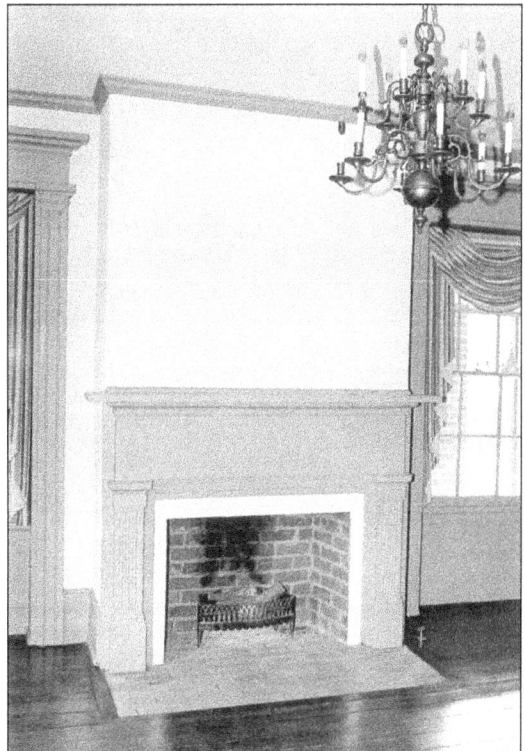

The parlor fireplace at Great Oaks warmed the feet of the Pratt family members and their guests for generations. The spacious and attractive brick house stands across from the Presbyterian Church on Mimosa Boulevard. (Photo by Joe McTyre.)

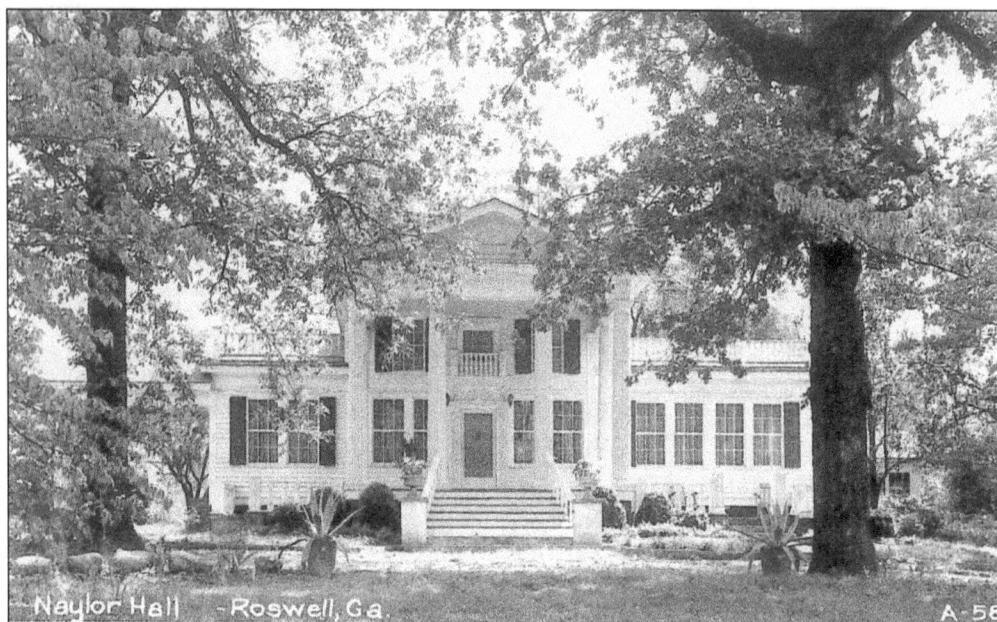

Naylor Hall may have been built in the 1800s as a much smaller residence. This 1950s photo shows the Canton Street house after it was remodeled by Harrison Broadwell, who purchased it in the 1930s and named it for his wife's family. Broadwell added the columns and the portico. Naylor Hall is a special events facility. (Courtesy of Mary Wright Hawkins.)

Allenbrook, built about 1857 as a residence for Ivy Mill loom boss John Brown and his wife, Mary, overlooked the dam from above Vickery Creek. The house, pictured in the 1940s, was named Allenbrook when it was purchased by Barnett A. Bell in the 1930s. The dwelling is now owned by the National Parks Service. (Courtesy of Georgia Department of Archives and History.)

Francis J. Minnhinnett, an English landscape gardener and stonemason, built this frame dwelling on Main Street (now Mimosa Boulevard) about 1849. Privately owned, the house has been restored and altered for office use but several original features remain. Like Bulloch Hall, the house has a basement kitchen. (Photo by Joe McTyre.)

Minnhinnett House on Mimosa Boulevard still has its original door and counter-balance system leading to the second floor. (Photo by Joe McTyre.)

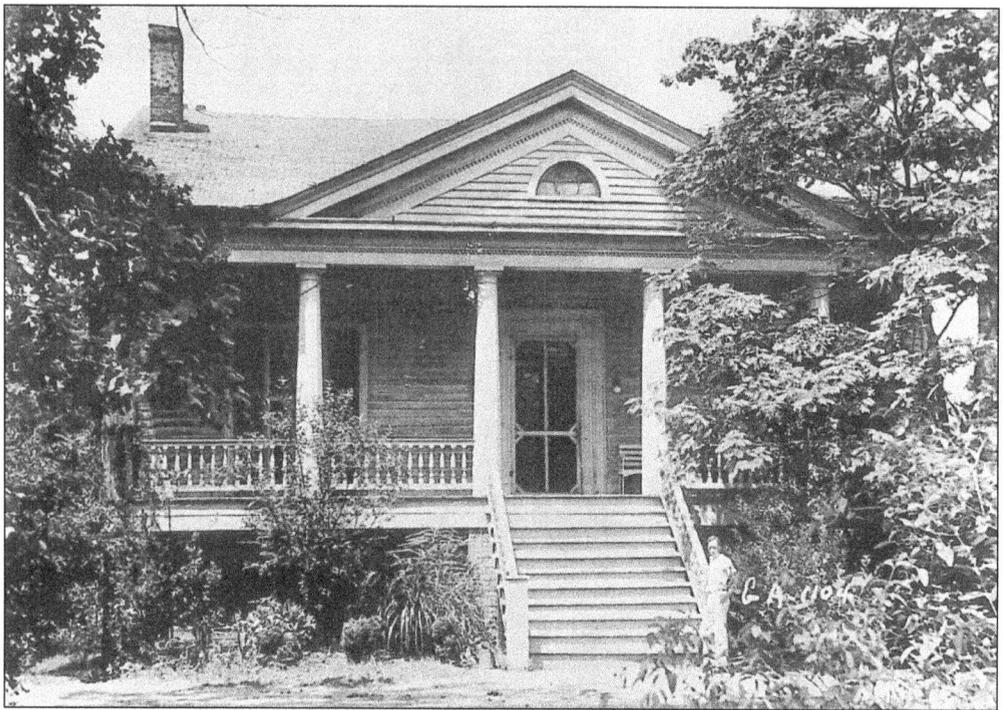

Holly Hill has undergone only a few changes since it was built in 1847. The house was included in the Historic American Buildings Survey in the 1930s. (Courtesy of Nancy Gray.)

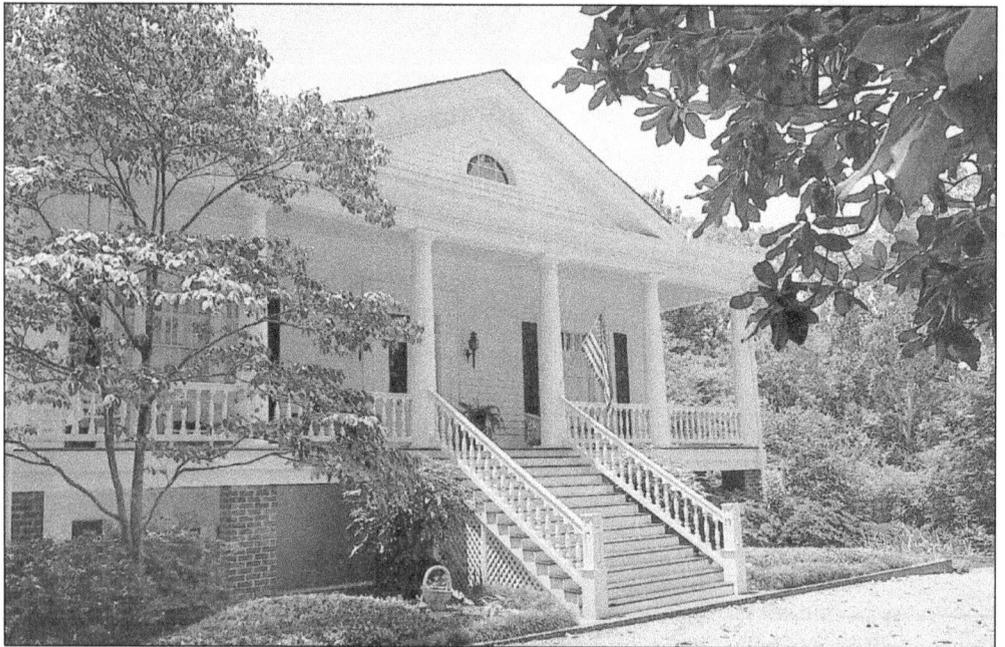

Holly Hill was built for Robert Adams Lewis and his wife, Catherine Barrington Cook Lewis, Roswell King's niece, as a summer home. The outstanding raised cottage with Greek Revival roof plan is located on Mimosa Boulevard. Its owners are Nancy and Lew Gray. (Photo by Joe McTyre.)

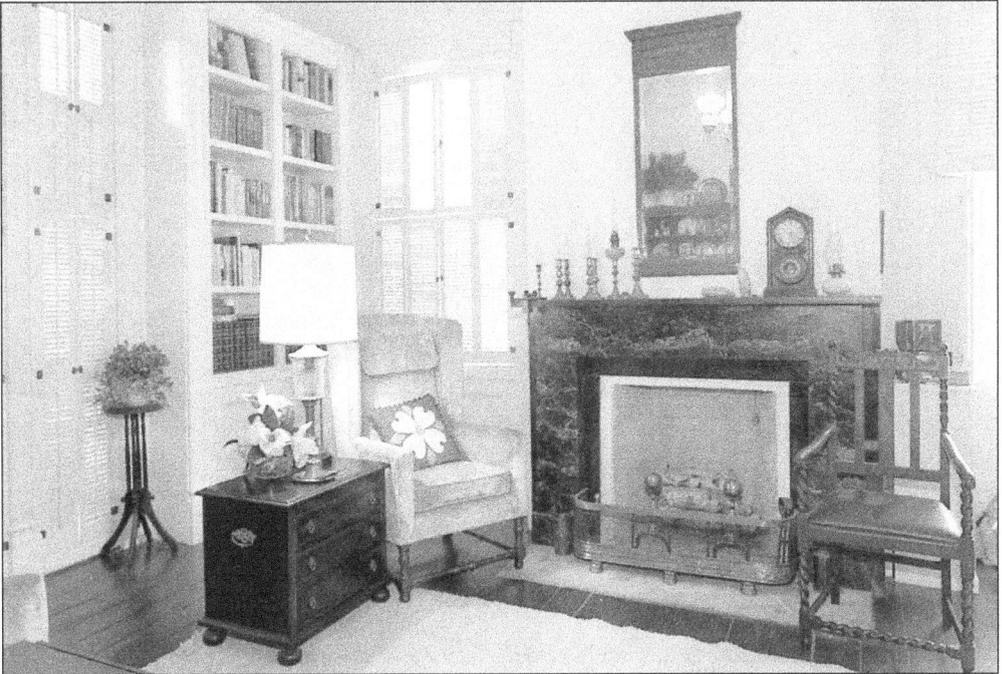

An Italian marble fireplace is a feature of one of Holly Hill's parlors. The Lewis family chose fine materials and other features more elaborate than those used in other early Roswell homes. (Photo by Joe McTyre.)

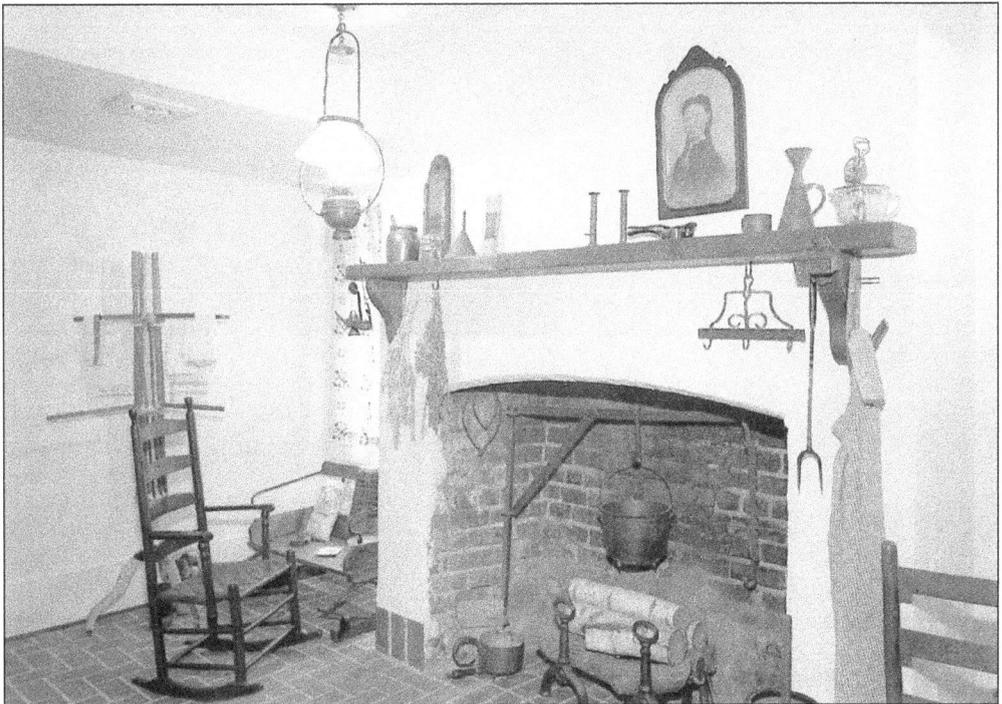

Holly Hill's original kitchen fireplace is located on the ground floor of the 1845 house. The kitchen has been converted to a large bathroom. (Photo by Joe McTyre.)

The Roswell Manufacturing Co. built a large number of houses for mill workers in the early 1850s on Factory Hill. The dwellings include several folk building types. Most are wood frame constructions on stone foundations with a central chimney, an example of the New England influence. Today, the buildings are used for both business and residential purposes. (Photos by Joe McTyre.)

Heavily damaged during the Civil War, this late 1840s house built by John Minton still stands on Canton Street. The dwelling has been converted for use as professional offices. Its remaining original exterior features add to its charm. (Photo by Joe McTyre.)

One of Roswell's early settlers, John Minton came from Liberty County in the 1840s. He served in five wars including the Civil War until he was wounded in the first Battle of Manassas in July 1861. His house, which he probably built soon after his arrival in Roswell, stands facing Norcross Street at Canton Street. This photo was taken in 1960, before the house was restored. (Courtesy of Georgia Department of Archives and History.)

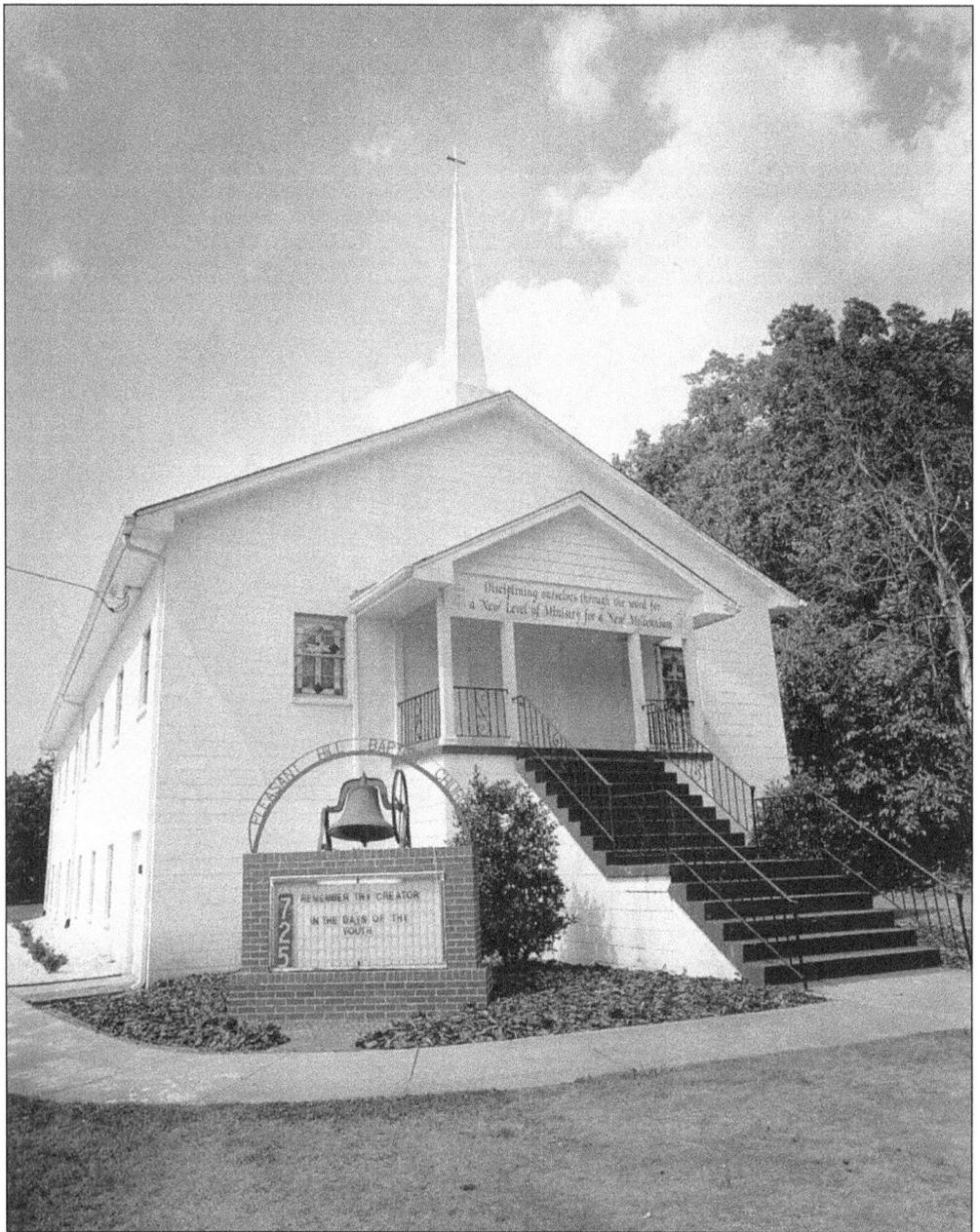

Pleasant Hill Missionary Baptist Church was built on its present site at Pleasant Avenue and Pleasant Hill Street in 1962. Organized in 1855 by slaves who until that time had worshiped with their masters as members of the Lebanon Baptist Church, the Church built its first building near the Lebanon community, the present location of Roswell Lake Place behind the Roswell Mall. Around 1900, members left the site and moved to Roswell. Among the charter members were the Hembree, Grogan, Blake, and Smith families. (Photo by Joe McTyre.)

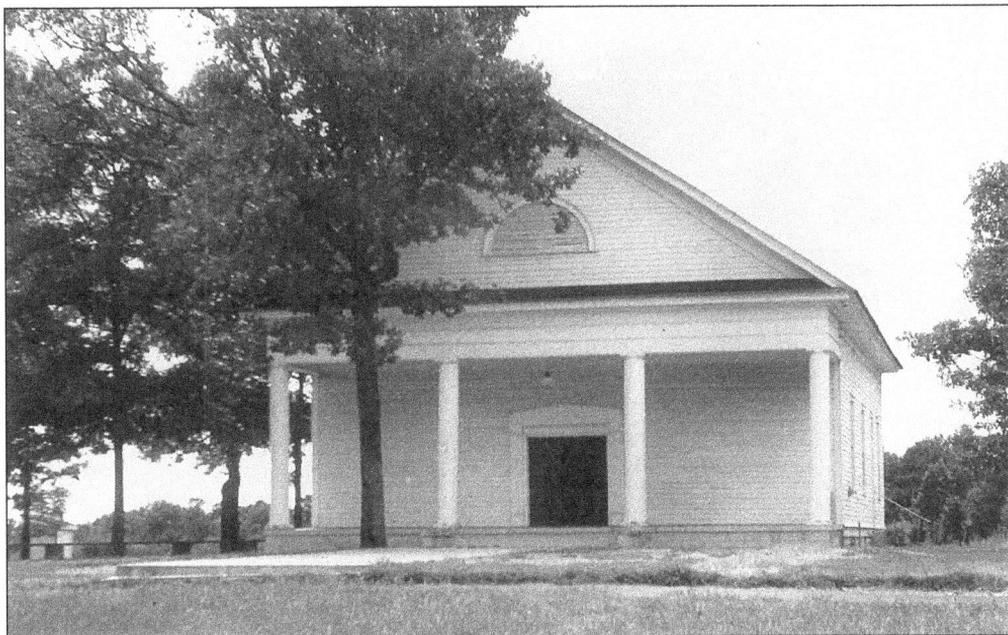

Organized with 19 charter members in 1836 in Amariah Hembree's home, the Lebanon Baptist Church raised funds for its first building in 1838 and built a house of worship soon afterwards. Although there are conflicting accounts, the church was probably damaged during the Civil War. Afterwards, members built the Greek Revival white frame building shown here. The structure was remodeled and its exterior covered with bricks in the 1950s, soon after this photo was made. The building was destroyed by fire in 2004 and a commercial building now occupies the site. (Photo by Ralph A. Wright.)

This picture made in 1959 at Lebanon Church shows a house in the background that is the present location of the Chic-Fil-A restaurant on Alpharetta Street. (Photo by Ralph A. Wright.)

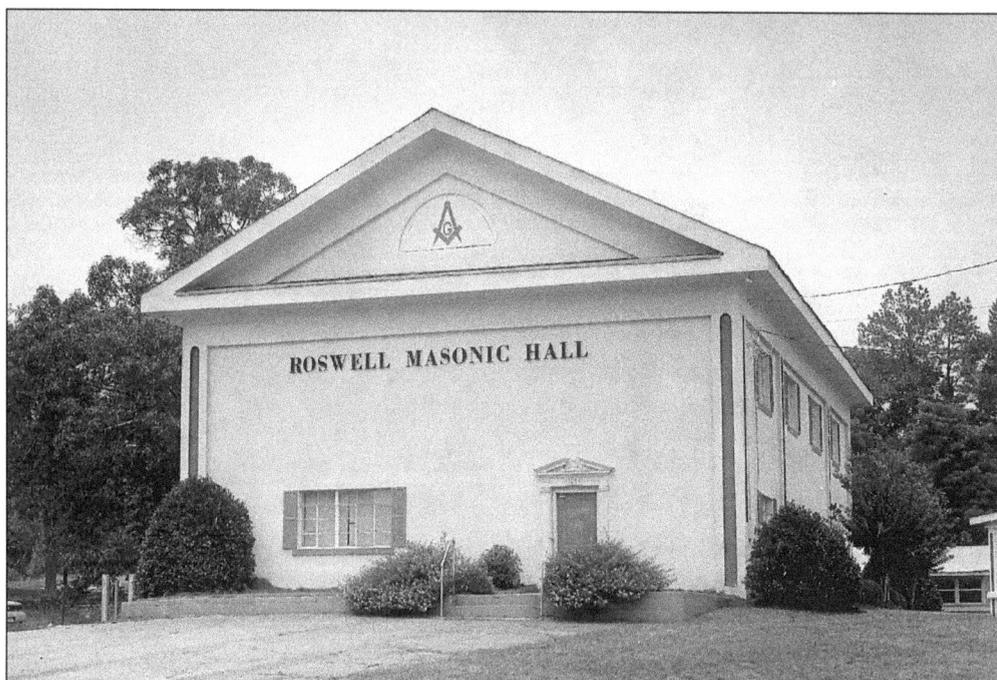

The Roswell United Methodist Church built a new structure on Mimosa Boulevard in the 1920s, moving from the Church's first building shown here in a recent picture. The Alpharetta Street site was donated to the church by Barrington King in 1859. The building is now the Roswell Masonic Hall. (Photo by Joe McTyre.)

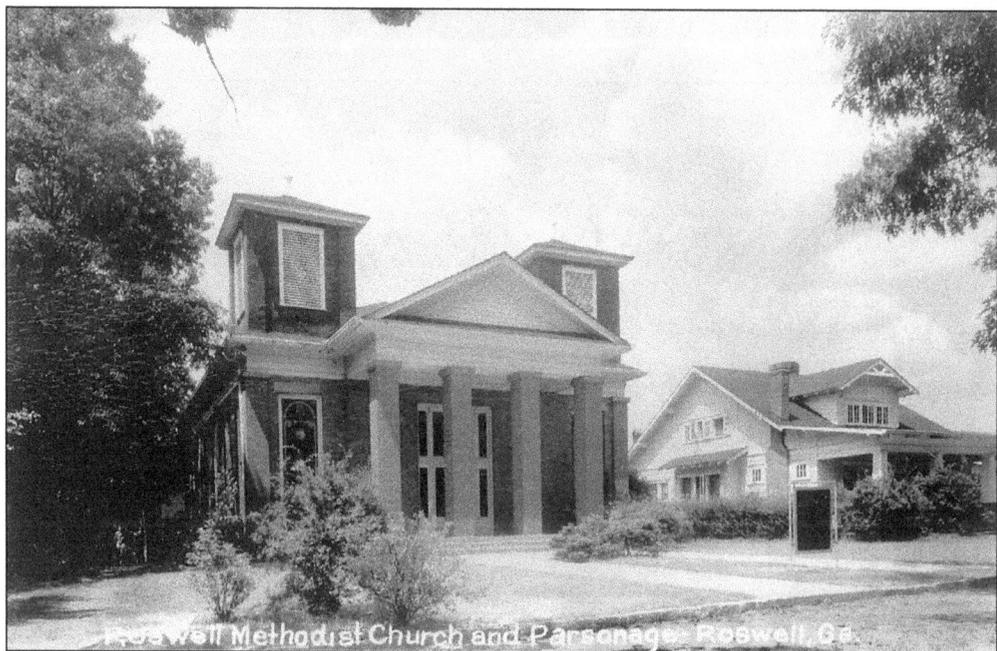

This 1950s picture of the Roswell Methodist Church sanctuary shows the brick building constructed in the 1920s on land donated by the Kimball-Williams family. The building was remodeled in the 1950s and a steeple was added. (Courtesy of Mary Wright Hawkins.)

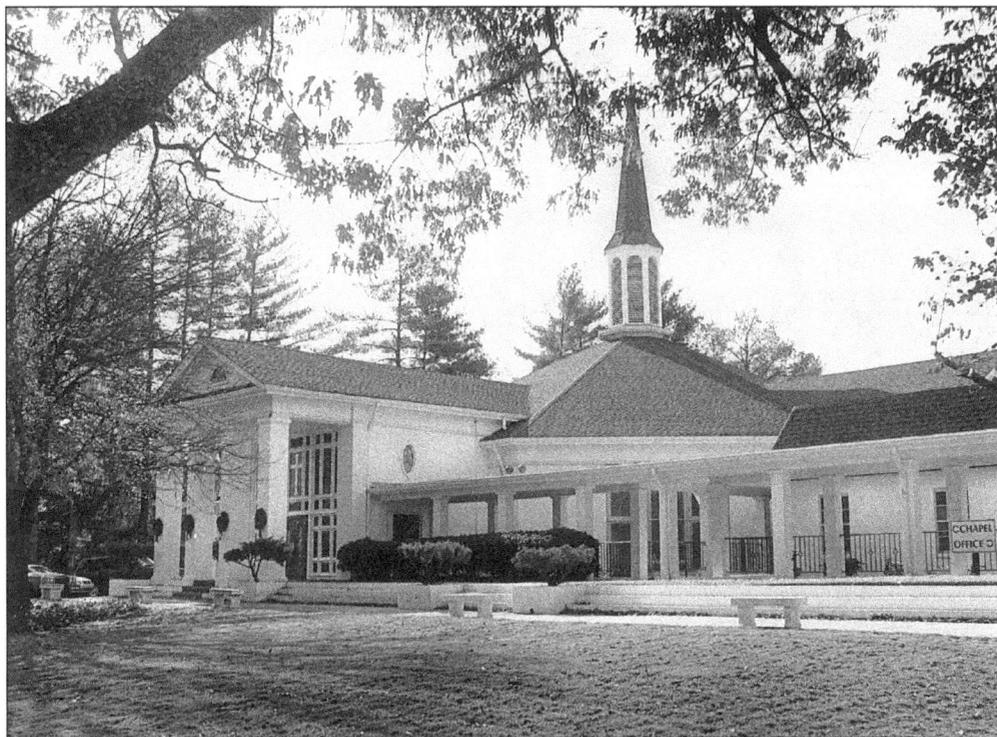

Roswell United Methodist Church built the sanctuary building shown here on Mimosa Boulevard in the 1970s. Today the building is used for a chapel. (Photo by Joe McTyre.)

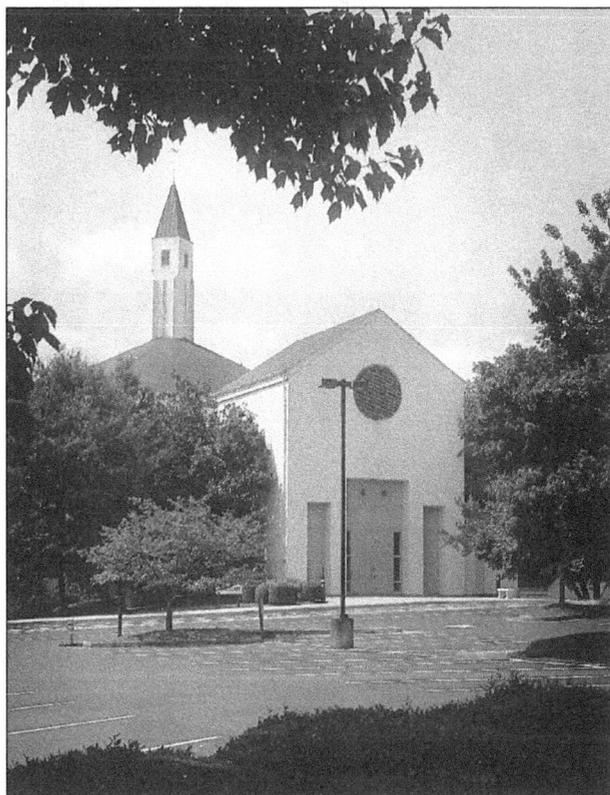

Roswell First United Methodist Church was organized as Mount Carmel Methodist Church in 1836. A log building near the center of the present Historic Roswell Cemetery at Woodstock and Alpharetta Streets housed the early worshipers. In 1859, Barrington King donated a tract for a new building at Alpharetta and Green Streets. The building was used until the 1920s when the church moved to Mimosa Boulevard. This view shows the church's sanctuary built in 1989 on Mimosa Boulevard. (Photo by Joe McTyre.)

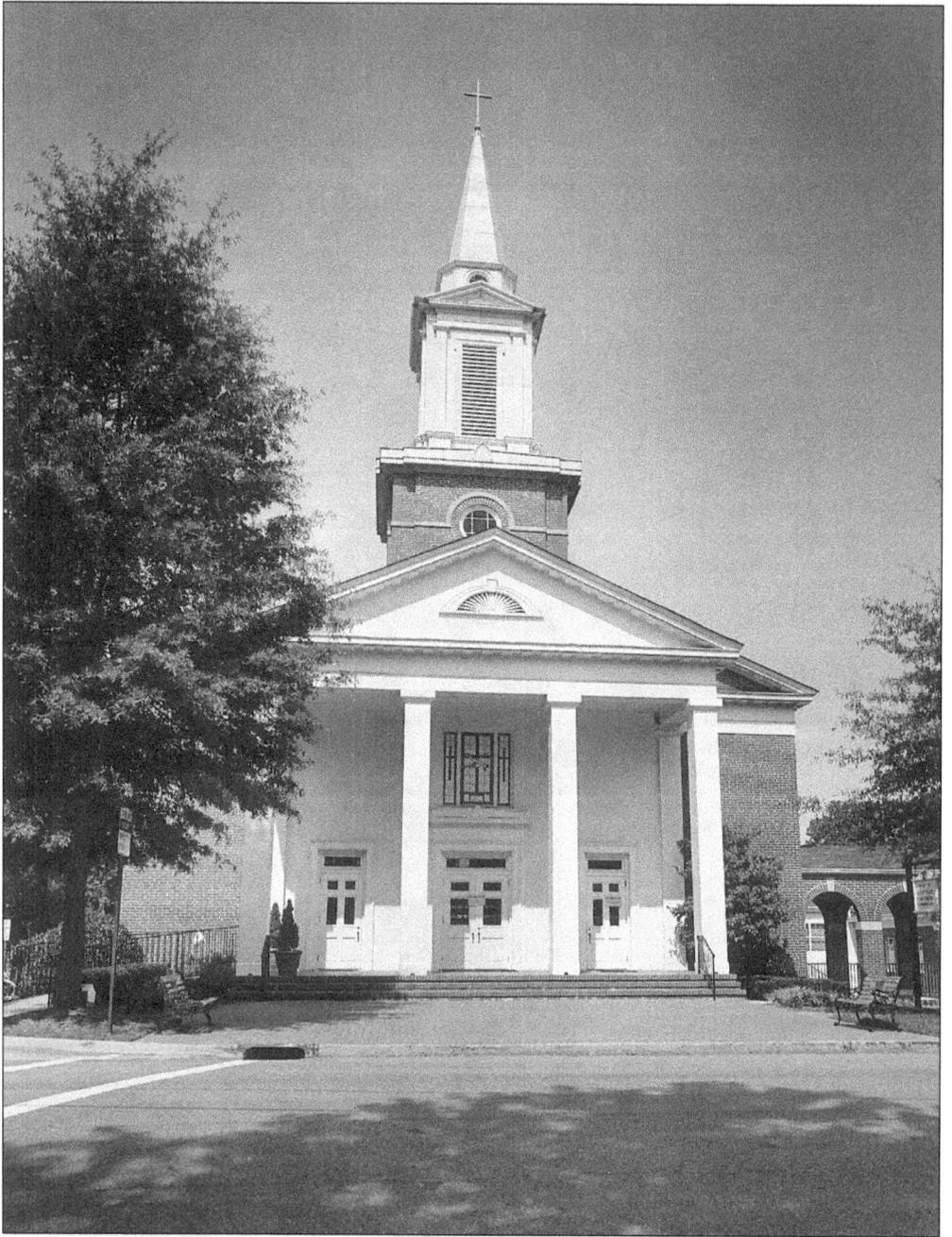

The Roswell First Baptist Church built this new sanctuary on Mimosa Boulevard in 1964. (Photo by Joe McTyre.)

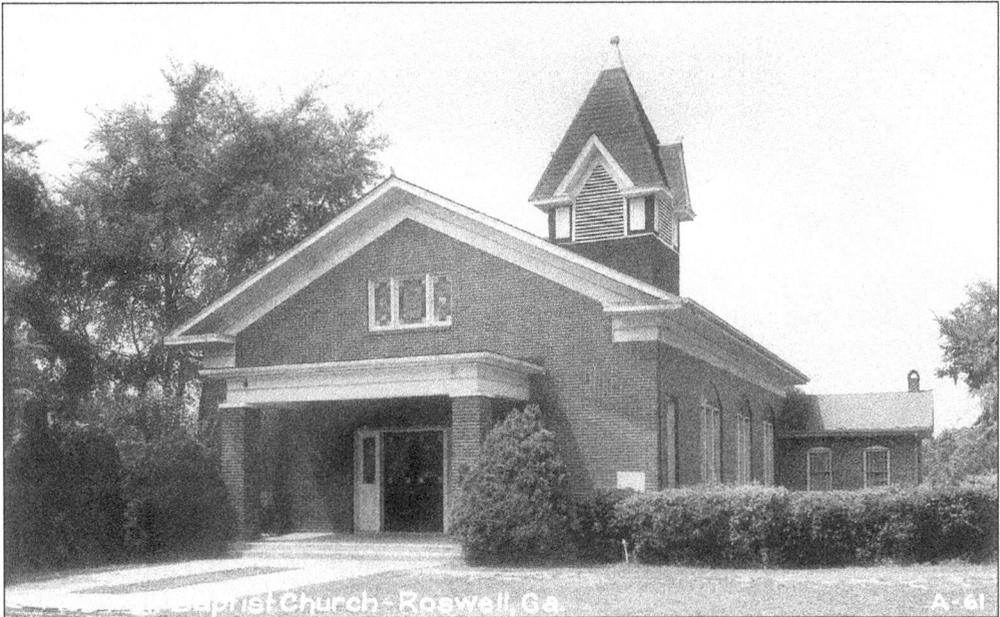

Roswell First Baptist Church was organized as Roswell Baptist Church in 1872. After meeting once a month in a local house, members acquired property on South Atlanta Street where they built a sanctuary, now the location of the Second Baptist Church, which split from the congregation in 1927. That same year, members of First Baptist built the sanctuary, shown here in the 1950s, on Mimosa Boulevard. (Courtesy of Mary Wright Hawkins.)

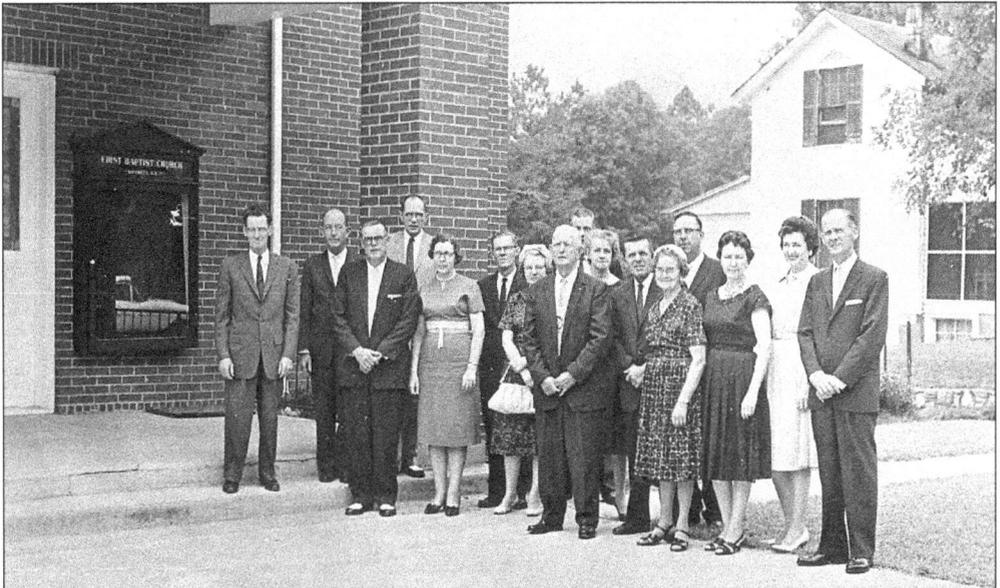

Members of a First Baptist Church Sunday school class pose in front of the sanctuary in the 1950s. The Gentry house, razed in the 1980s, is shown in the background to the right. From left to right are Lewis Clements, Pat Donehoo, Maynard Stephens, Wilbert Hembree, ? Stephens, Clifford Hollifield, Edith Hollifield, H.C. Farr, Everett Wright, Sue Clements, Walter Mansell, Annie Houze Cook (teacher), Joe Almand, Ruth Dorris, Opal Wright, and Thornton Wright. (Courtesy of First Baptist Church.)

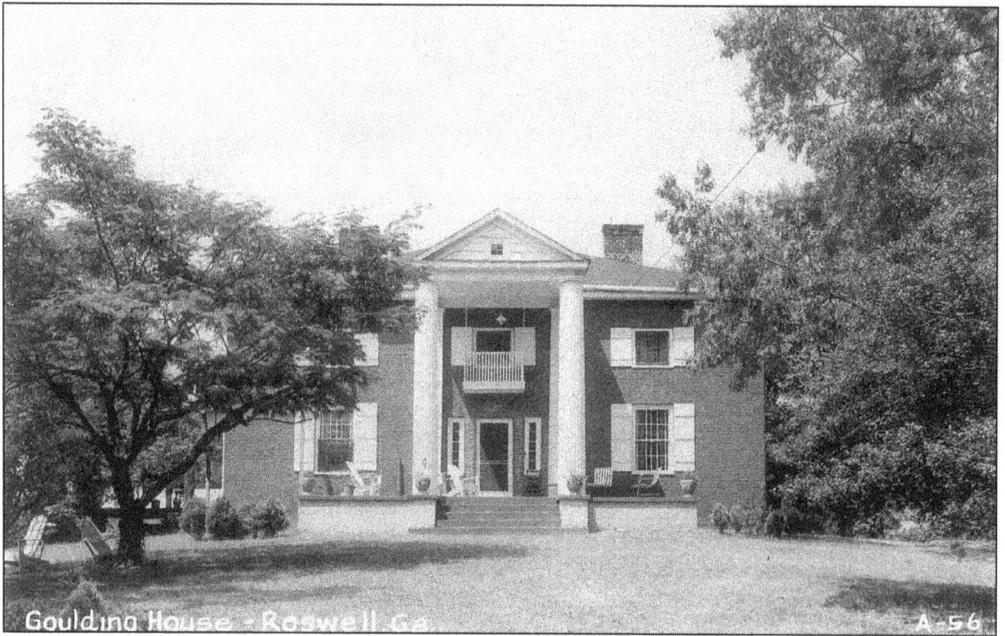

Goulding House was originally named Colonial Place when it was built just before the Civil War. Historical accounts list Dr. Francis R. Goulding as the owner in the late 1860s. The house is pictured here in the 1950s. (Courtesy of Mary Wright Hawkins.)

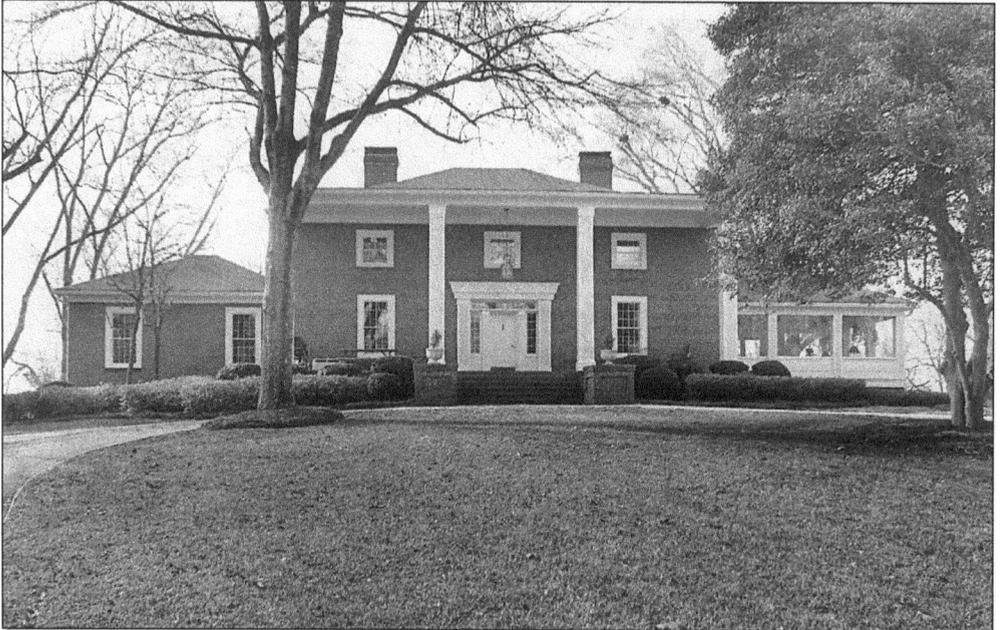

This recent picture of Goulding House shows modern additions to the 1850s spacious house, which sits on 16 acres of its original site. Dr. Goulding probably moved to Roswell after his service as a Confederate army chaplain in the Civil War. Historical accounts vary; some credit him as the builder and others suggest he purchased the house after it was built. After the residence belonged to the Goulding family and others, it was owned by James I. Wright and his family for 35 years. Its present owners are Ann and Bill Miller. (Photo by Joe McTyre.)

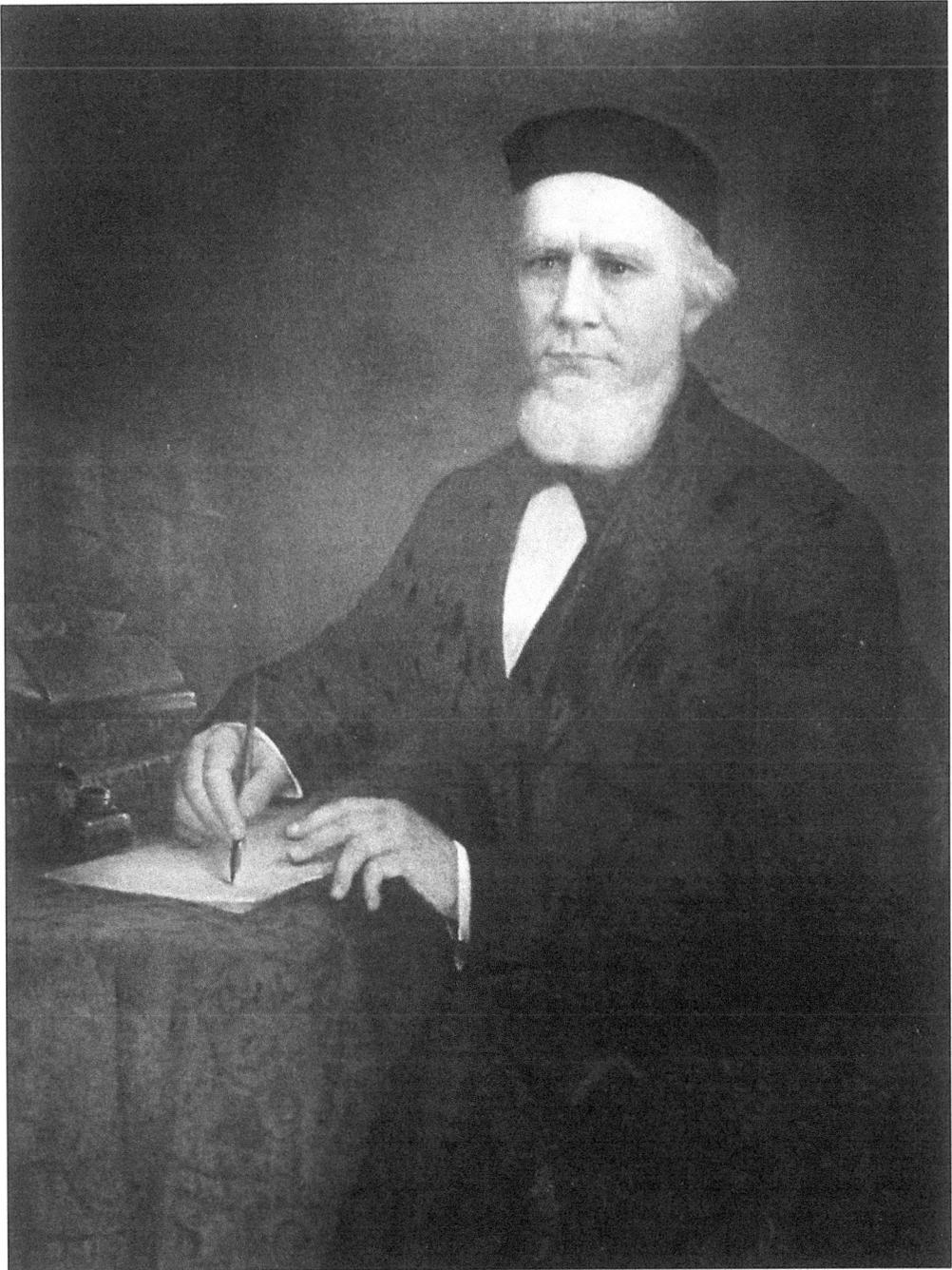

Dr. Francis Robert Goulding (1810–1881), a Presbyterian minister, author, and inventor, was the son of Dr. Thomas Goulding, founder and first president of Columbia Theological Seminary. Francis Goulding invented a sewing machine in 1842 but was never credited with the invention because he did not receive a patent for his work. He wrote a series of adventure stories for children including his most famous book, *Young Marooners*. He served as a chaplain to Confederate soldiers in Macon during the Civil War and lived in Roswell from the late 1860s until his death in 1881. His home still stands on Goulding Place. (Courtesy of Bulloch Hall.)

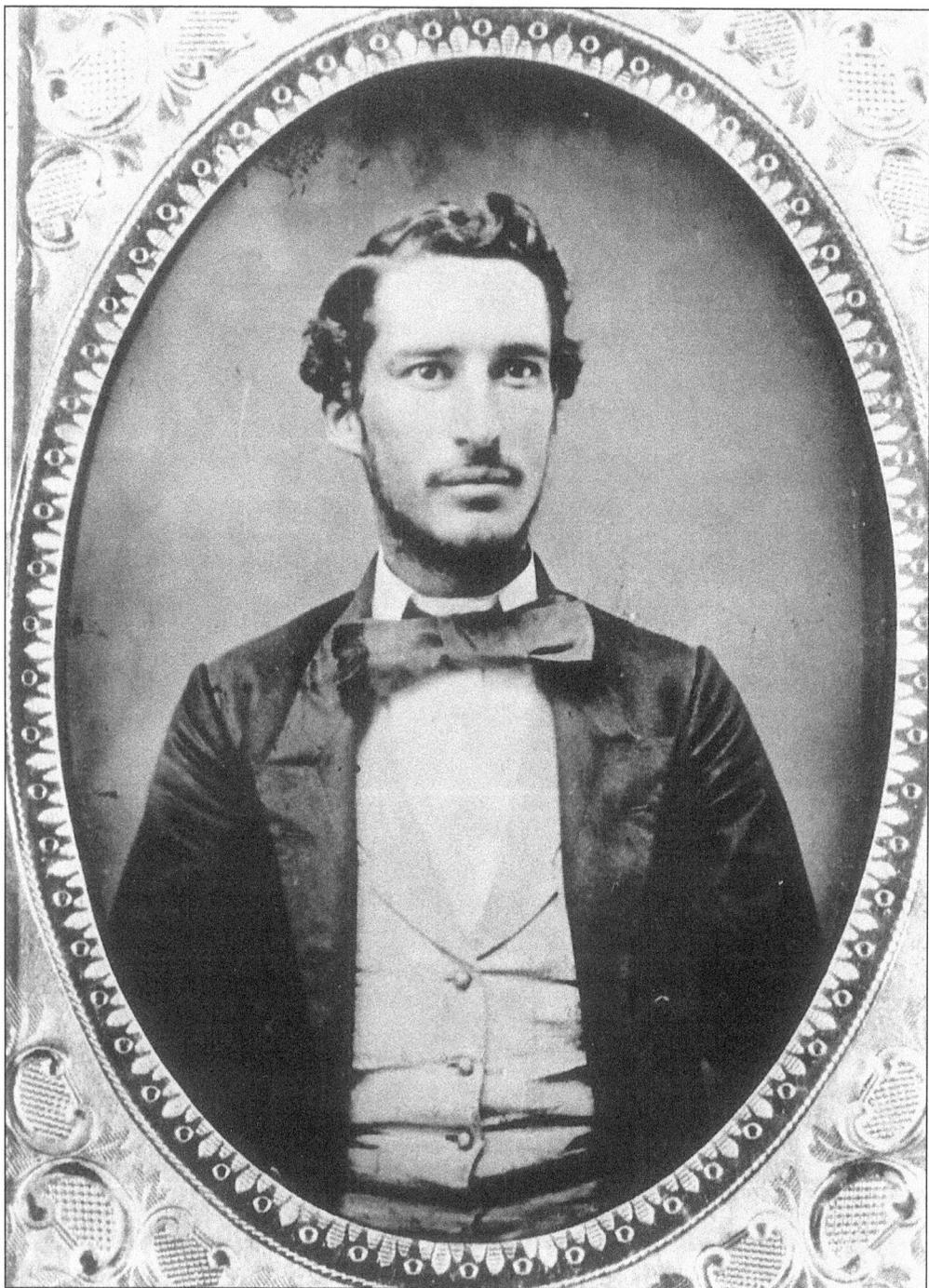

William Seagrove Smith, son of Archibald and Anne Smith, is shown in an 1860 portrait. Known to his family as "Willie," he served in the Confederate army and died of dysentery in Raleigh, North Carolina, three weeks after the war ended. (Courtesy of Archibald Smith Plantation Home.)

Four

CIVIL WAR AND RECONSTRUCTION

With Georgia's entry into the Civil War in 1861, men joined the Confederate army in droves, hoping for an opportunity to fight before the conflict came to what they believed would be a quick conclusion. Soldiers from Roswell fought and died in some of the war's major battles. Barrington King and Catherine King sent six of their sons off to fight in the Confederate army. Two died in battle—Thomas Edward King (1829–1863) at Chickamauga, Georgia, and Barrington Simral King (1833–1865) at Averasboro, North Carolina. A third son, Joseph Henry King (1839–1917) was severely wounded at First Manassas in 1861 and never fully recovered. Ralph Brown King (1835–1878) sustained a lesser injury.

Through its factories' output, Roswell provided strategic support for the Confederate army. The cotton mills turned out cloth and yarn while the woolen mill made "Roswell Gray" fabric for Southern uniforms. Despite the mills' importance, it was access to the Chattahoochee River that made Roswell a strategic target for Gen. William T. Sherman and the Union army. The Confederate army unit guarding Roswell—the Roswell Battalion Georgia Volunteers commanded by Capt. James Roswell King and consisting of boys and men from ages 16 to 60—burned the river bridge and evacuated the town just before Federal troops invaded Roswell on July 6, 1864. Barrington King, his wife, and younger children joined other Roswell citizens who fled to the Georgia coast and other places of refuge. Barrington Hall, Great Oaks, and other houses were occupied by Union officers; Phoenix Hall, the Bricks, and the Presbyterian Church were used as hospitals for Federal soldiers, mostly victims of heat rather than battle wounds. Dr. Pratt and his family were among the few residents remaining in Roswell, electing to stay to protect their property and that of their family and friends. Most houses in Roswell were plagued with looting and vandalism by soldiers as well as by local people. In President Theodore Roosevelt's autobiography, he wrote, "Pretty much everything portable [in his grandfather's Bulloch Hall] was taken by the boys in blue, including most of the books in the library."[14]

The Federal occupation of Roswell was brief but catastrophic. Union Brig. Gen. Kenner Garrard's cavalry units burned the mills and marched about 400 factory hands, mostly women and children, to Marietta where they were loaded on cattle cars and shipped north to Indiana and other places. Some workers made their way back after the war, but most of them never saw Roswell again.[15] When the Kings returned in 1865, all the Roswell Manufacturing Company properties had been destroyed except for the commissary. But they rejoiced to find that their beautiful Barrington Hall and the homes of their family and friends had been spared. In a report to the mill stockholders on July 19, 1865, Barrington King related the following:

The U.S. Army entered the village on Tuesday, 6th of July 1864 and the following evening destroyed by fire both cotton factories, the machine shop, cotton house and office. They did but

71

little injury to the store building and dwelling houses for operatives. We regret to report the conduct of a few men, in our employment for years with the women and children, from whom we expected protection to our property. They plundered and destroyed to a large amount, tearing down the shelves in the store to burn, breaking glasses and otherwise injuring the houses, hauling off iron and copper to sell, and putting the [mill] wheel in motion and seriously injuring it.[16]

Roswell was a vital passageway to the Chattahoochee River crossing for Union troops until October 1864. After the South's surrender, residents who had left for safer havens returned and found food and necessities in short supply as they tended the wounded, grieved for their men killed in battle, dealt with a decline in currency, and repaired their damaged property.[17] Fortunately, the manufacturing company owners had enough capital to begin rebuilding soon after the war. George Camp oversaw the cotton mill's reconstruction (only one was rebuilt), and by 1867, the company was back in business. Barrington King resumed direction of the company until his death in 1866 after he was kicked by a horse.[18] Camp briefly succeeded King until Gen. Andrew Jackson Hansell was named president in 1867. After James Roswell King returned home about 1870, the woolen mill was rebuilt. According to records, he sold the factory in 1871 to the Empire Manufacturing Company, which ran the mill until 1877 when the Laurel Mills acquired the woolen mill and changed the name to the Laurel Mills. The woolen mill closed about 1911.[19]

After the Civil War, the importance of a rail line to Roswell was still a priority of the Roswell Manufacturing Company. Finally, the Roswell Railroad opened for business on September 1, 1881. The 9.8-mile local narrow gauge rail line connected to the Atlanta & Charlotte Air Line Railroad, running between Roswell Station (south of the Chattahoochee off Roswell Road) and Chamblee.[20] Although the area enjoyed general prosperity in the late 1800s, the Roswell Manufacturing Co. faced significant changes and problems with diminishing dividends and declining markets.[21]

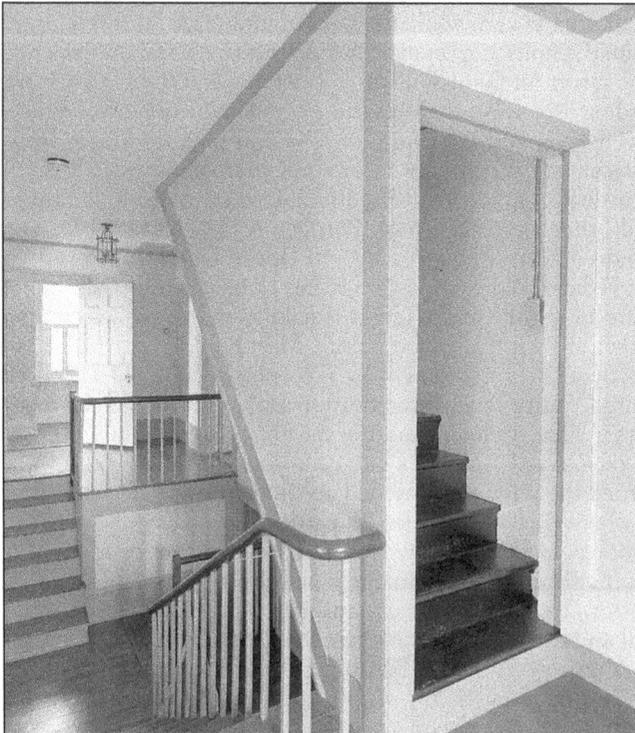

This view of Great Oaks, built for the Pratt family in 1842, shows the "Good Morning staircase" where family members greeted each other at the start of each day. The other steps lead up to "Augusta" and "Macon," names given to the attic where the Pratts hid their valuables and things left behind by their friends during the Civil War. Accounts of the period relate that Dr. Nathaniel Pratt truthfully answered the Yankee soldiers' inquiries about the whereabouts of the Roswell families' treasures, replying that everything was "taken to Augusta or Macon." Great Oaks is now privately owned and used for offices and special events. (Photo by Joe McTyre.)

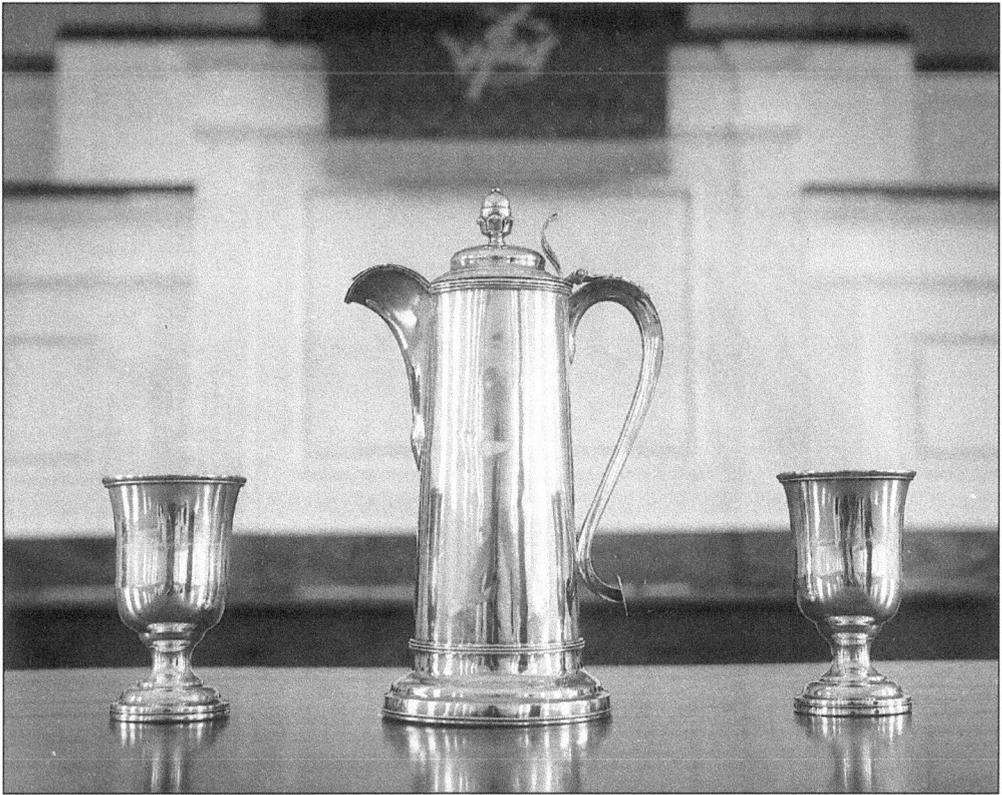

The Roswell Presbyterian Church's beautiful silver communion service was preserved during the Civil War by Dr. Nathaniel Pratt who smuggled the pieces to mill superintendent Olney Eldredge. Eldredge then passed the silver on to mill employee Frances Whitmire who removed it to her mother's home, where Mrs. Stephen Whitmire hid the pieces until the war's end. The fine sterling service, on display in the church History Room, was a gift from the Savannah Independent Presbyterian Church about 1840. (Photo by Joe McTyre.)

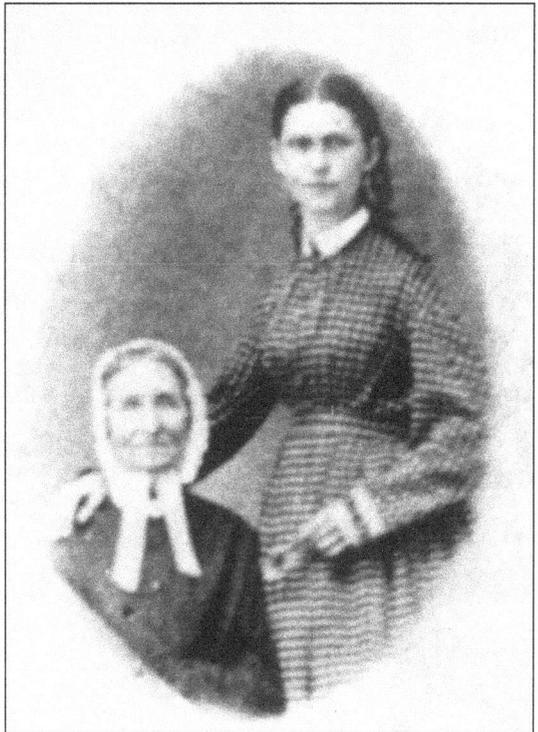

Frances "Fannie" Whitmire and her mother, Mrs. Stephen Whitmire, are credited with helping to save the Presbyterian Church communion silver from confiscation by Union soldiers. (Courtesy of Roswell Presbyterian Church History Room.)

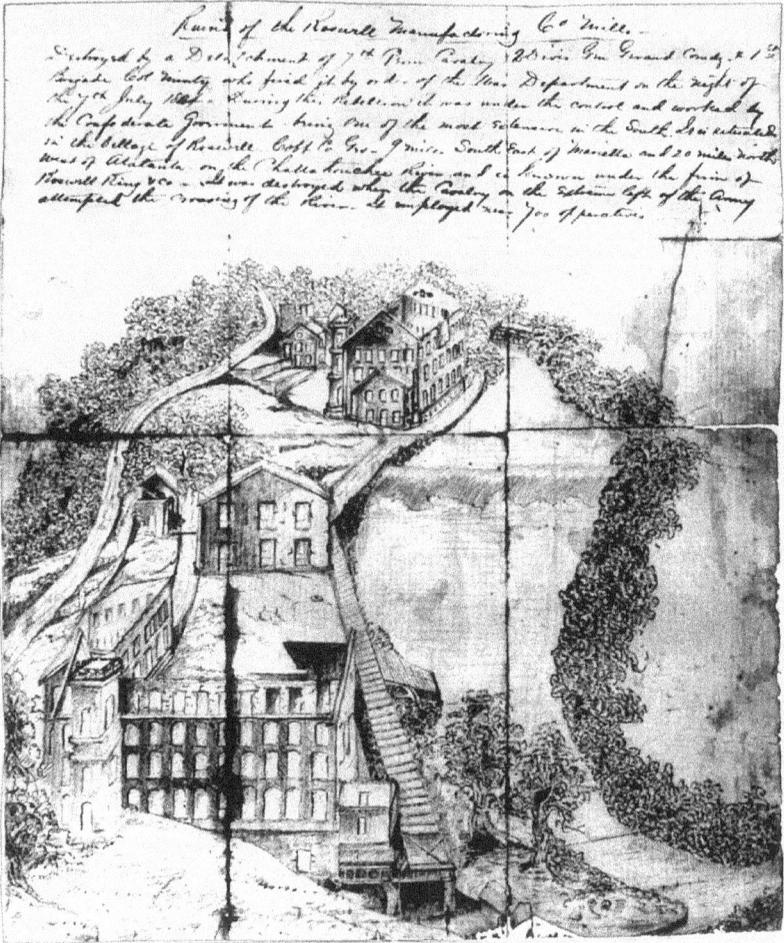

Charles Holyland, a Union soldier in the Chicago Board of Trade Battery, sketched the Roswell Manufacturing Co. cotton mills ruins in July 1864. (Courtesy of Dr. James L. Skinner III; donated to Roswell Historical Society by James L. Skinner Jr.)

Brig. Gen. Kenner Garrard commanded the 2nd U.S. Cavalry Division that invaded Roswell on July 5, 1864 and burned the mills. Garrard's troops moved out of Roswell, about eight miles up the Chattahoochee River by July 14, but soldiers, at times as many as 36,000, remained in the area, camping on the grounds of the beautiful homes until September. (Courtesy of Lois King Simpson.)

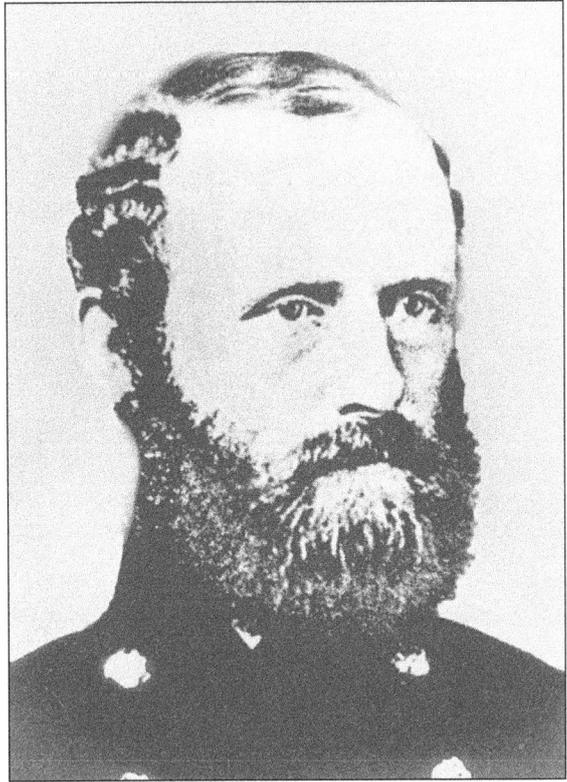

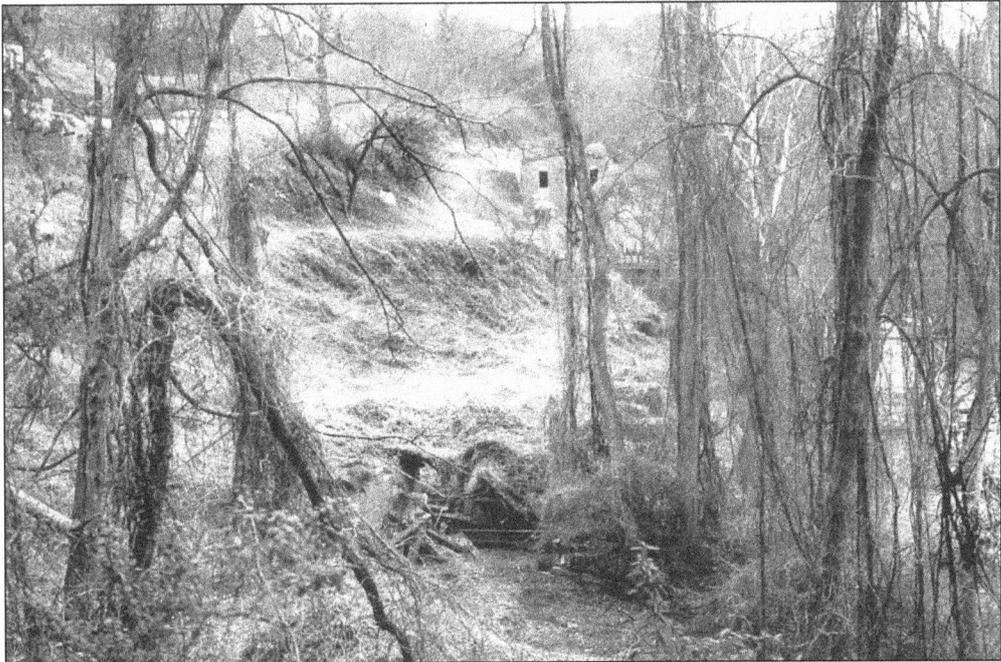

Compare today's view of the Roswell Manufacturing Co. mill ruins with artist Charles Holyland's sketch on page 74, after the mills were destroyed in July 1864. The shell of the brick machine shop is the only building intact. (Courtesy James L. Skinner III.)·

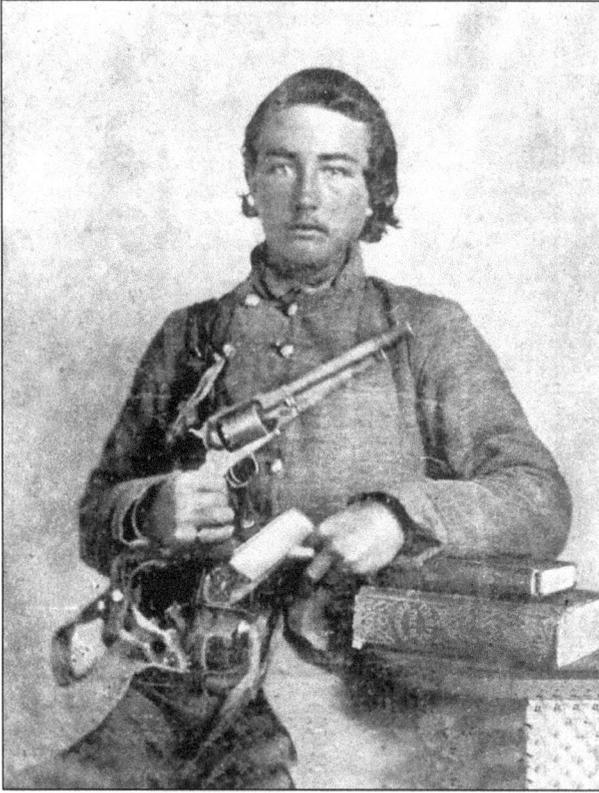

Pvt. John Gideon Morris (1847–1936) was photographed in his Confederate army uniform when he served with Wheeler's Cavalry in Augusta in 1865. The son of Joel Emory Morris and Mary Wing Morris, Gideon was born in Roswell, joined the army at age 16, and returned there after the war. He moved to Marietta about 1900, where he owned a large farm as well as Belmont Farm in Smyrna. He was treasurer of Cobb County from 1905 to 1911 and served as mayor of Smyrna in 1925–1926. Morris and his wife erected a monument to Gen. Leonidas Polk to mark the spot where Polk was killed by Yankee cannon fire near Kennesaw Mountain. (Courtesy of Marian and Rachel Dabney.)

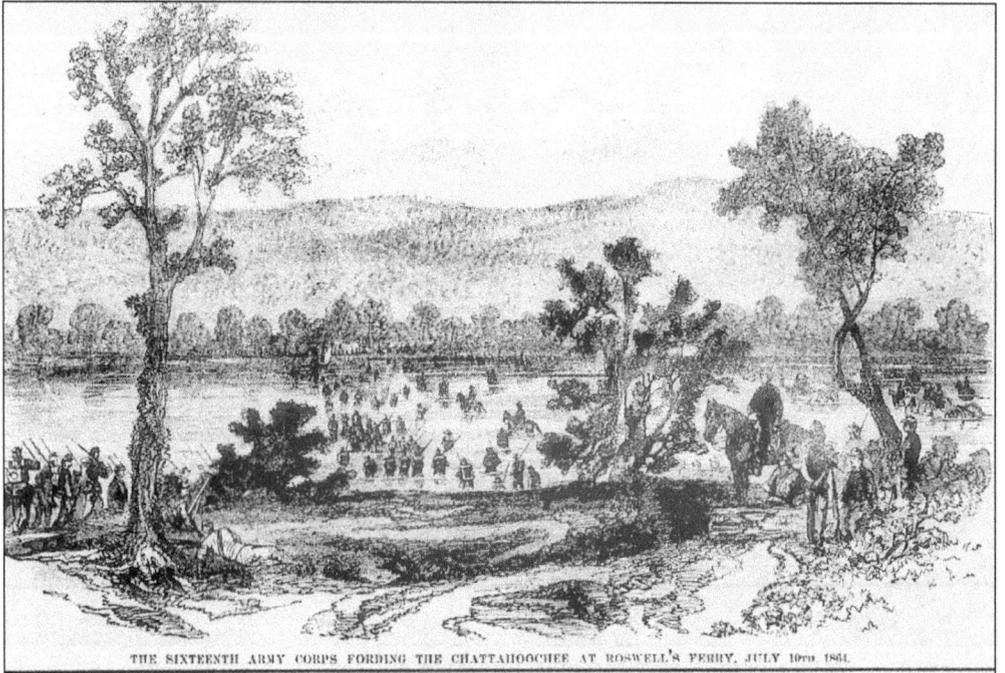

THE SIXTEENTH ARMY CORPS FORDING THE CHATTAHOOCHEE AT ROSWELL'S FERRY, JULY 10TH 1864.

This drawing of Sherman's 16th Army Corps fording the Chattahoochee River "at Roswell's ferry," dated July 10, 1864 was originally published in *Harper's Weekly*.

James Madison Hartsfield of Roswell was 18 when he enlisted as a private in Georgia's Cobb Legion, Company E. Hartsfield's sister was among the mill workers sent north by Sherman's troops. She never returned. Hartsfield was the grandfather of Lex Jolley (1903–1994), a Roswell resident who graduated from Roswell High School and moved to the Smyrna area to teach school in 1922. (Courtesy of Malinda Jolley Mortin.)

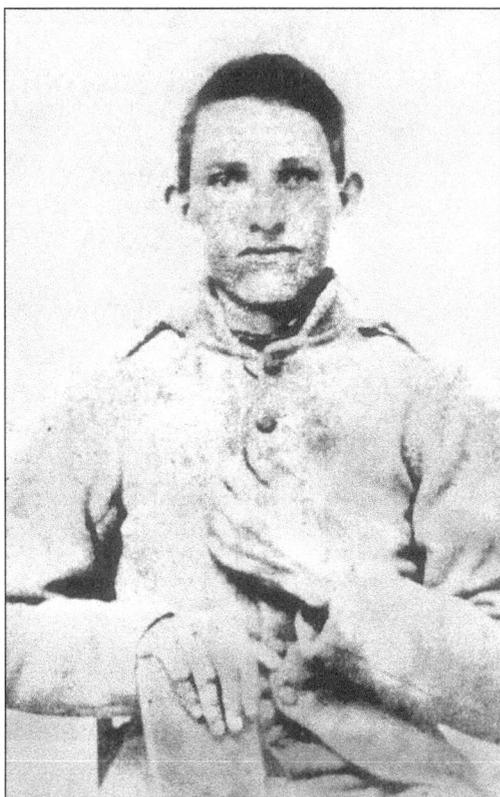

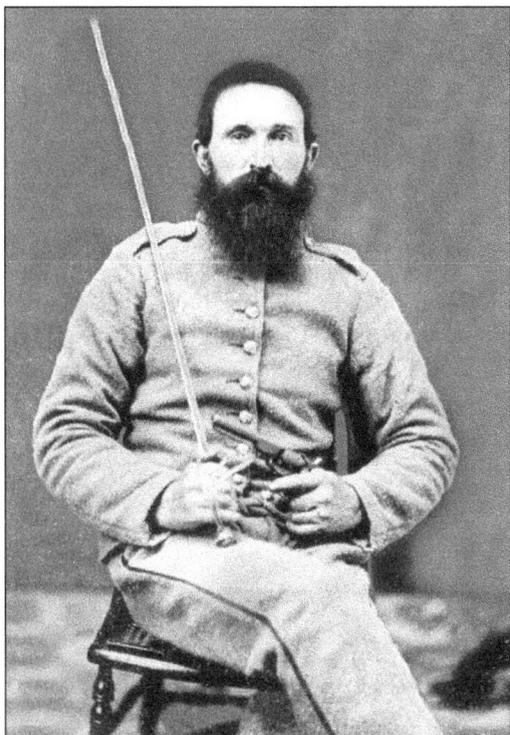

James Madison Drake, born in Pike County in 1832, served as a private in the Roswell Troopers, later a part of Cobb's Legion. After the war, he worked as a brick mason on several buildings in uptown Roswell including the Perry Building on Canton Street. He died in 1908. (Courtesy of Eleanor Drake.)

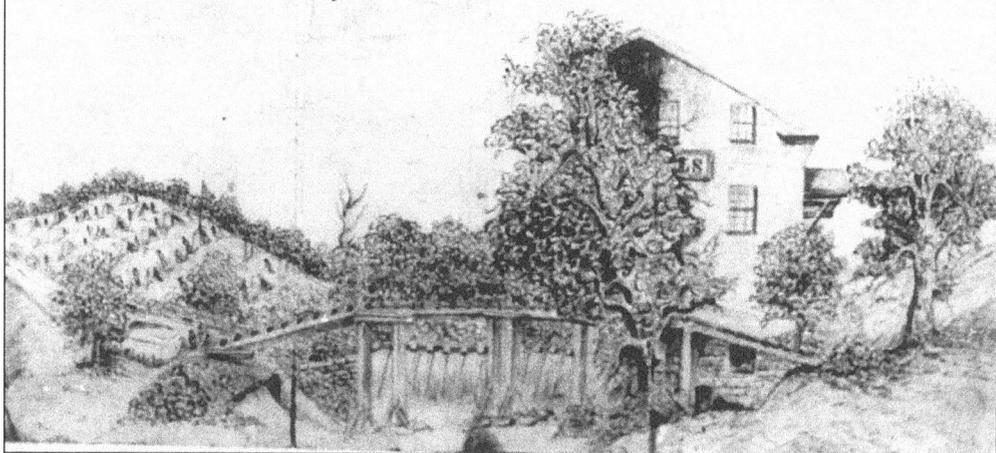

Ruins of the Lebanon Mill are seen in this July 15, 1864 drawing by Union soldier Charles Holyland. Notice the tents sketched on the hillside on the left, the location of Gen. Kenner Garrard's headquarters. (Courtesy of James L. Skinner III; donated to Roswell Historical Society by James L. Skinner Jr.)

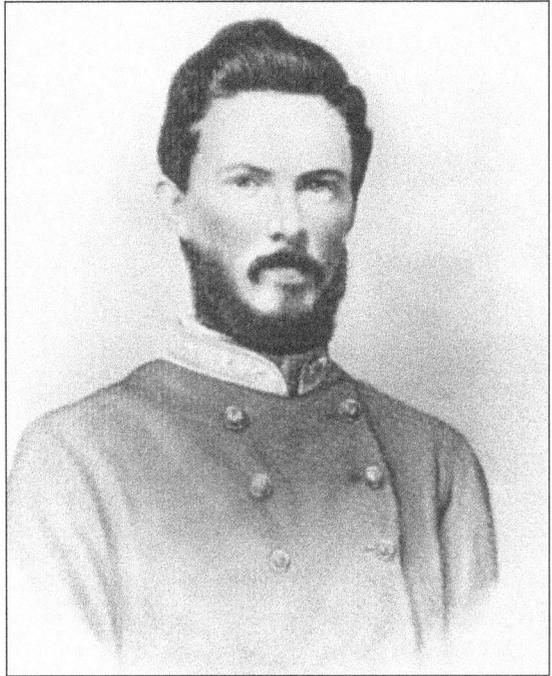

Capt. Barrington Simral King (1833–1865), son of Barrington and Catherine N. King, served in the Confederate army under Gen. Wade Hampton. He died in battle just before the war's end. Etched on his tombstone in the Presbyterian Cemetery in Roswell are the words "Say to my wife I die willingly defending my country." (Courtesy of Lois King Simpson.)

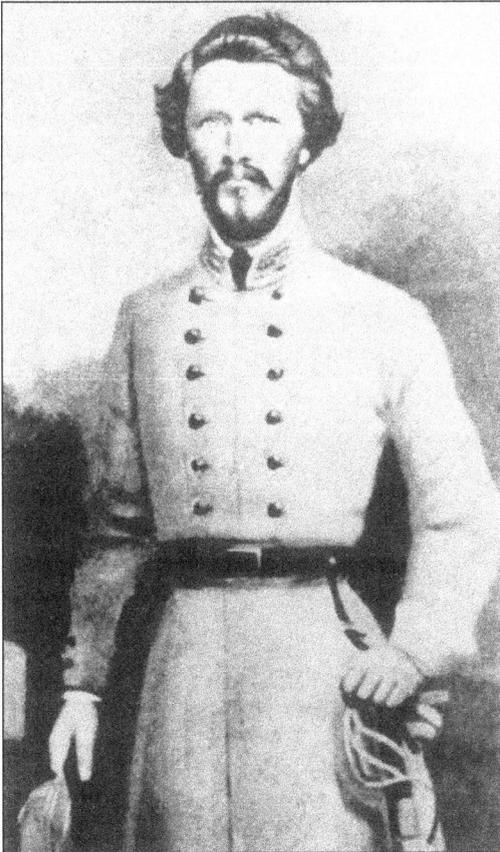

Capt. Thomas Edward King (1829–1863), son of Barrington and Catherine N. King, was seriously wounded at the Second Battle of Manassas in 1862 and returned to Roswell to recuperate. He joined Gen. Preston Smith's staff in 1863 and died at the Battle of Chickamauga. According to city records, he was mayor of Roswell about the time of his death. (Courtesy of Lois King Simpson.)

Mary Kendley May (1843–1924) and her husband, Albert Alexander May, are shown during one of her two return trips to Roswell in 1873 and 1910. Mary was one of 400 mill workers arrested and sent north by Union Gen. William T. Sherman when Roswell was captured by his troops in 1864. She and other mill employees went first to Louisville, Kentucky, then to Indianapolis, Indiana, and finally to Cannelton, Indiana, where she went to work and, later, met and married Albert May. (Courtesy of George Kendley.)

Left: Former Roswell mill worker Mary Kendley was sent to Cannelton, Indiana in 1864. She never resided in Roswell again. (Courtesy of George Kendley.)
Right: Thomas Hugh Kendley was one of the Roswell mill workers sent to Kentucky and Indiana with other Roswell and Sweetwater mill workers. (Courtesy of George Kendley.)

Gen. Andrew Jackson Hansell (1815–1881) was a lawyer, served as adjutant general of Georgia during the Civil War, and was a founder of the Georgia Military Institute. After the war, he moved to Roswell, purchased Phoenix Hall, which his wife, Caroline, renamed Mimosa Hall, and became president of the Roswell Manufacturing Company. His descendants own Mimosa Hall at present. (Courtesy of Sylvia and Edward Hansell.)

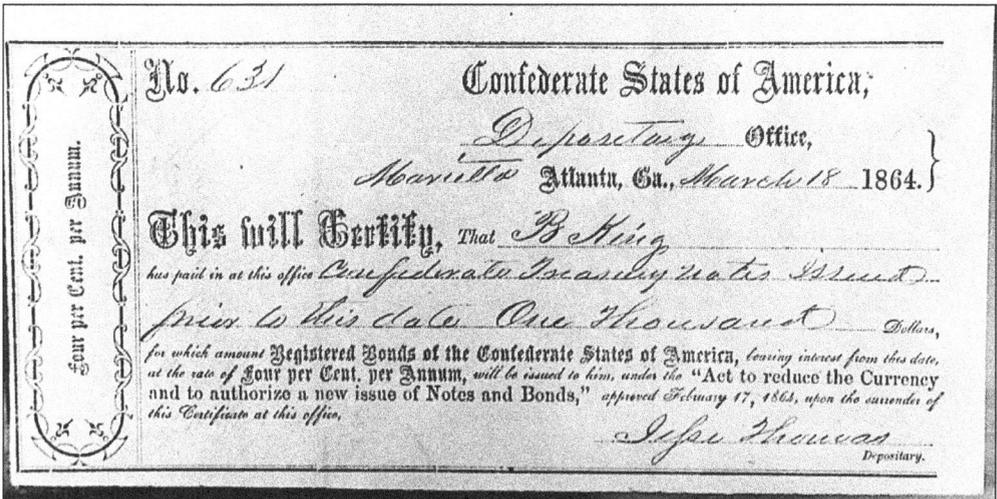

The Confederate government's depository office at Marietta issued this $1,000 bond receipt to Barrington King on March 18, 1864. The loan was supposed to be repaid at four percent interest. More than likely, King never redeemed his bond. (Courtesy of Marietta Museum of History.)

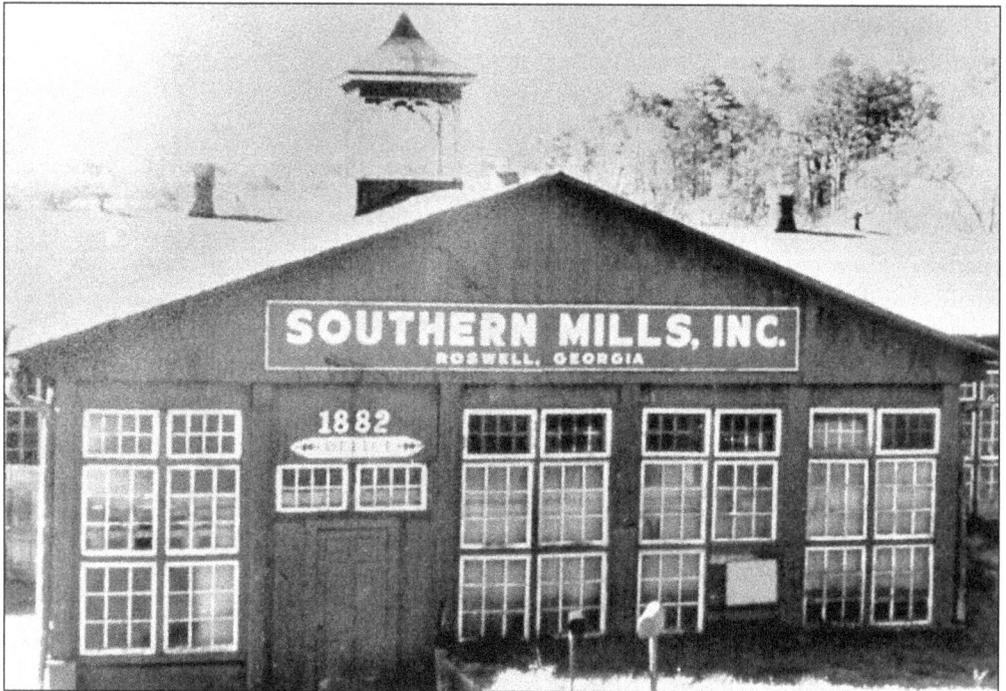

The Southern Mills built this factory building in 1882 near Vickery Creek. Today it is the only remaining mill building in Roswell. The mill closed in the mid-1970s, and was renovated for shopping, restaurants, and entertainment in the 1980s. Mimms Enterprises Inc., headed by Malon Mimms, purchased the building in 1991 and preserved it and its surroundings. Today the old factory is used as office space and a special events facility. (Courtesy of Malon Mimms.)

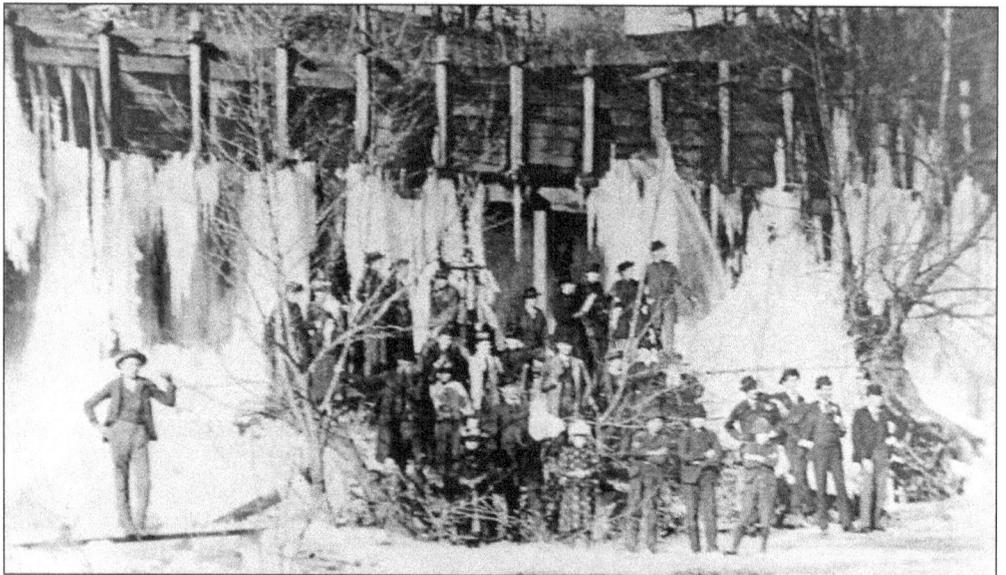

Roswell factory employees stood in front of a large spillway in this early 1900s scene. During the winter, water used to operate the mill often froze in the flume requiring men to stand on top of the penstock and break the ice with long wooden poles so the mill operation could resume. (Courtesy of Teaching Museum North, Fulton County Schools.)

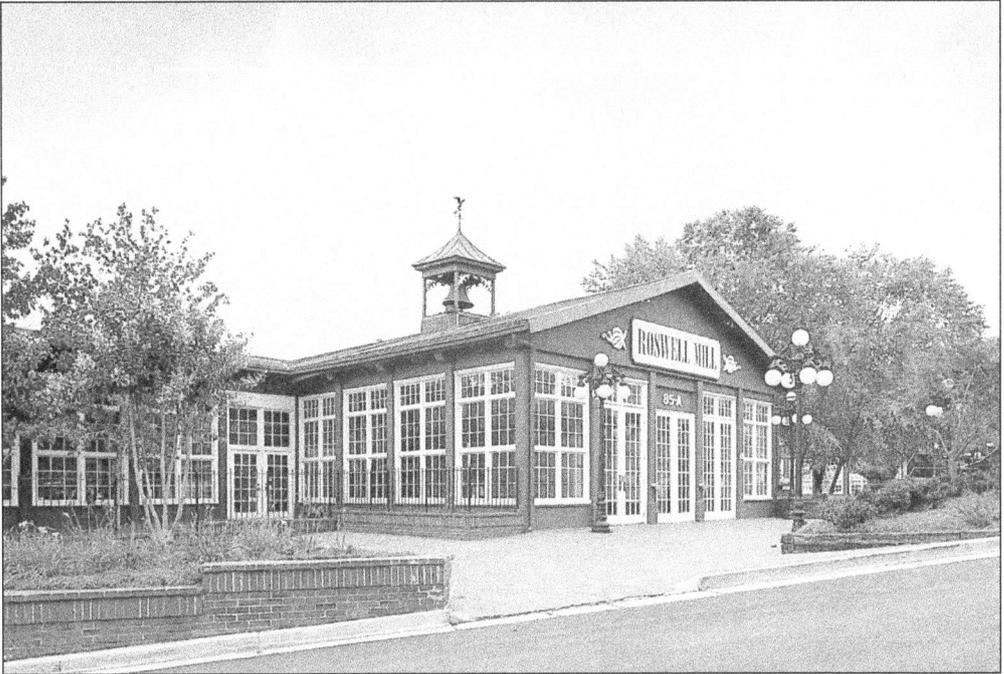

This view shows the 1882 Roswell Mill, the only cotton factory building still in use. The old mill, adapted for office space, overlooks the creek that once supplied water power for the early mills. (Photo by Joe McTyre.)

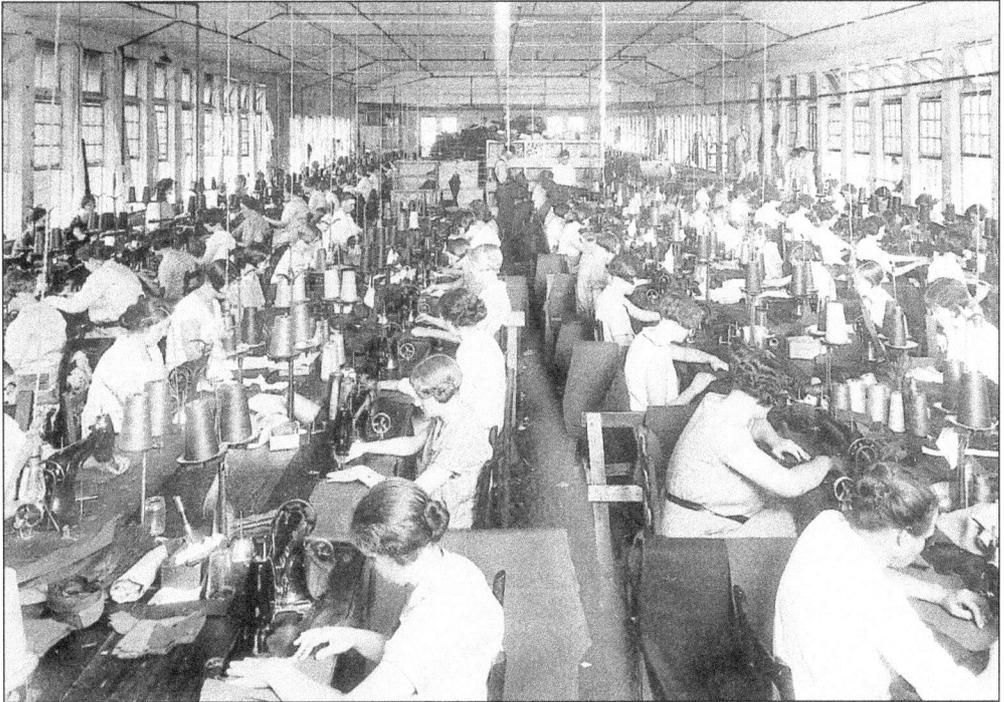

Women employees are pictured at work in the Oxbo Pants Factory in the 1930s. (Courtesy of Elwyn Gaissert.)

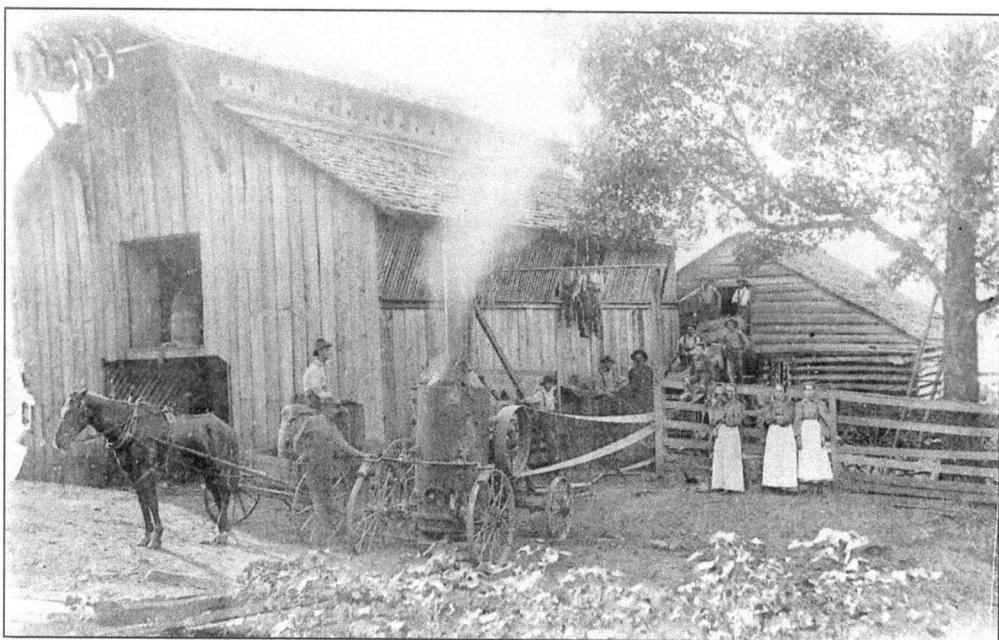

The Coleman family used a steam engine on their farm in the early 1900s. The farm was located on Coleman Road. (Courtesy of Dorcas Coleman McDonald.)

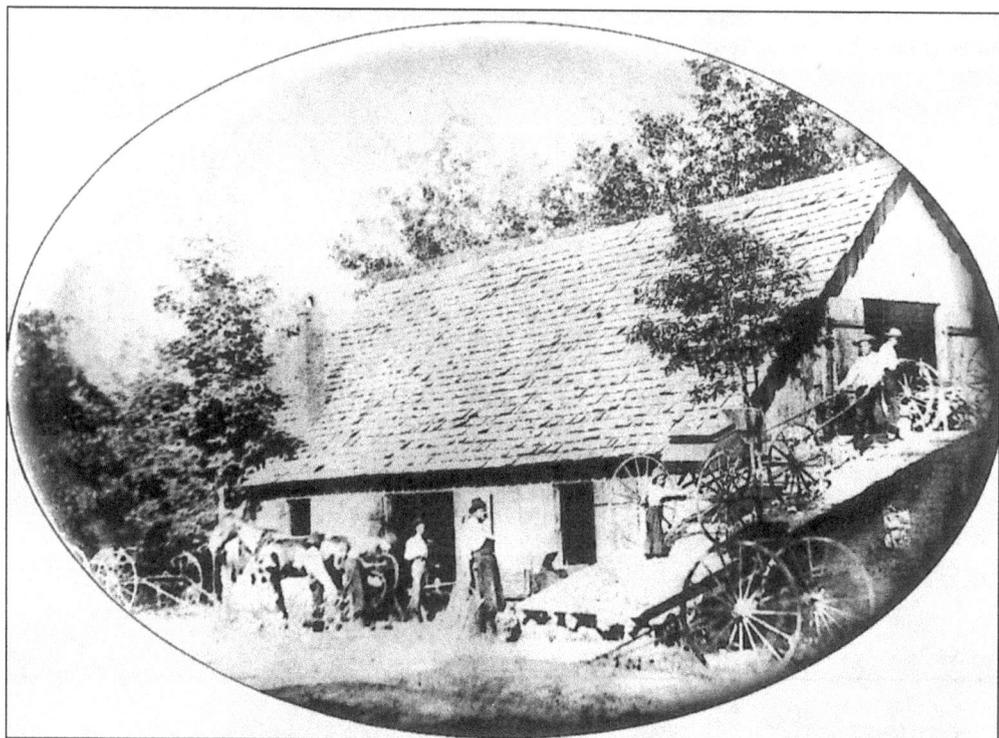

A blacksmith shop at Alpharetta and Norcross Streets is shown in the late 1890s or early 1900s. The ramp led to an upstairs work area where wagons and buggies were made. (Courtesy of Georgia Department of Archives and History.)

Robert J. "Bob" Phillips operated the Phillips Hotel on Canton Street in the early 1900s. (Courtesy of Dorcas Coleman McDonald.)

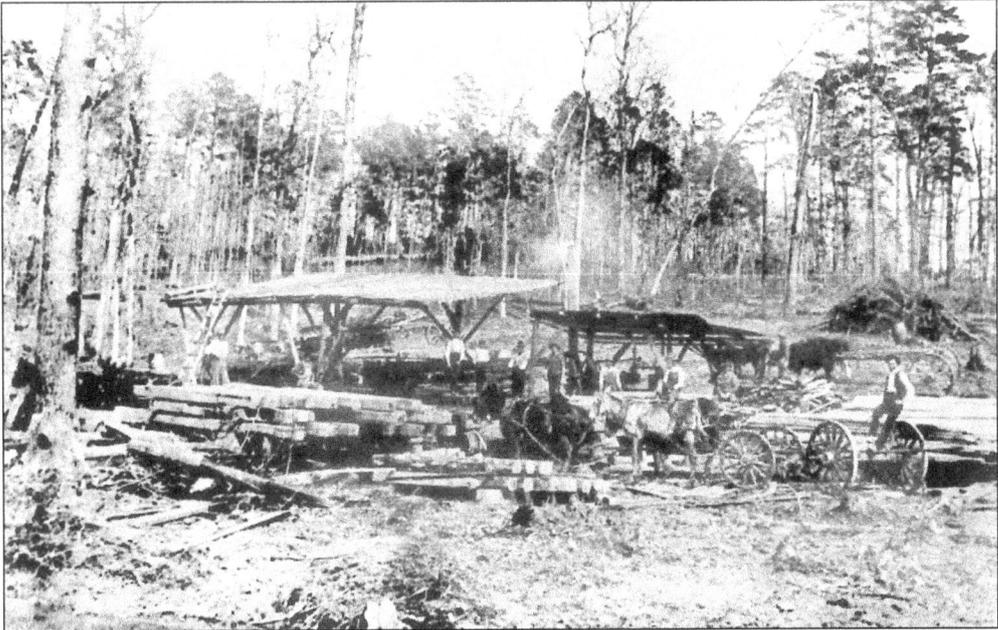

Arthur T. Coleman and his family ran an itinerant sawmill in the 1930s and 1940s, first in Dallas and later in Roswell. Using mules and oxen for hauling, the Colemans moved the woodcutting equipment around to various places in the area. (Courtesy of Dorcas Coleman McDonald.)

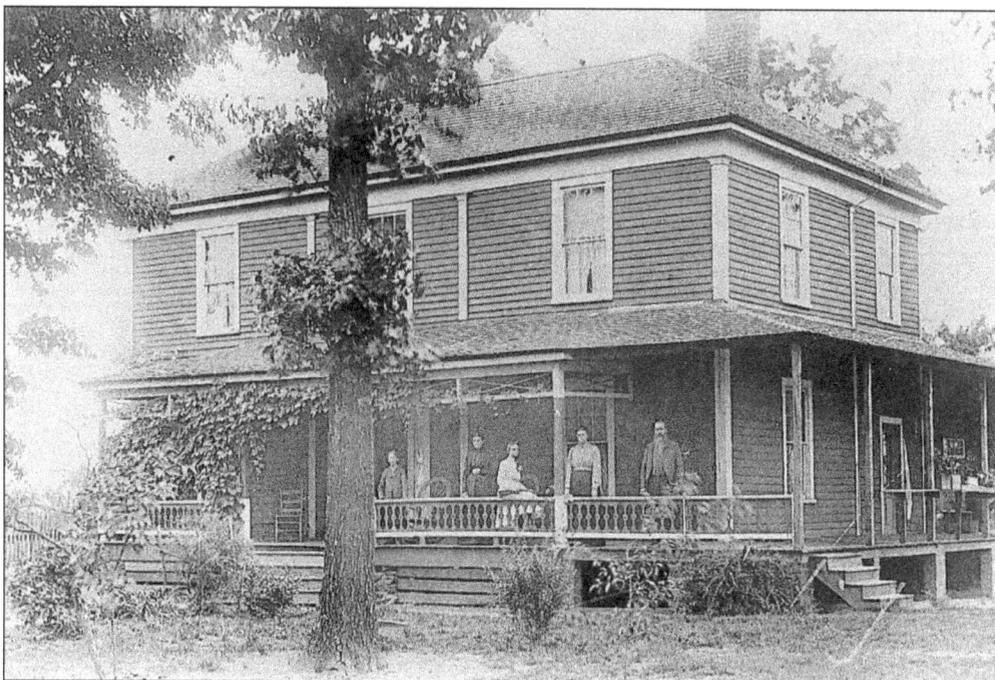

Charles Jefferson Perry and members of his family posed for this photo on the porch of their Canton Street house about 1910. Perry bought the house from Robert Anderson who built it in the early 1880s. Shown from left to right are Lucius Fowler, unidentified, Emily Phillips, Ola Mayfield, Salena Perry, and C.J. Perry. (Courtesy of Dorcas Coleman McDonald.)

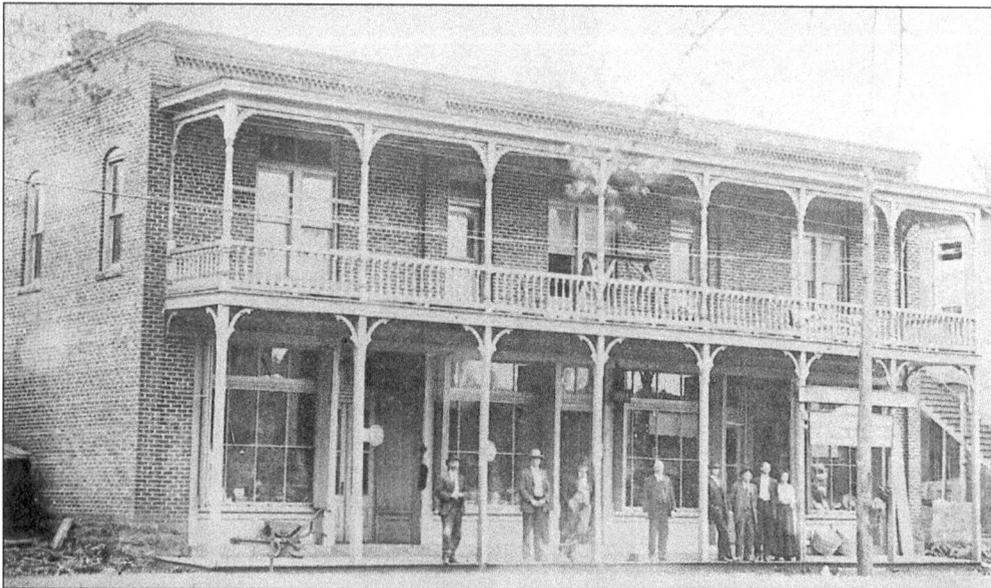

The uptown landmark known as the Perry Building was built by Charles Jefferson Perry on Canton Street in the 1880s. Through the years, several businesses have kept shop there including Perry's general store, a hardware store, a grocery store, and the local telephone exchange office. The building still has its original two-tier veranda and houses an antique business and a clock shop. (Courtesy of Dorcas Coleman McDonald.)

Charles Jefferson Perry and Salena Phillips Perry settled in Roswell in the 1880s. Charles ran a general store and was a founder of the Citizens Bank of Roswell. (Courtesy of Dorcas Coleman McDonald.)

Isaac Martin Roberts (1853–1930) was the Roswell Railroad's only engineer during its 40 years of operation. After the railroad discontinued service in 1921, Roberts went to Washington, D.C. where he paid $1 for the deed to the Roswell Station house. He then converted the structure into a barn. (Courtesy of Henry Wing.)

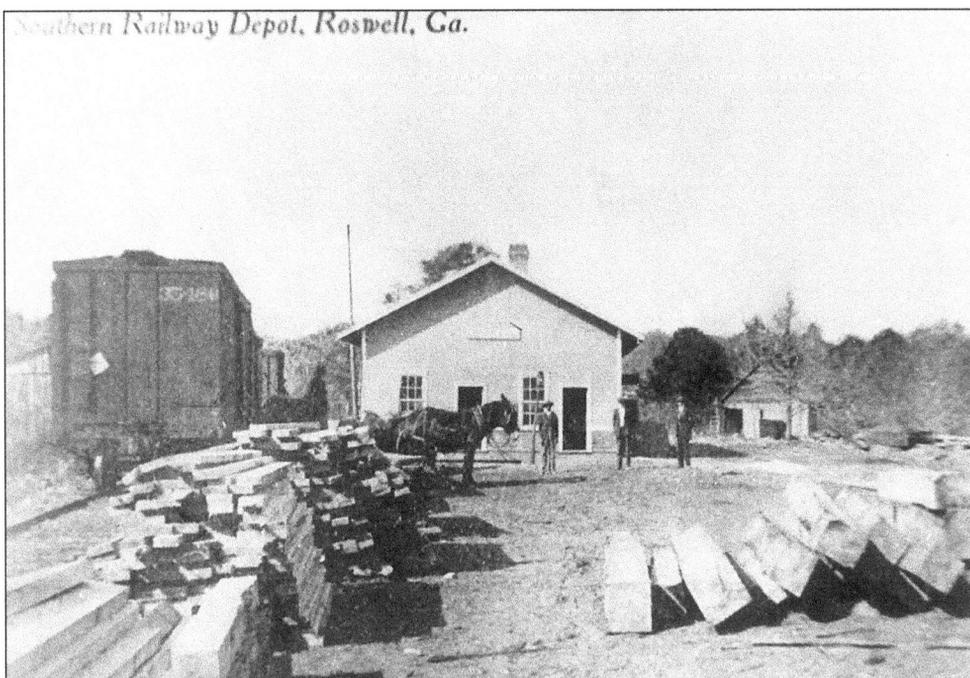

The Roswell Railroad Station was located on the south side of the Chattahoochee River near Roberts Drive. (Courtesy of Jo Ann Browne.)

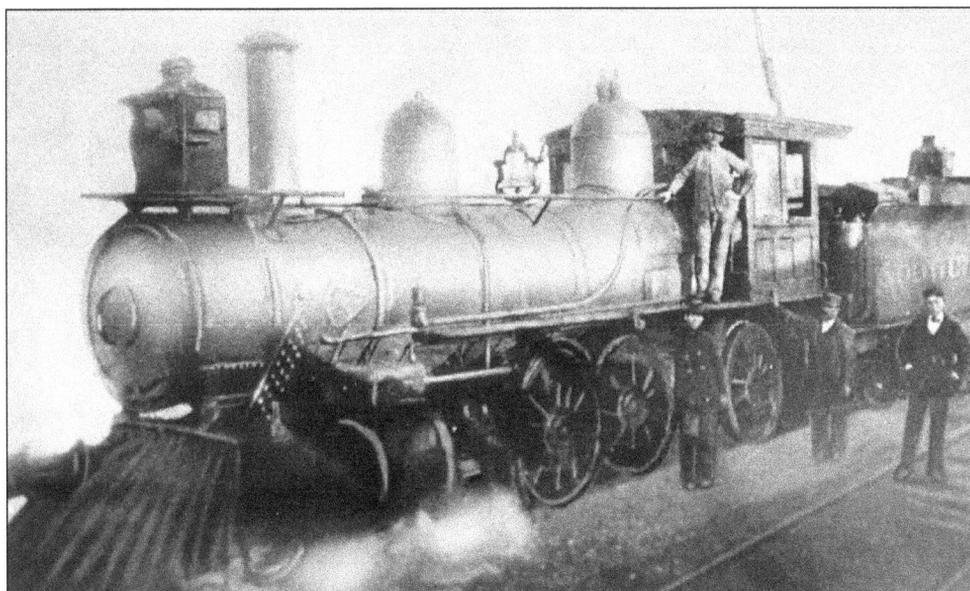

Between 1881 and 1921, the "Buck," the locomotive on the Roswell Railroad's line, ran from the Roswell Station south of the Chattahoochee River to a connection with the Atlanta and Charlotte Air Line Railway Co. at Chamblee, almost ten miles. Originally built as a narrow gauge railway, the line consisted of a locomotive, passenger-baggage car, and several freight cars. The train made two round trips to Chamblee daily except Sunday and remained at the Roswell station at night. The locomotive ran backwards from Roswell to Chamblee because turn-around facilities were never provided. (Courtesy of Henry Wing.)

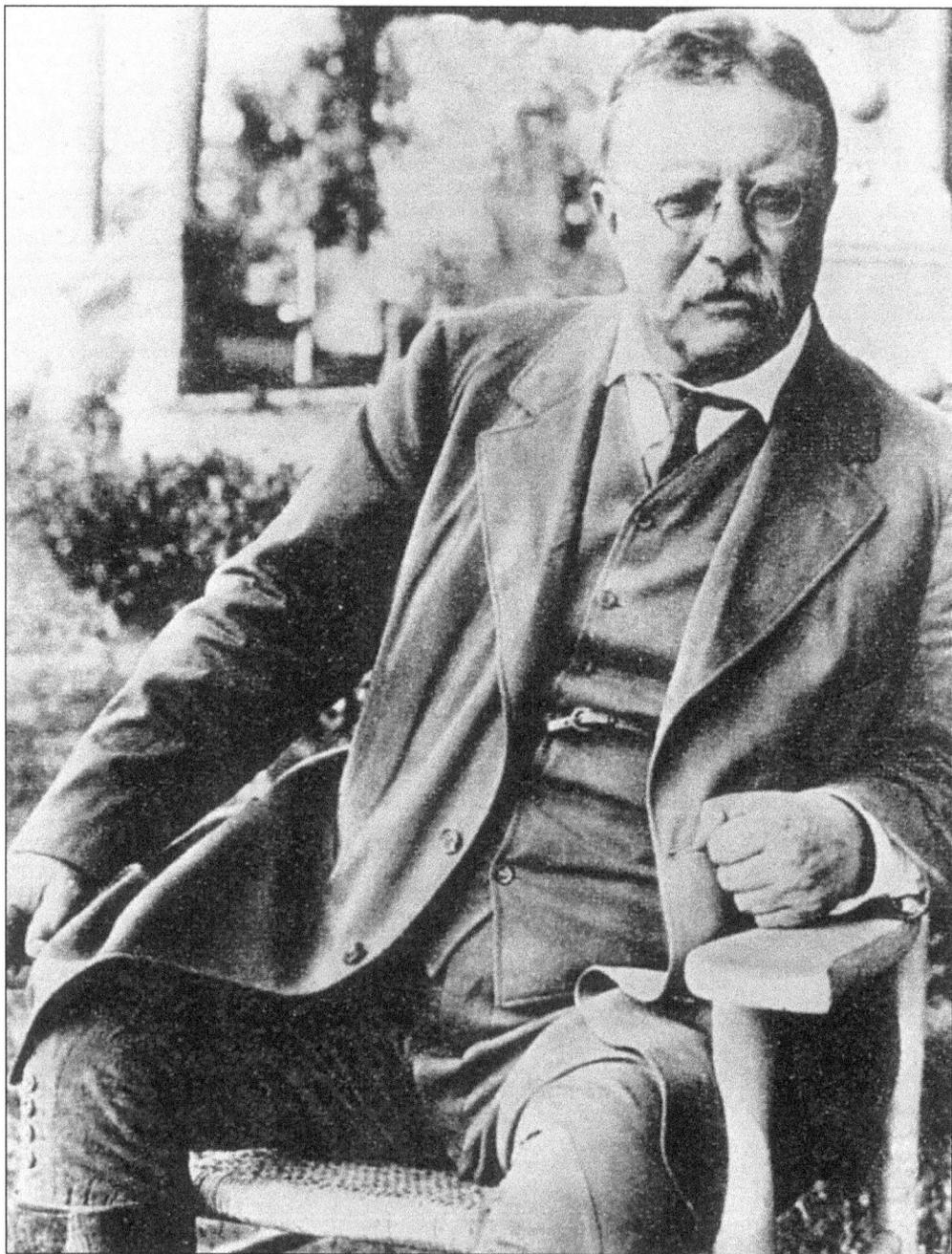

President Theodore Roosevelt Jr. stopped at Barrington Hall to visit his mother's friend Evelyn King Baker in 1905. (Courtesy of *The Atlanta Journal-Constitution*.)

Five

THE 1900S

With many scars from the Civil War and Reconstruction healed, the beginning of the 20th century was full of promise for Roswell. Among the changes residents saw early in the 1900s were the establishment of Roswell's first bank and the addition of telephone service, electricity, and paved streets. A new two-story brick school building was built in 1914 for white children while a one-room wooden structure housed black students. Slow growth continued—there were only 1,329 inhabitants in 1900. Many farms, most growing cotton, were located around the city's vicinity but the mills remained the town's largest employers. On October 2, 1905, Roswell residents turned out in droves to see President Theodore Roosevelt and his wife, Edith, who visited the town during a tour of the South. The president traveled to his mother's birthplace, Bulloch Hall, attended a reception at the Presbyterian Church, made a speech at the park, and, just before leaving Roswell, called at Barrington Hall to visit Evelyn King Baker, his mother's longtime friend and a bridesmaid in the Roosevelt-Bulloch wedding 52 years earlier.[22]

During the 1920s, a boll weevil infestation and the declining economy affected farmers all over the South, bringing about changes ranging from the types of crops produced to alterations in the methods for earning a living. Roswell remained mostly rural through the 1930s with farms and mills supporting the majority of its population of about 1,400 citizens. Motivated by a desire for lower taxes, better schools, more paved roads, and better access for legal transactions, a group of Roswell leaders including Mayor Clifford P. Vaughn promoted annexation into Fulton County. Roswell residents overwhelmingly passed a resolution appealing to Cobb County to allow the Roswell militia district to become part of Fulton County. Cobb reluctantly let go of the five-square-mile area in 1932.[23]

The Roswell Manufacturing Company's cotton mill, rebuilt following the Civil War, was destroyed by fire when lightning struck during a violent storm in 1926. Instead of rebuilding, the company enlarged a plant built in 1882 and continued operating. Under different owners and names, production continued until 1975. Another important industry, the clothing factory founded in the 1890s by J.H. Waller and later known as the Oxbo Pants Factory, provided jobs in the community until 1980 when a later owner, the Roswell Co., shut down production. The Roswell Store closed its doors in the mid-1960s, more than 120 years after it was established.

Roswell's population was 3,500 when a new mayor, W.L. "Pug" Mabry took office in 1967. The Roswell Bank, established to serve the payroll and bookkeeping needs of the mills, moved from a corner of the old company store to its own building next door on Atlanta Street. At the start of the 1970s Roswell had less than 10,000 citizens, but the construction of Georgia Highway 400 brought about unprecedented growth. By 1980, population had more than quadrupled, and in 1990 it reached 48,250. In 1985, the city acquired 28 acres of the Archibald Smith plantation site for a new municipal complex. The new $20-million project, including City Hall, the Cultural Arts Center, and the police headquarters buildings, was completed in 1991.

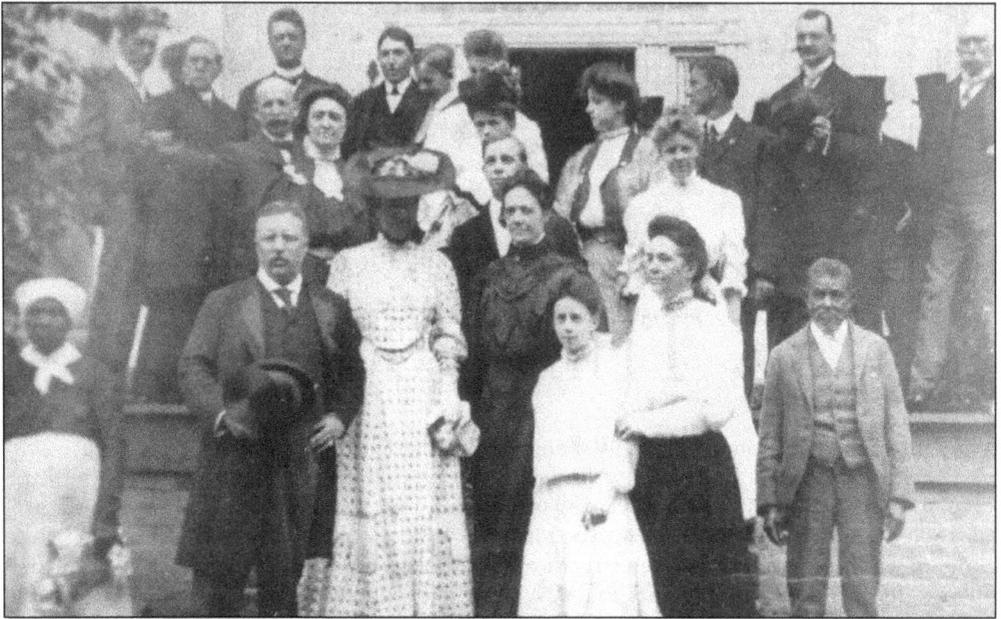

President Theodore Roosevelt and his wife, Edith, pose with Roswell citizens who welcomed them at Bulloch Hall in 1905. Those identified are, from left to right, (front row) "Maum" Grace Robinson, President Theodore Roosevelt, Edith Kermit Roosevelt, Annie Wing Wood, Cecile Wood, and "Daddy" William Jackson; (second row) Eugene H. Wood Jr. and Edith Wing Wood; (third row) John Dunwody, Ella Wing Dunwody, Hattie Suddath (Mrs. Jehu) Wing, unidentified, and unidentified; (back row) unidentified, unidentified, U.S. Senator Alexander Stephens Clay of Marietta, Max Garrison (Hattie Wing's brother-in-law), Katharine Suddath Stribling, and several unidentified men. (Courtesy of Georgia Department of Archives and History.)

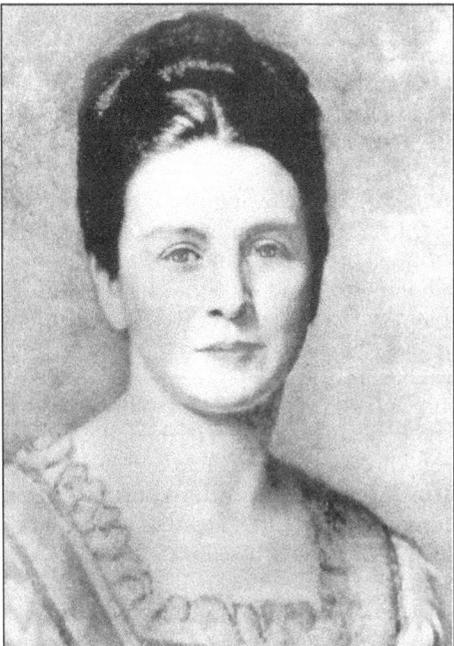

Martha "Mittie" Bulloch Roosevelt, mother of Theodore Roosevelt Jr., was married in Roswell at Bulloch Hall. (Courtesy of *The Atlanta Journal-Constitution.*)

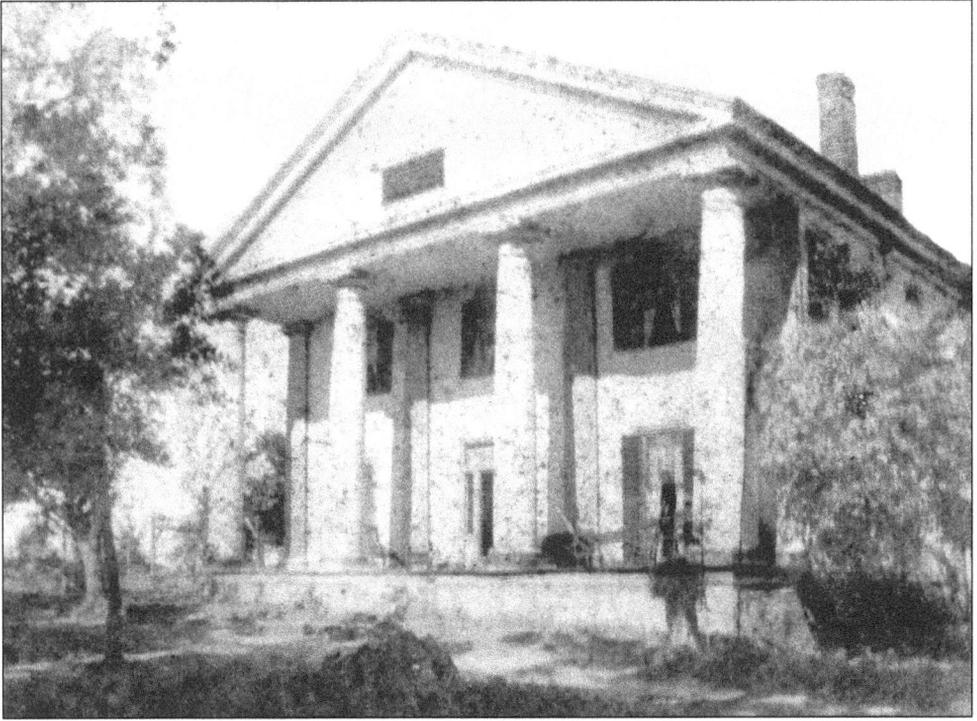

One of the earliest photographs of Bulloch Hall shows the house during the ownership of the Wood family, 1872–1892. (Courtesy of Marian and Rachel Dabney.)

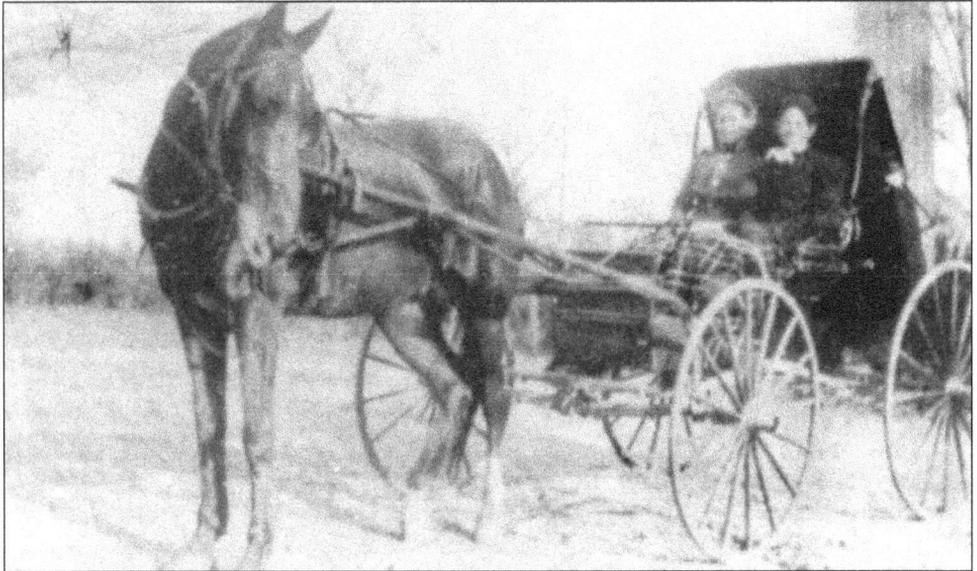

A familiar sight on many Sunday mornings was Evelyn King Baker (1837–1923) and her daughter Sarah Clifford Baker driving to church in their buggy drawn by a faithful mare, "Bess." Mrs. Baker was the daughter of Barrington and Catherine Nephew King and the wife of Rev. William Elliott Baker, Roswell Presbyterian Church's supply pastor for eight years. Evelyn was a bridesmaid in the Roosevelt-Bulloch wedding. (Courtesy of Roswell Presbyterian Church History Room.)

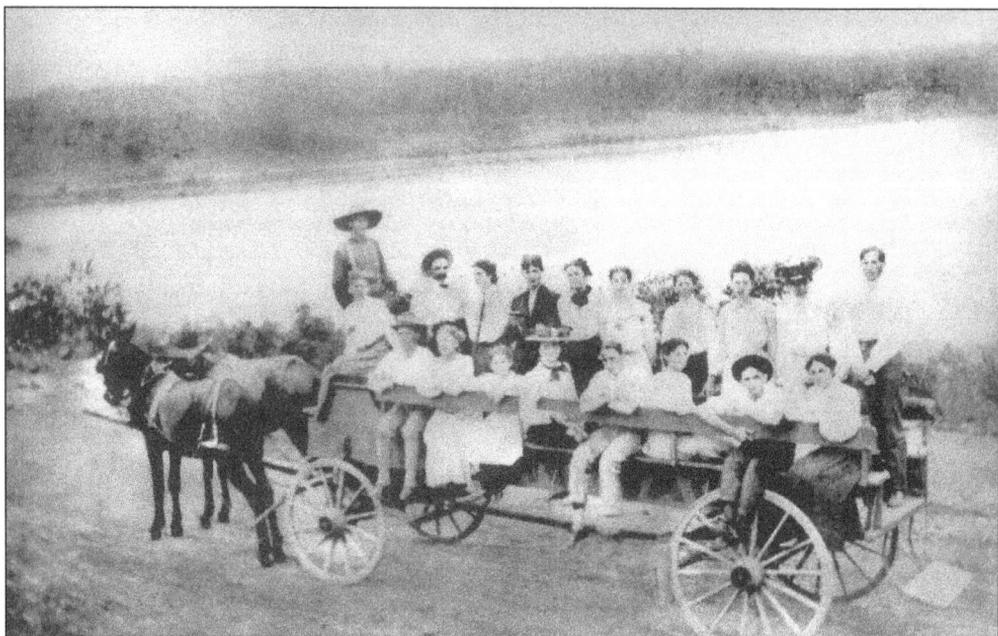

In this c. 1903 scene, a group of Roswell citizens are pictured on their way to a picnic at Bull Sluice (now Morgan Falls), the shoals located about six miles below Roswell on the Chattahoochee River. (Courtesy of Georgia Department of Archives and History.)

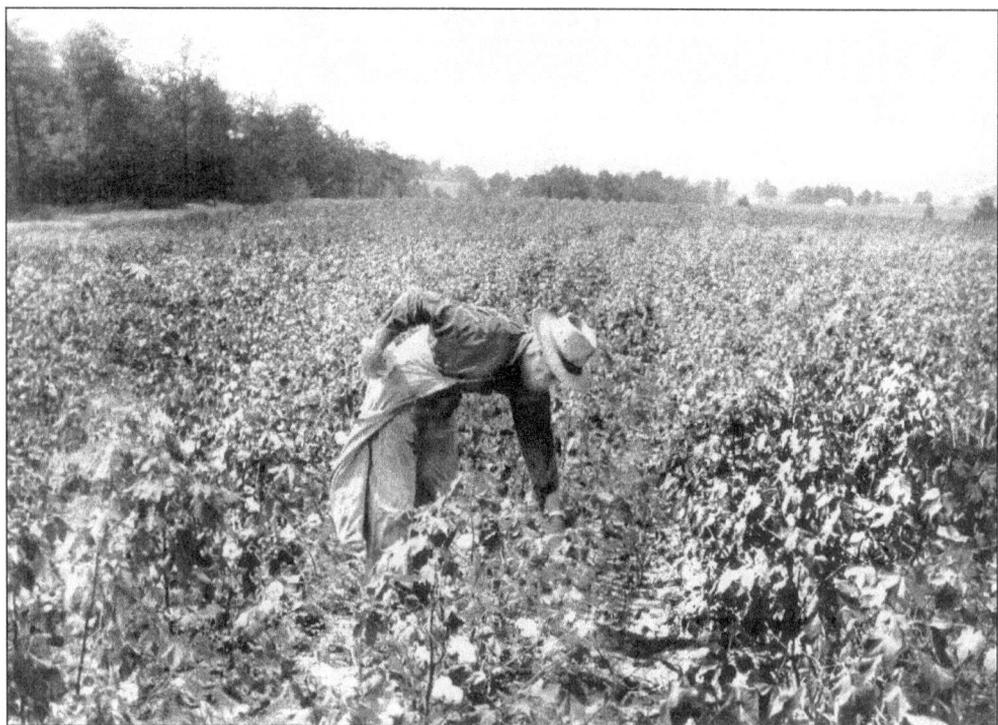

Gid Lane picked cotton in a field near Holcomb Bridge and Highway 9 in Roswell in this scene. Lane was the father of Sara Lane Mabry of Roswell. (Courtesy of Sara Lane Mabry.)

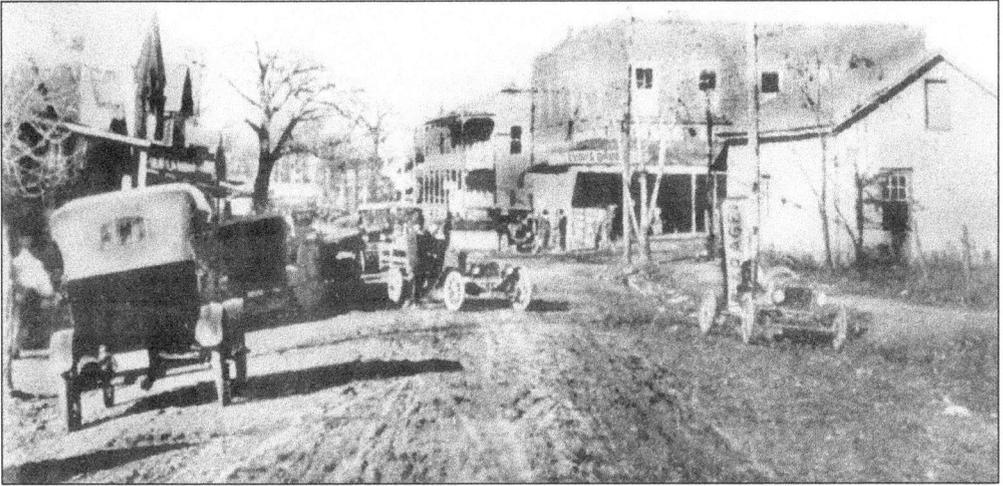

Canton Street was a dirt road in 1914 with Lyon's Drug Store and the Perry Building in the background. (Courtesy of Georgia Department of Archives and History.)

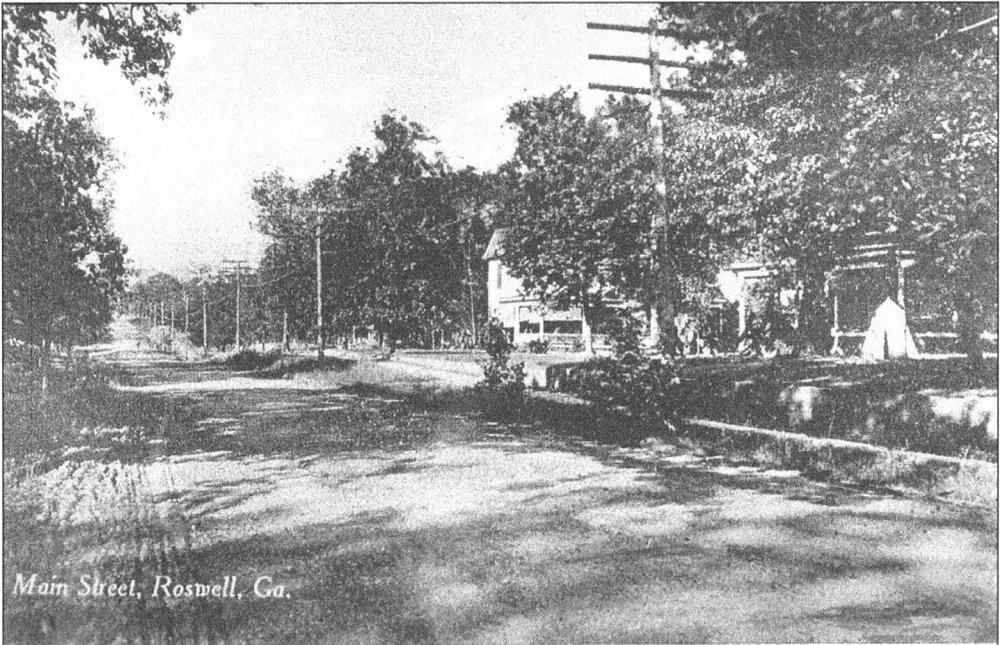

Main Street, known today as Mimosa Boulevard, was a dirt street in this postcard from 1924. (Courtesy of James and Carole Perry, Linda Bray collection.)

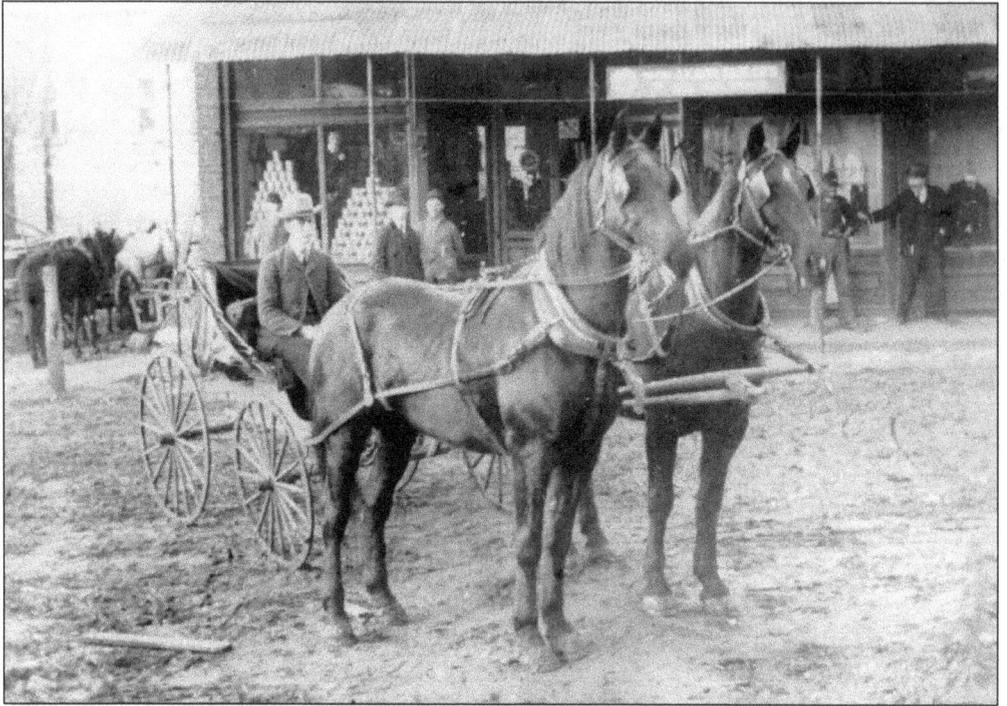

H.P. Carpenter drove his horse and buggy in front of stores in uptown Roswell in this February 1903 photo. (Courtesy of Georgia Department of Archives and History.)

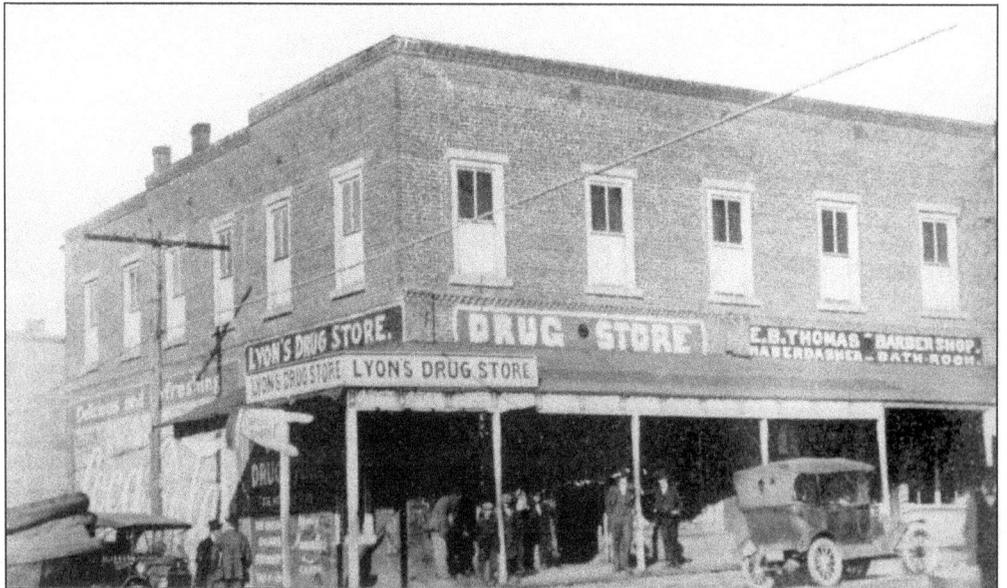

In this 1914 scene, Lyon's Drug Store on Canton Street was a hub of activity in the uptown business area. The building is now occupied by Go With the Flow, a kayaking and canoeing outfitters store. (Courtesy of Georgia Department of Archives and History.)

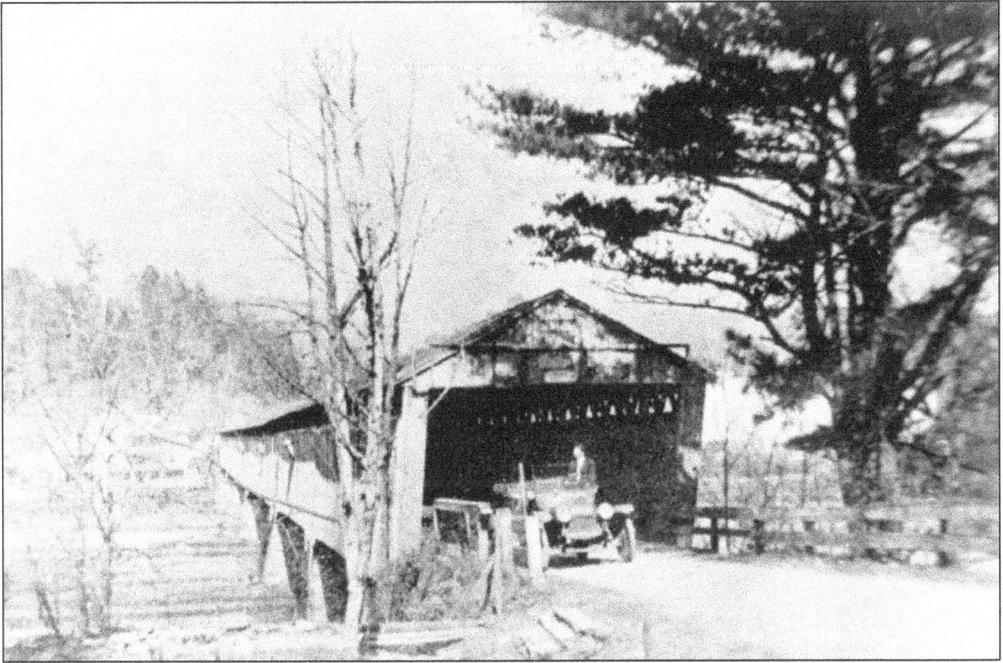

The Chattahoochee River covered bridge was built after the Civil War to replace the original bridge burned by the Roswell Battalion Confederate soldiers as they retreated to the south side of the river. (Courtesy of Jo Ann Browne.)

The original bandstand in the Park Square was built in 1905 for President Theodore Roosevelt's visit to Roswell. The structure has been replaced through the years. (Courtesy of Michael Hitt.)

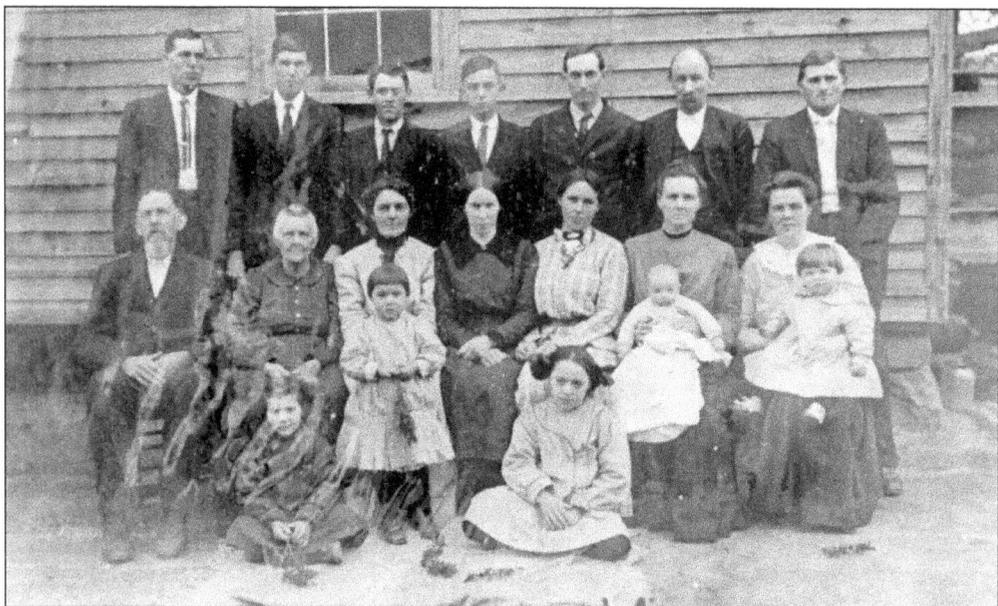

The Phillips family members are shown in this picture taken before 1920. From left to right are (front row) Alfred Phillips, Amanda Phillips, Done Phillips Landrum, Mamie Lee Wood, Lillie Phillips Westbrook, Lizzie Phillips Wood, and Lee P. Gibbs; (back row) Ubert Phillips, Walter Phillips, John Landrum, Willie Wood, Claude Westbrook, and John Gibbs. The children are Grace Landrum, Vivian Landrum, Lura Mae Landrum, Ollie Mae Wood, and Lorene Gibbs. (Courtesy of Dorcas Coleman McDonald.)

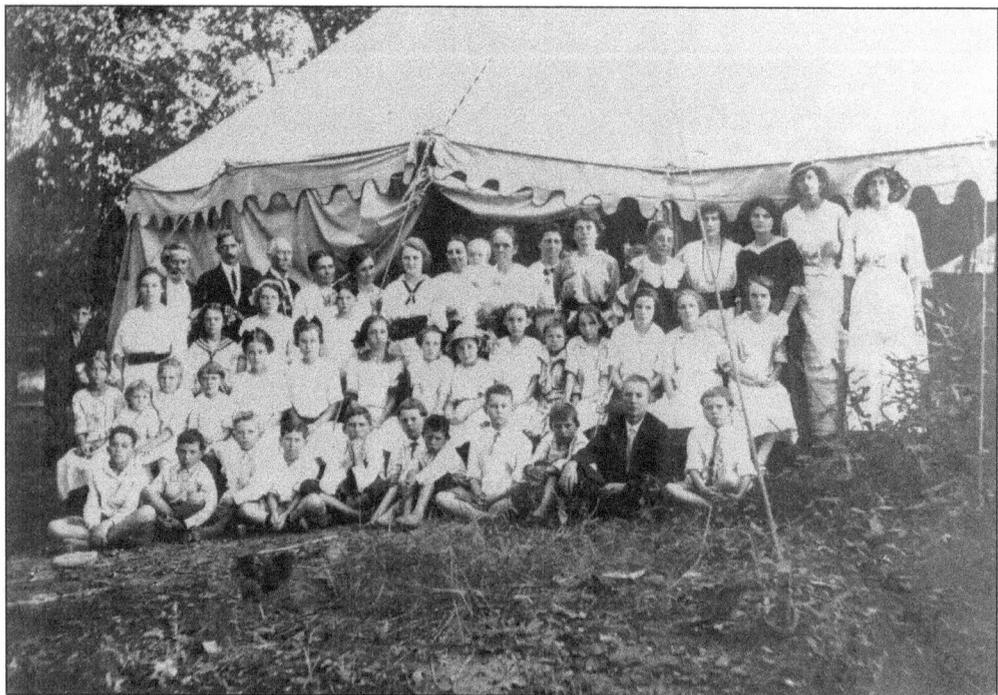

Local citizens gathered for a "Chautauqua" with a tent to lend shade on a fine summer day about 1910. (Courtesy of Georgia Department of Archives and History.)

98

Two Roswell natives, cousins (left) Etha Bearden (1908–1995) and Gladys Wright (1908–1989) are shown in this photograph about 1917. Etha Bearden, daughter of Lem and Lula Berry Bearden, was one of the first women bankers in Georgia and spent her entire career at the Roswell Bank. Gladys Wright, daughter of Emma Berry Wright and John Thornton Wright, taught school in the Cobb County School System. She married James Weir Nash of Smyrna. (Courtesy of Rebecca Nash Paden collection.)

"Aunt" Jane Hill, a washerwoman who traveled about washing clothes for people in the community, is pictured with her wash pot in Roswell about 1938. (Courtesy of Georgia Department of Archives and History.)

The Gentry family resided in this house next door to the First Baptist Church on Mimosa Boulevard when this photo was made in 1931. The house was probably built in the late 1880s. It was razed 100 years later. (Courtesy of Georgia Department of Archives and History.)

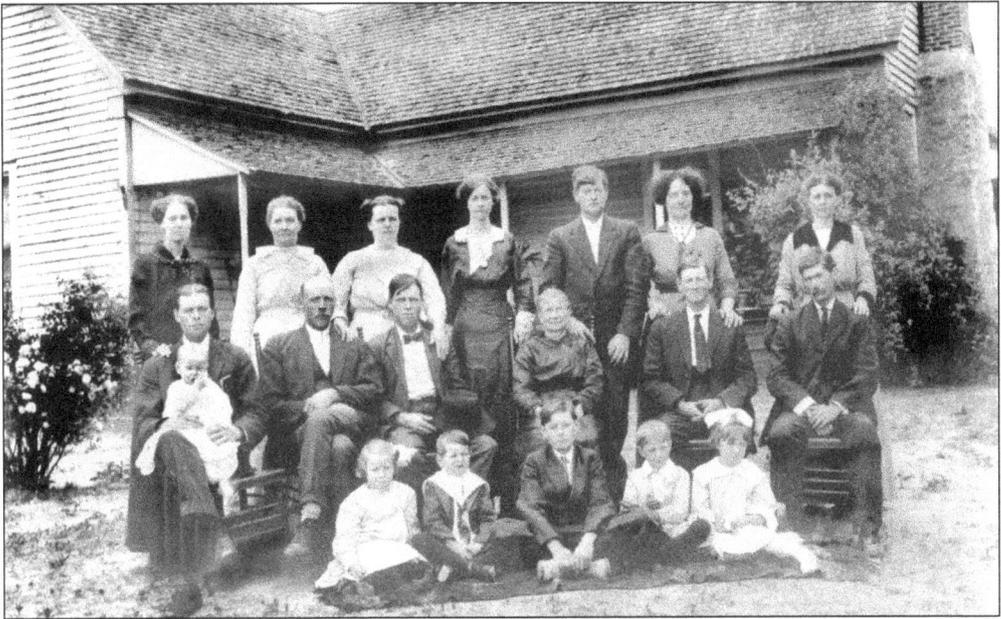

The Berry family posed for this picture in front of their home on Woodstock Road about 1915. The site is the present location of a church. From left to right are (first row) Etha Bearden, Roy Berry, unidentified, Ralph Wright, and Gladys Wright; (second row) James Jefferson Berry (holding James Cecil Berry), Lem Bearden, Bose Berry, Sarah Stark Berry (widow of John Allmon Berry, a Confederate veteran), Charlie Berry, and John Thornton Wright; (third row) Lois Daniel Berry, Lula Berry Bearden, Effie Reeves Berry, Zelia Berry, Walter Berry, Mary Hood Berry, and Emma Berry Wright. (Courtesy of Mary Berry Terrell.)

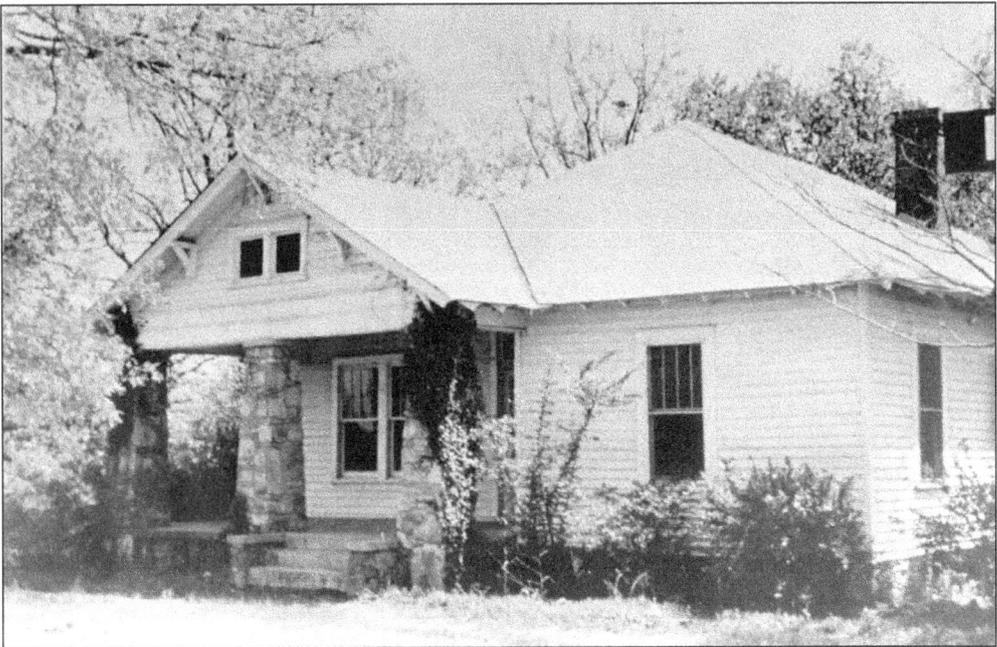

The Coleman Drive house built in 1915 was the home of the George Coleman family. This picture was made in 1964. (Courtesy of Phil Mosher.)

Aubrey and Tera Morris are pictured in front of Aubrey's family home, which he moved to Alpharetta and restored in the 1990s. Built about 1900 by his grandfather Richard Perry Perkins, the original house once sat on the present location of Greenlawn Cemetery on Mansell Road in Roswell. Aubrey is a retired broadcaster known throughout Atlanta for his work with WSB radio and historic preservation. (Photo by Joe McTyre.)

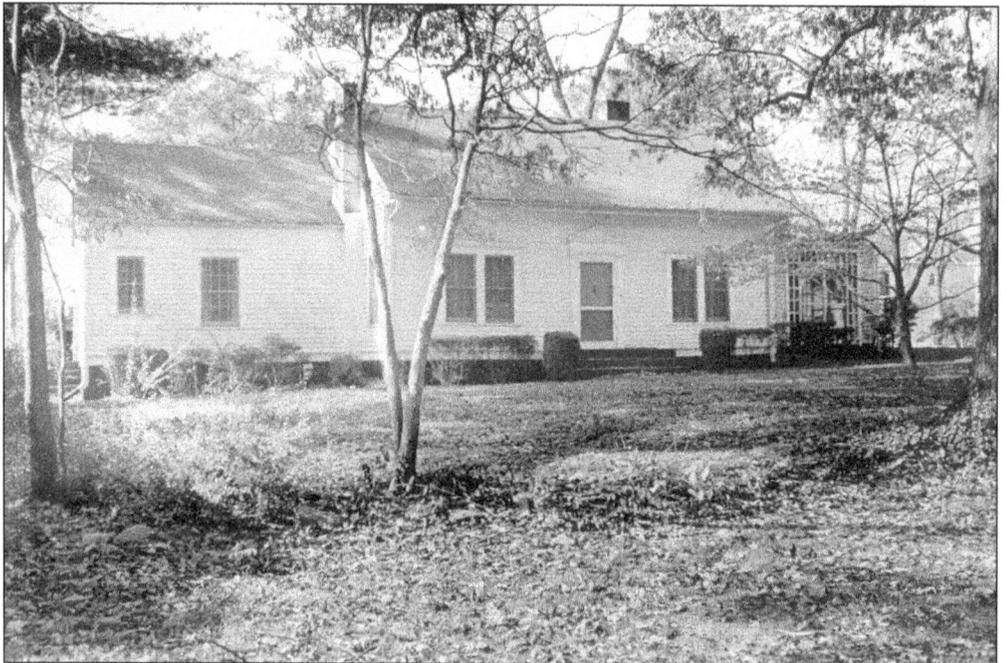

Well-known Atlanta architect Neel Reid designed the D.H. Brantley House in 1919. Located next to Roswell United Methodist Church on Mimosa Boulevard, the house is privately owned. (Photo by Joe McTyre.)

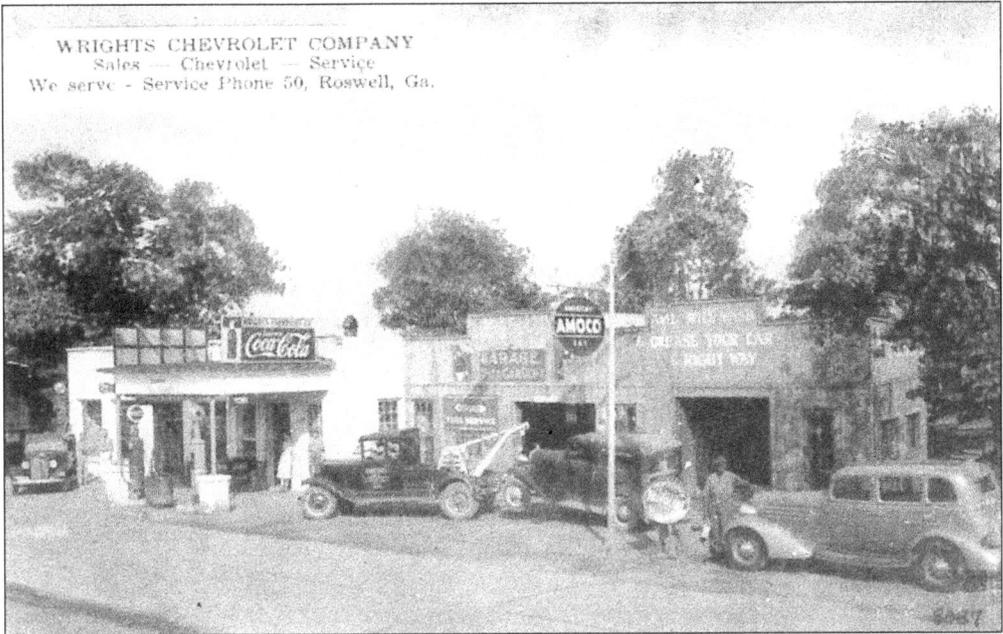

This 1930s photo of James I. "Jim" Wright's Chevrolet dealership was probably made soon after Wright expanded his auto service station business to include the dealership. (Courtesy of Mary Wright Hawkins.)

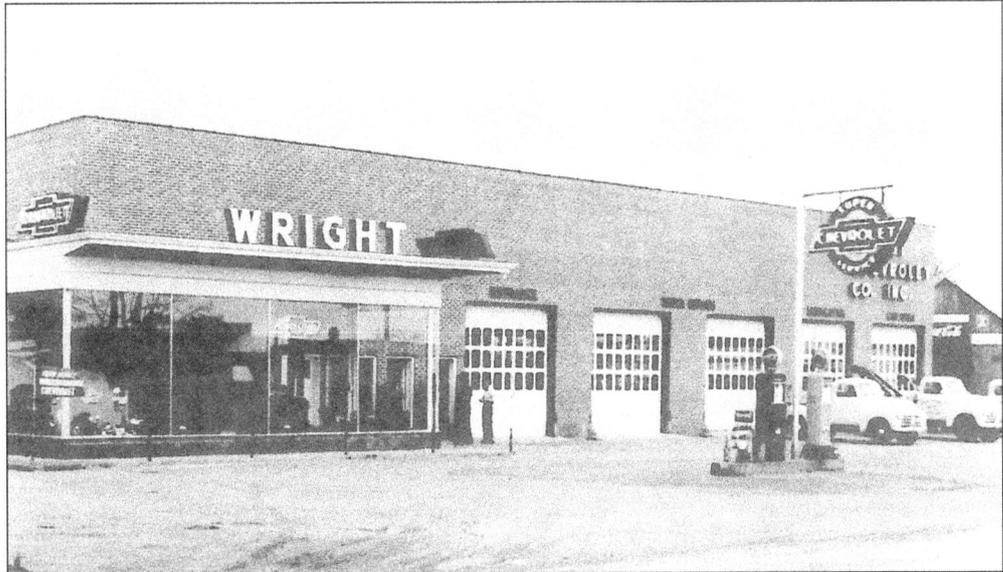

James I. "Jim" Wright constructed the building pictured here in 1946 for his Chevrolet dealership on Alpharetta Street. The new building housed a showroom and service department. Wright operated the business until 1958. The city of Roswell purchased the property in 1980 for use as a central fire station for its Volunteer Fire and Rescue Department, organized in 1937. A fire museum, now part of the main station, includes an antique fire truck, alarms, bells, fire buckets, helmets, and other memorabilia and artifacts. Photographs of outstanding fires in Roswell, including a devastating fire on Elizabeth Way and Canton Street in 1935, are on display. (Courtesy of Mary Wright Hawkins.)

103

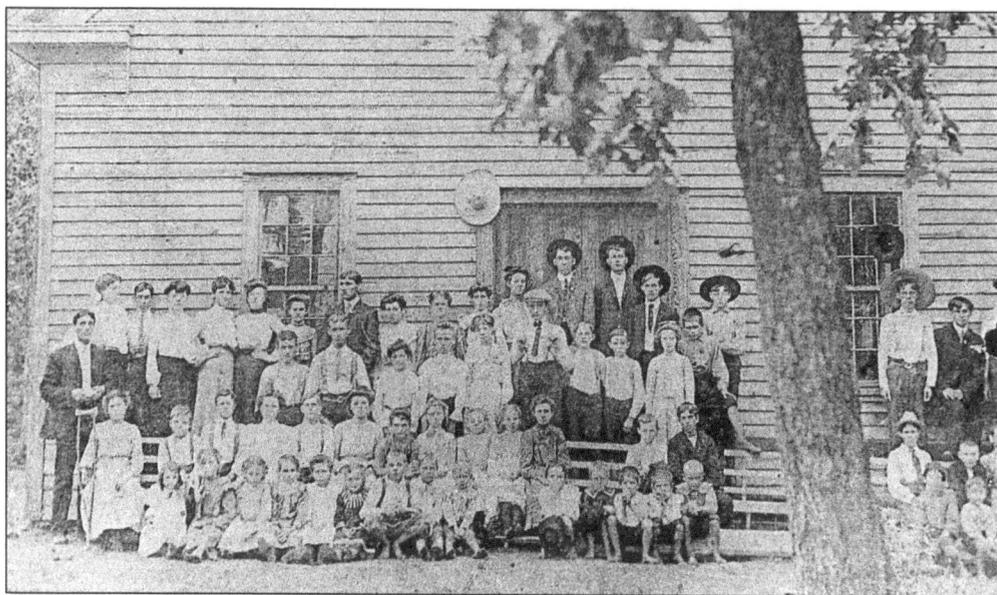

This undated photo of Hardscrabble School goes back to the early days of Roswell's education facilities. The school, located on the northwest corner of King and Hardscrabble Roads, no longer exists. (Courtesy of Richard D. Coleman.)

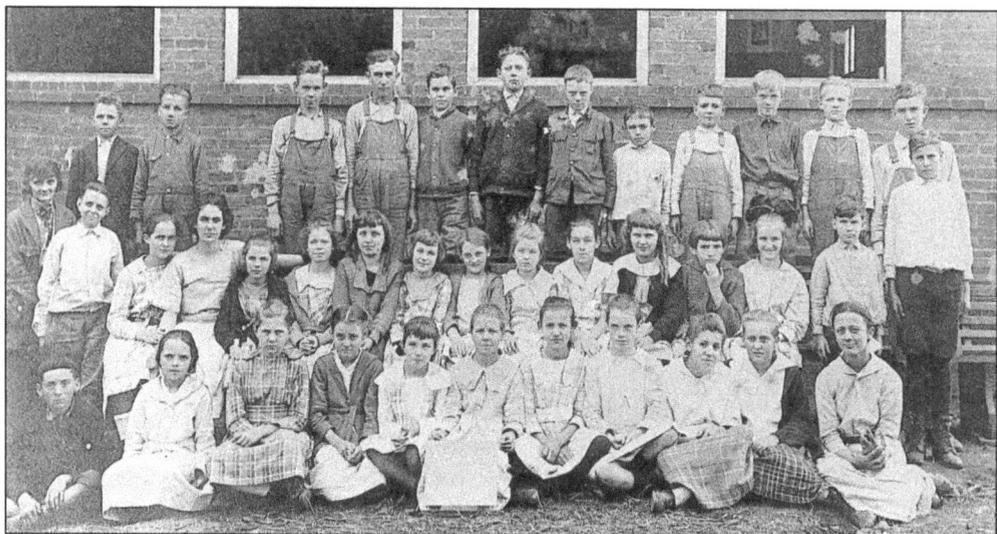

Roswell Elementary School fifth and sixth grade students are shown in their class photo in 1922. Pictured, from left to right, are (first row) Morris Reeves, Helen Jameson, Mamie Sue Owens, Reba Chamblee, Margaret Hughes, unidentified (holding sign), Esta Stroup, Marie Hembree, Mae Will Coleman, Lessie Coleman, and Bessie Reeves; (second row) Samuel Jones, Jewell Rouch, Dara Strickland, Charlotte Wright, Sybil Butler, Nellie Clyde Blackwell, Katherine Johnson, Audrey Westbrooks, Mary McNeely, Voncile Whitley, Sarah Roberts, Frances Bush, Hayden Hartsfield, Zack Berry, and Ralph Wright; (third row) Earl Mansell, Leo Rollins, Twiggs Merritt, Earley J. Coleman, Arthur Douglas, Taylor Williams, Horace Hembree, Hayward Whitley, Bennett Hardeman, Stephen Kirby, Leo Broadwell, and Loy Hackett. Not shown are James Weaver and Alda Roberts (teacher). (Courtesy of Richard D. Coleman.)

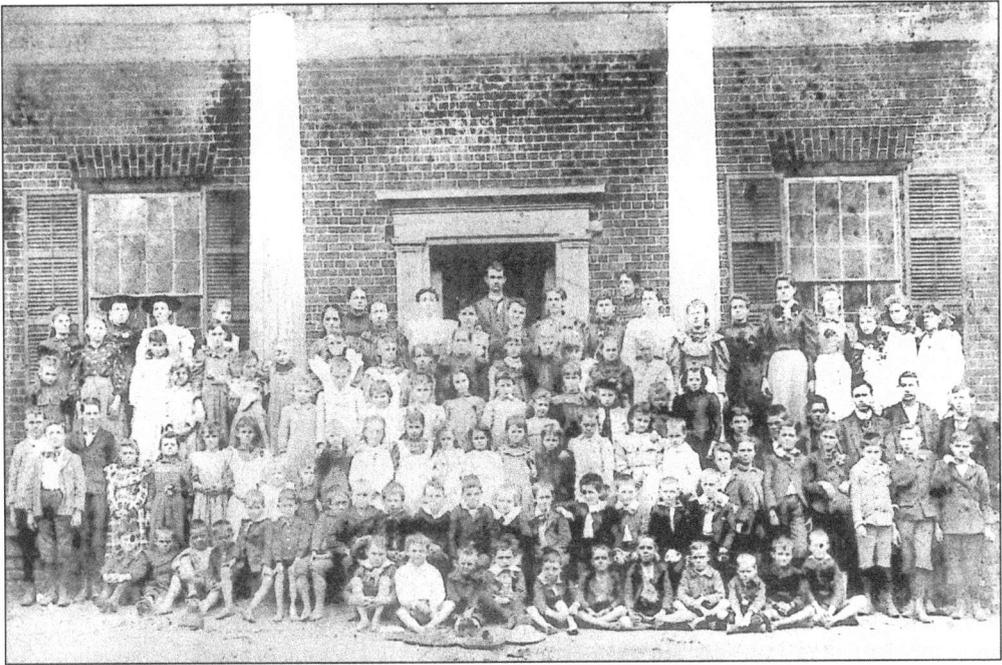

Roswell Academy students posed for this picture in front of the school about 1895, soon after it became the Roswell Public School. Located next to the Presbyterian Church on Mimosa Boulevard, it was built on a site donated by Roswell King and replaced a log school house, the town's first school, in about 1840. (Courtesy of Georgia Department of Archives and History.)

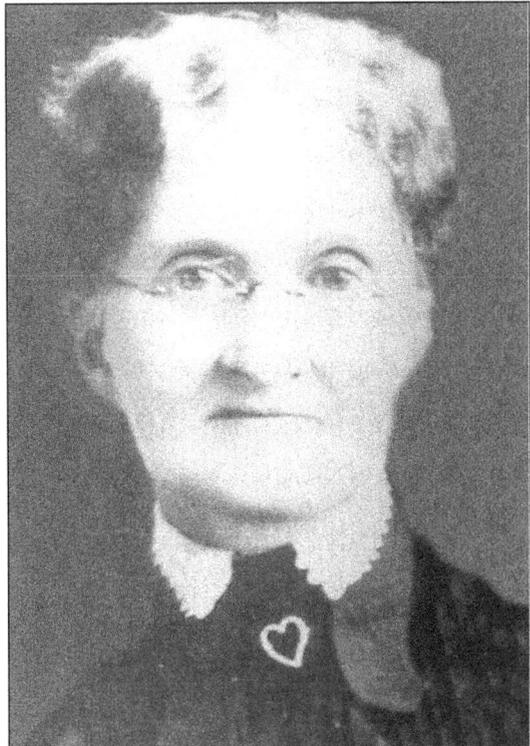

Miss Belle Pratt, daughter of Dr. and Mrs. N.A. Pratt, was an early teacher at the Roswell Academy. (Courtesy of Roswell Presbyterian Church History Room.)

This 1950s view of the Roswell School on Mimosa Boulevard shows the building as it looked for many years after it was built in 1914. The building has undergone extensive remodeling and today it is the location of Fulton County Schools' Teaching Museum North. (Courtesy of Mary Wright Hawkins.)

In 1938, Milton High School seniors presented a play, *The History of Roswell*, on Atlanta radio station WATL. The dramatization, written by Mary Wright (seated, second from left), was performed on stage at the school. Roswell students attended high school in Alpharetta at the time. Reading parts in the play were Annette Medlock, George Wills, Clara Mae West, Emily Almand, Chestine Moore, Morris Reid, Frank Burgess, Robert Waters, Grace Boyd, Glennis Braswell, Edwina Long, and Harold Coleman. (Courtesy of Mary Wright Hawkins.)

FULTON TO MERGE WITH MILTON AND CAMPBELL JAN. 1

How Fulton County Will Look

HERE IS THE WAY FULTON COUNTY WILL LOOK AFTER JANUARY 1, 1932, when Milton and Campbell Counties will lose their identities and merge with Fulton. The Roswell District, now a part of Cobb County, may also be included in Fulton if the grand juries and county commissioners of Cobb and Fulton agree to changing the boundary.

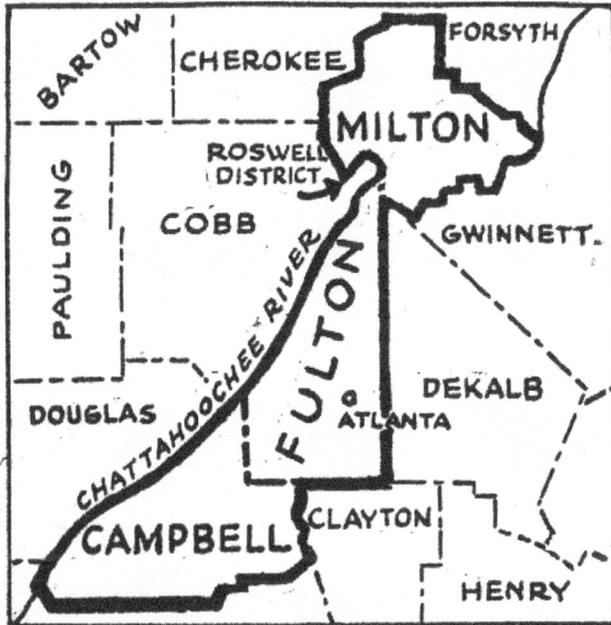

New Union Is Voted by 1,936 to 1,077—County to Be Second Largest

Milton and Campbell Counties will be merged with Fulton on January 1, 1932, increasing the area of the county to 341 square miles and making it the second largest in the state, and bringing its population up to 334,-317, far overtopping any other county in Georgia.

Voters of Fulton County Wednesday approved the Milton-Fulton merger 1,936 to 1,077 in a special referendum election in which little interest was displayed. More than 29,000 persons were qualified to vote. The city of Atlanta voted 1,220 to 566 for the merger, while the county precincts approved it 719 to 512.

Consolidation of Campbell County was approved by the voters of Fulton several months ago. Both Campbell and Milton Counties voted for the mergers by far more than the necessary two-thirds majority. Only a simple majority of those voting was necessary in Fulton.

Milton County, created in 1857, was named for Homer V. Milton. It is the second smallest county in the state, with 137 square miles of territory, a population of 6,730 and taxable property values of $2,208,000. Campbell County has an area of 211 square miles and a population of 9,000.

All county offices in Milton and Campbell will be abolished January 1, 1932, when the mergers became effective on proclamation of Governor Richard B. Russell, Jr., and all litigation will be transferred to the courts of Fulton County. All county property also will be turned over to Fulton.

The double merger will reduce the number of Georgia counties from 161 to 159, in line with the movement to cut the cost of government by consolidating political units.

A 1931 news article from The *Atlanta Journal* shows the significance of the merger of Milton and Campbell Counties. (Courtesy of *The Atlanta Journal-Constitution*.)

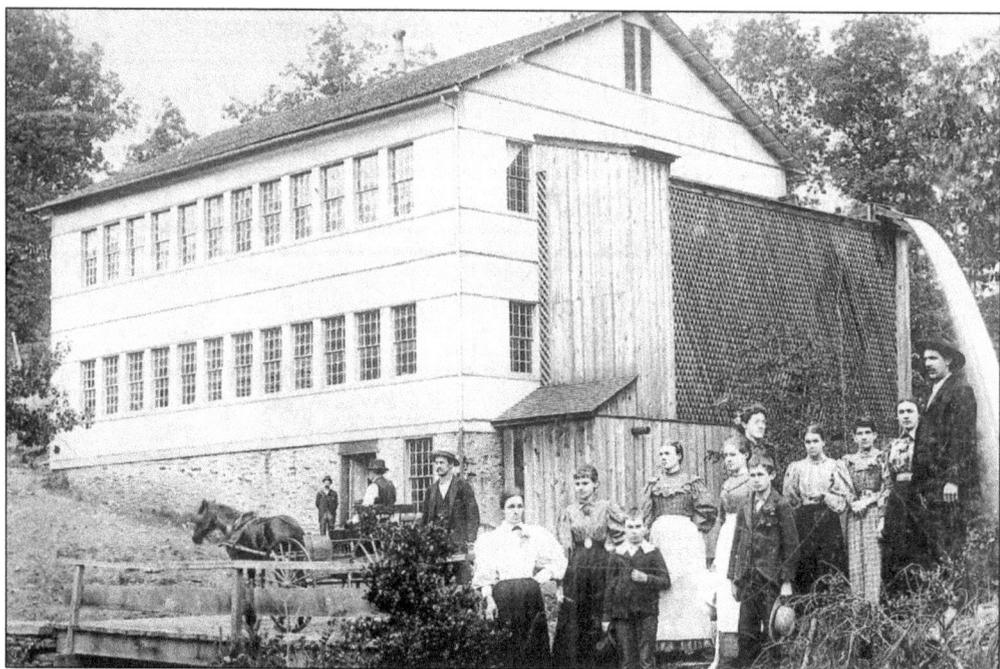

This photograph of the Roswell clothing factory known as Oxbo Pants Factory shows several employees around the turn of the century. J.H. "Pony" Waller established the manufacturing plant on Oxbow (later Oxbo) Creek and Oxbo Road about 1890 on the site of an earlier grist mill. Chartered as the Roswell Company in 1935, the factory burned in 1941 but was rebuilt the next year on Hill Street after Roswell citizens raised the money to replace it. Approximately 200 employees worked there until the plant closed permanently in 1980. The site is now the location of the Roswell Police Department headquarters. (Courtesy of Janice Wright Hill.)

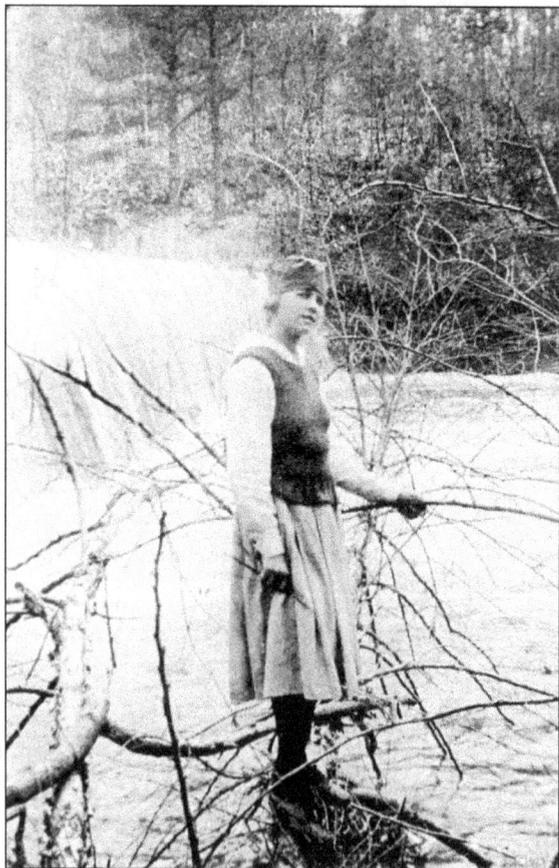

Eula Reed is shown in this photo made at the Vickery Creek dam in the early 1900s. She was the sister of Roswell sheriff Hubert Reed. (Courtesy of Nancy Hancock.)

Members of Roswell First Baptist Church were baptized in 1944 in a pool built by Lebanon Baptist Church across Alpharetta Highway from the church. (Courtesy of Leila Stephens Hawkins.)

In this scene on Sloan Street in the mid-to-late-1930s, millworkers' houses provide a background for an unidentified young woman, possibly a mill worker or a worker's family member. (Courtesy of City of Roswell.)

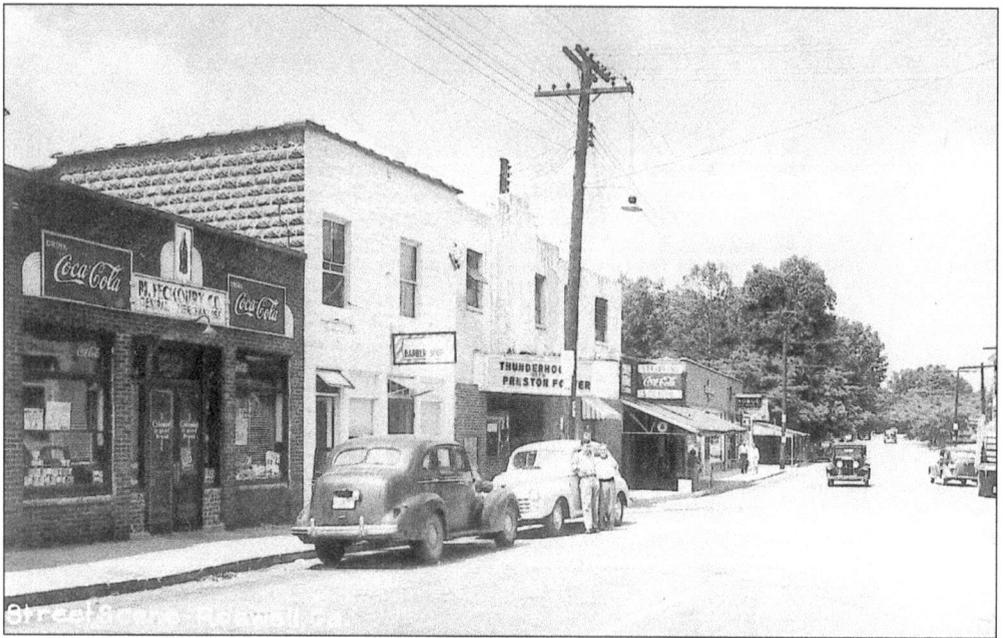

Roswell's uptown business district located on Canton Street is shown in this 1947 photo. On the left are Feckoury's general merchandise store, a barbershop, a theater, Stribling's Drug Store, and other businesses. (Courtesy of Georgia Department of Archives and History.)

Lamar "Hobo" Coleman's Sinclair service station at Woodstock Road and Canton Street was, for many years, a favorite gathering place for men in the community. Coleman sold bait, groceries, gasoline, and seasonal special items. Pictured in the mid-1950s are, from left to right, Cliff Westbrook, T.B. Rucker, Coleman, Henry Westbrook, and Edd Coleman. (Courtesy of Dorcas Coleman McDonald.)

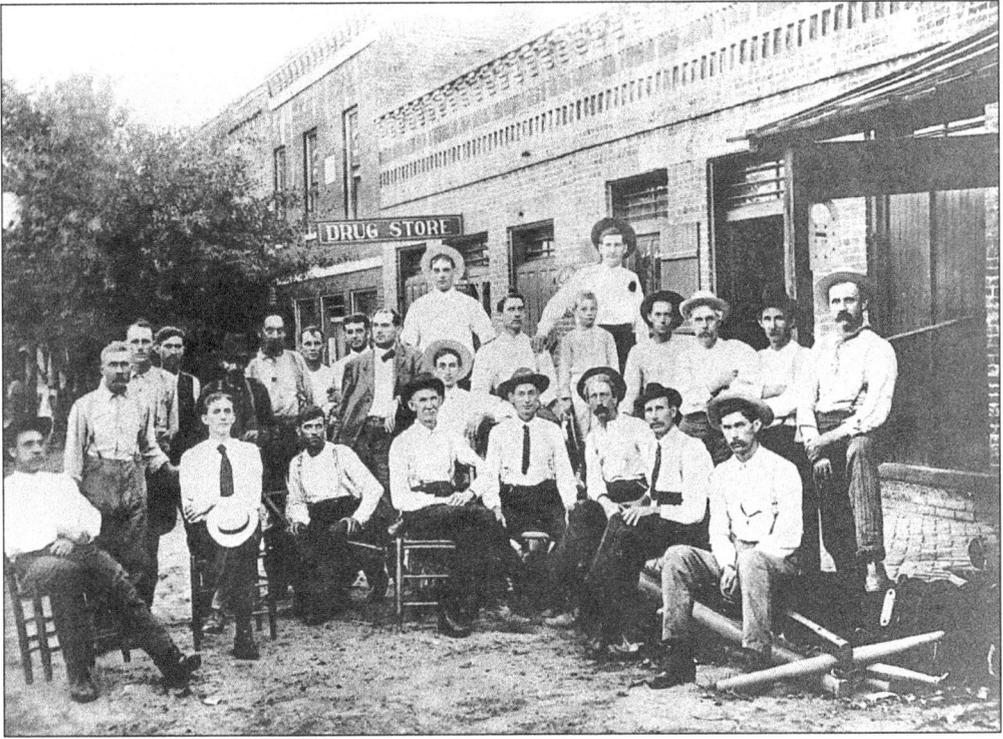

This early 1900s scene includes a group of men in front of uptown Roswell buildings. The only person identified is John Thornton Wright, seated at right. (Courtesy of Rebecca Nash Paden collection.)

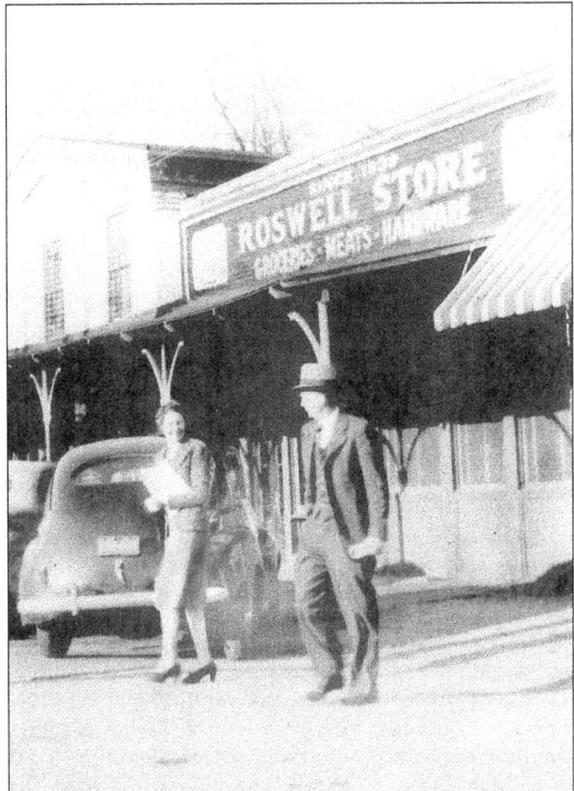

In this 1940s photo of downtown Roswell, Etha Bearden and an unidentified man are shown crossing Atlanta Street in front of the Roswell Store. (Courtesy of Rebecca Nash Paden collection.)

Longtime Roswell Mayor W.L. "Pug" Mabry is pictured in 2000 in front of the home he and his wife, Sara Lane Mabry, restored on Canton Street in 1999. The house was built in 1912 by C. C. Fowler. Mabry is vice president of public relations of the Flagler Co. and remains active in community projects. (Photo by Joe McTyre.)

Six

FROM SMALL TOWN TO MAJOR SUBURB

Phenomenal growth has transformed this small mill town into a bustling Atlanta suburb, now Georgia's sixth largest city (2000 population: approximately 75,000), which has some of the largest homes and highest incomes in Georgia. Still Roswell retains much of its small-town character. Within its 35-square-mile city limits are 12 public and 5 private schools, branches of 2 colleges, and the Chattahoochee Nature Center. Even some rolling countryside may be found in undeveloped areas. Among popular attractions are special events like the Magnolia Storytelling Festival in June and Christmas at Bulloch Hall.

Although Roswell is generally known as a bedroom community, it now has many more jobs than housing units.[24] Among its major employers are the Kimberly-Clark Corporation, North Fulton Regional Hospital, and the City of Roswell. At least eight of every ten workers residing in Roswell are employed in white-collar occupations, with many well-paying jobs close to home. Retail trade is another of Roswell's largest industries with more than 7,500 workers. The unemployment rate is substantially lower than the rest of Fulton County and Georgia.

Modern encroachments, such as wider highways and a building boom, have altered some sections of the city but the 120-acre area listed in 1974 on the National Register of Historic Places has encouraged preservation efforts. While other communities are rapidly losing traces of their past to development, the Roswell founders' homes, considered among the finest antebellum structures in the South, are preserved and admired. Among important steps taken to protect Roswell's historic resources are the organization of Historic Roswell Inc. by Richard S. Myrick in 1971 and his purchase and refurbishment of Bulloch Hall. Myrick also bought and renovated the Roswell Square stores, bringing about a revitalization of the area in the early 1970s. The adoption of a citywide historic preservation ordinance in 1971 fostered heritage preservation through checks on exterior architectural alterations of historic district structures. And in the 1980s, the efforts of Josephine and James L. Skinner Jr. and their family to preserve the Archibald Smith Plantation Home and its buildings were a major contribution. As a result of these and other efforts, a host of visitors from all over the world come to Roswell each year, touring the sites open to the public and admiring the town's picturesque setting. And, like early visitors, some like what they see so much that they stay.

In this November 1974 aerial view of Roswell, Barrington Hall is seen slightly left of center on its heavily wooded lot. The town's park is just north of the estate. (Courtesy of Georgia Department of Archives and History.)

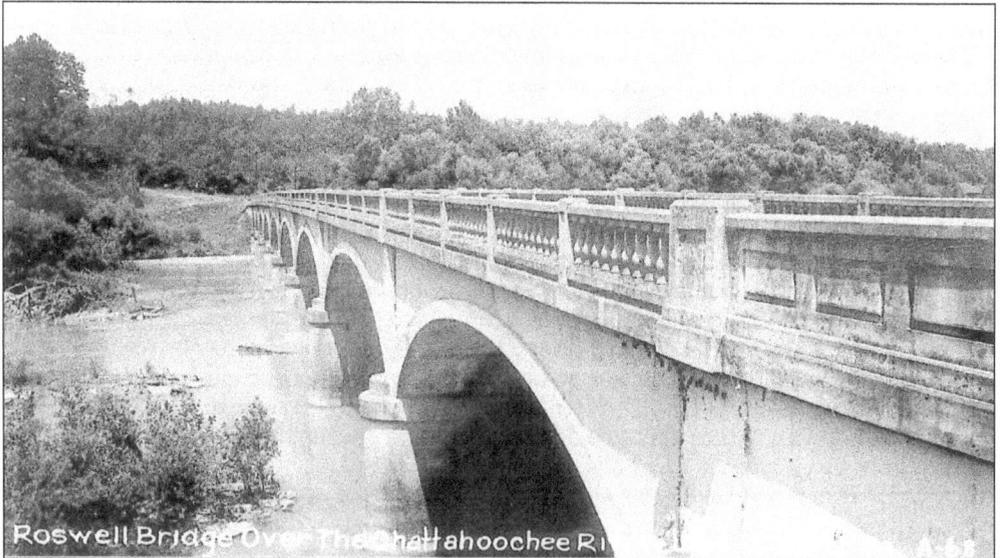

Roswell Bridge Over The Chattahoochee Ri

The Chattahoochee River bridge on Roswell Road, just south of the town, was built in 1925 to replace the old covered bridge. The new bridge was believed to be the first brick bridge built over the river. (Courtesy of Mary Wright Hawkins.)

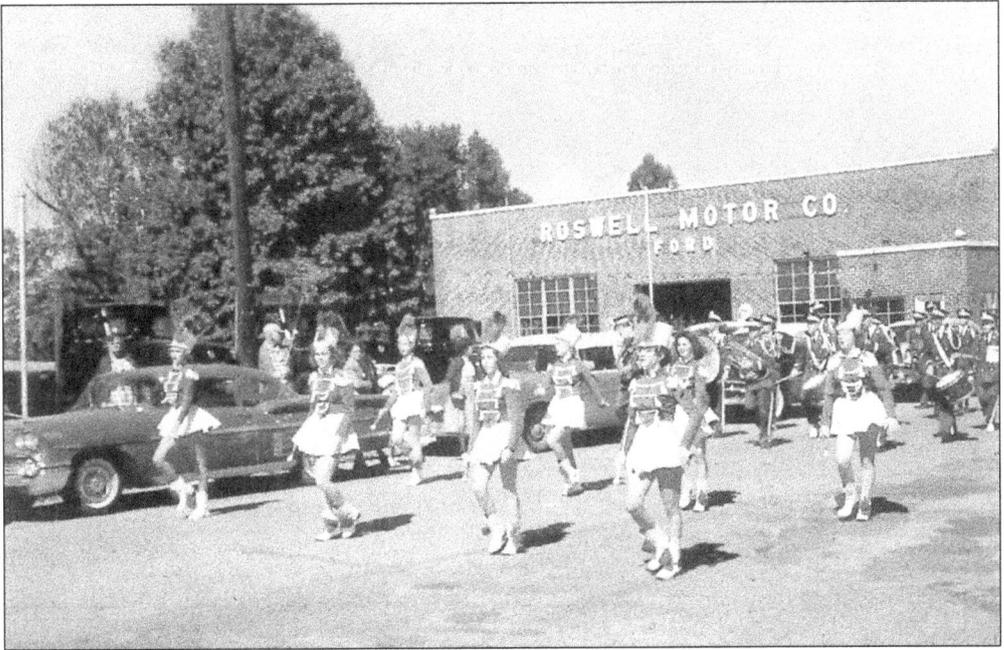

Members of a high school marching band parade along Canton Street in front of the Ford Motor Co. in the 1950s. (Photo by Ralph A. Wright.)

Roswell cloggers perform at a street dance on Canton Street during a community celebration in 1978. (Courtesy of Georgia Department of Archives and History.)

Funderburk's, shown in an undated photo, was a general merchandise store once a landmark on Canton Street. Opened in 1904 as a country store by Syrian immigrant Michael Feckoury, the business evolved into a combination groceries-flowers-plants establishment in the uptown section. Fred Funderburk, Feckoury's son-in-law, operated the business until the 1990s. An antique shop occupies the building today. (Photo by Charles Thon.)

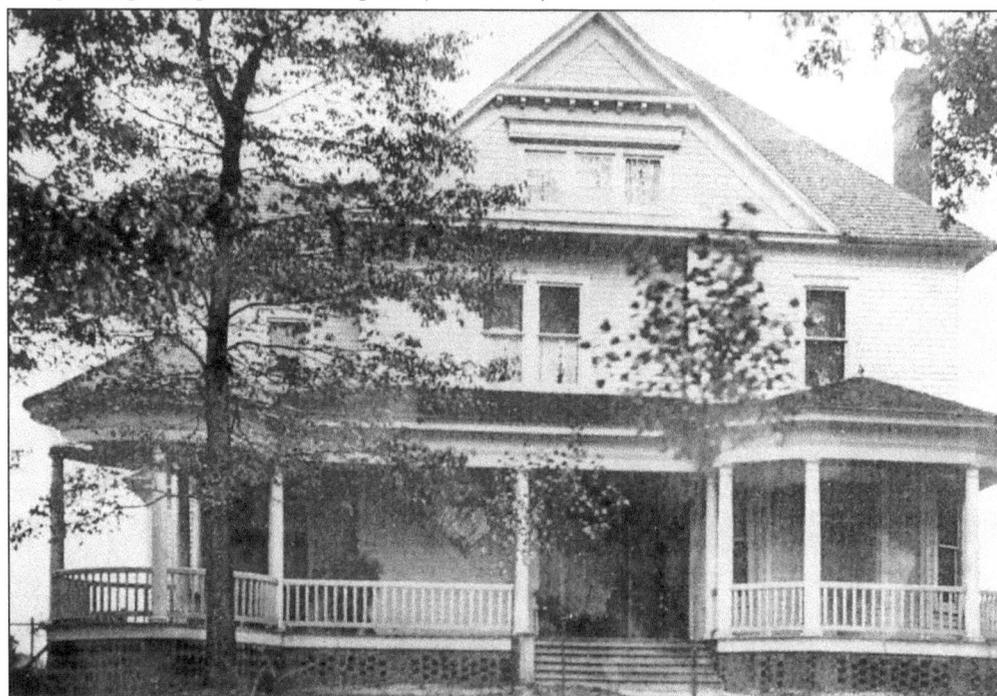

Dr. G.T. Lyon built this house on Canton Street shortly after 1904. In the 1950s the house was razed to make way for an apartment building. (Courtesy of Georgia Department of Archives and History.)

President Jimmy Carter is shown during one of his visits to Roswell while he was the chief executive. With him is his aunt Emily Dolvin Visscher about 1980. (Courtesy of Emily Dolvin Visscher.)

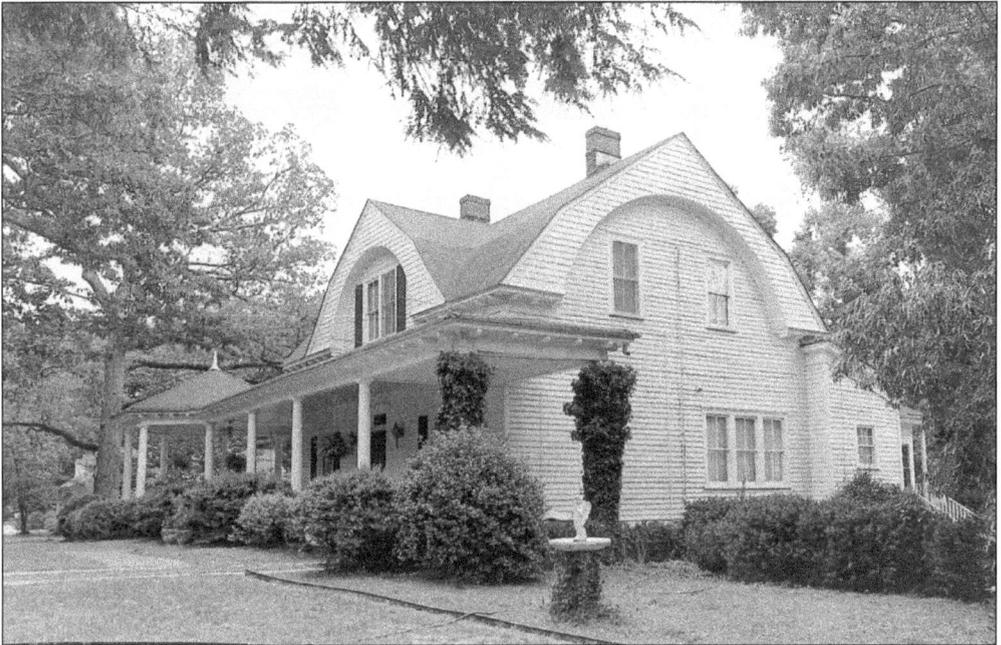

The residence of Emily Dolvin Visscher was originally a saltbox-style house built by J.M. Penland about 1870. The front porch, added in the early 1900s, gave the Bulloch Avenue residence a Victorian-style appearance. As late as the 1940s, the spacious 11-room house was heated entirely by four fireplaces. The house has hosted famous visitors including President Jimmy Carter, Mrs. Visscher's nephew. (Photo by Joe McTyre.)

Henry Wing, a descendant of early Roswell settlers, is shown in this recent photo with his scrapbook of family photos and memorabilia. The Wings owned Bulloch Hall from 1907 until 1971. (Photo by Joe McTyre.)

Michael Hitt talks to tour groups from all over the world about the Civil War in Roswell. Here he is shown in a Federal officer's uniform at the Chattahoochee River Park in fall 2000. (Photo by Joe McTyre.)

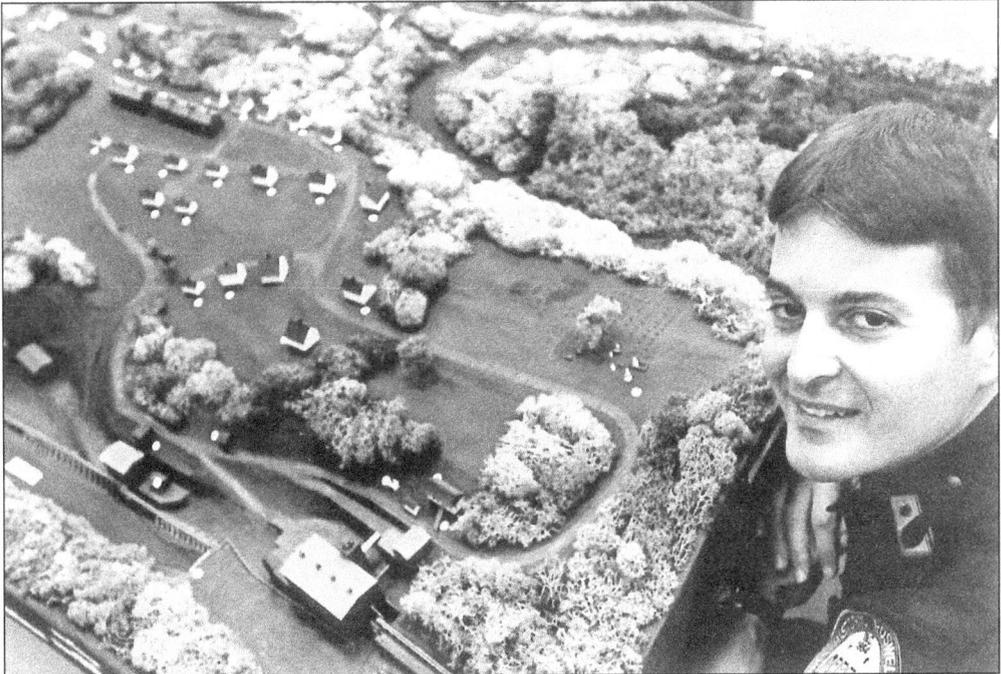

Roswell police officer and historian Michael Hitt built the 1800s scale model of the community displayed at the Roswell Convention and Visitors Bureau. (Photo by Rich Addicks; courtesy of *The Atlanta Journal-Constitution.*)

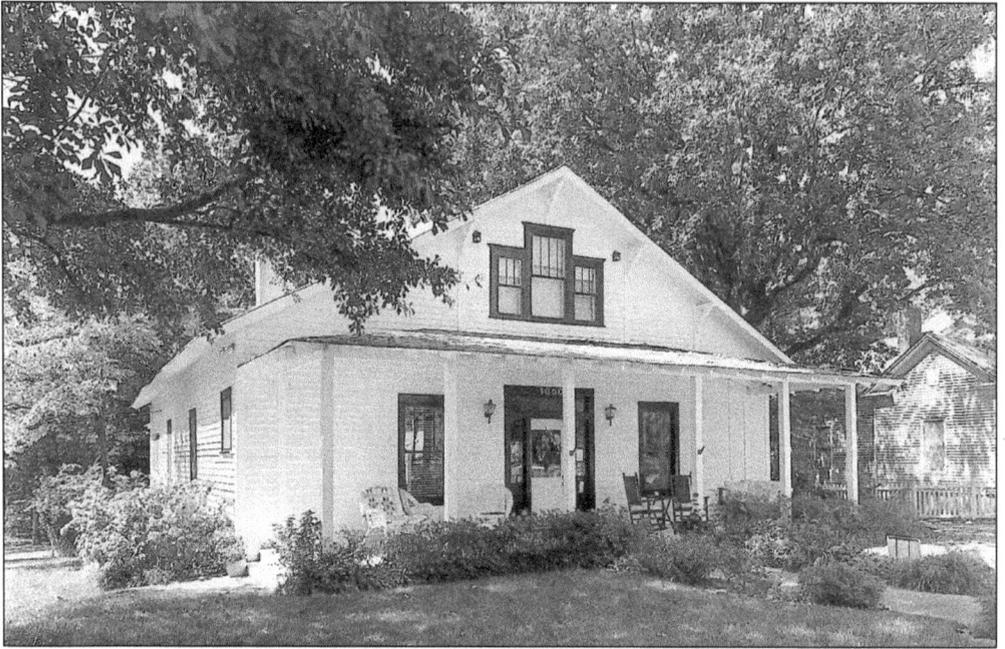

The Victorian style house at 1050 Canton Street was built in the late 1800s as a residence with four rooms and front and back porches. Almost a century later, the house was enlarged and converted for office use. Now it serves as a bed and breakfast inn, Ten Fifty Canton Street, and is owned and operated by Susan and Andy Kalifeh. (Photo by Joe McTyre.)

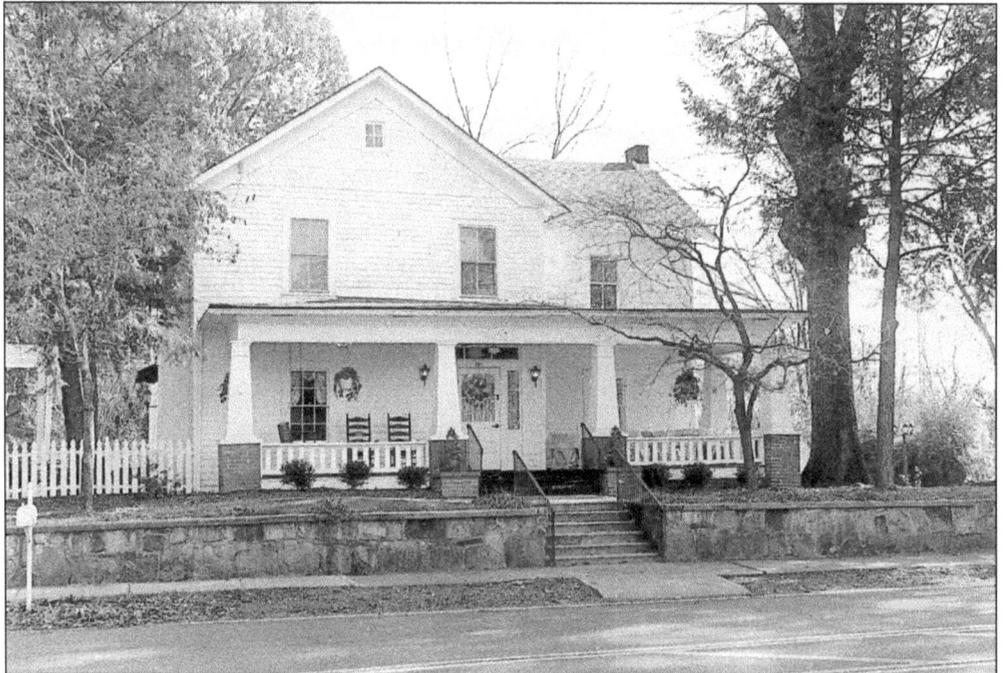

Kimball Hall, built in the late 1890s on Mimosa Boulevard, has been a private home and a boarding house through the years. In 1994 the house, named for former residents, was adapted for use as a special events facility. (Photo by Joe McTyre.)

120

W.L. "Pug" Mabry was mayor of Roswell in 1976 when the city joined the rest of the nation in celebrating the bicentennial. In this scene, the mayor spoke in colonial costume to the crowd at the Roswell Square Park. (Photo by Robert Brown.)

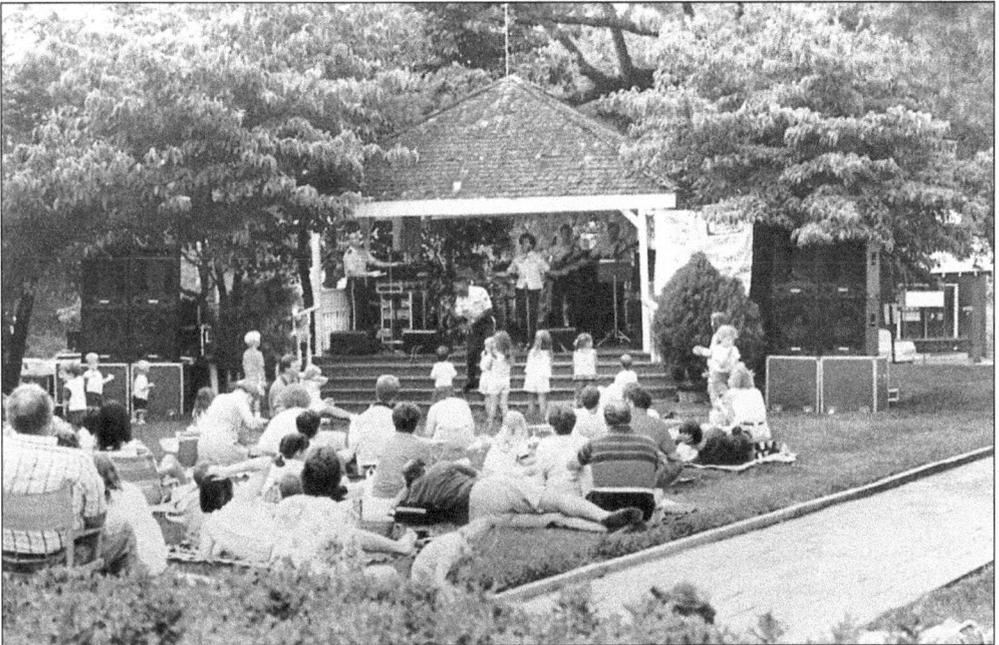

Warm spring and summer nights draw hundreds of Roswell residents to the Concerts on the Square. This 1992 scene is repeated each year with a variety of entertainment provided by the City of Roswell. (Photo by Charles Thon.)

Canadian geese show off at the park along the banks of the Chattahoochee River in this contemporary scene. The area shown is part of the Chattahoochee River National Recreation Area of the National Parks Service. (Photo by Joe McTyre.)

Chattahoochee Nature Center's new buildings that were added to the complex in recent years are shown. The center, established in 1976, is an environmental education facility that promotes ecological and nature-oriented experiences for about 50,000 school children and more than 100,000 visitors each year. Located along the Chattahoochee River on Willeo Road, the center utilizes 127-plus acres of river marsh, freshwater ponds, and wooded uplands, part of which is managed through a cooperative agreement with Fulton County, but the center raises all operating funds necessary to support its annual budget. (Photo by Joe McTyre.)

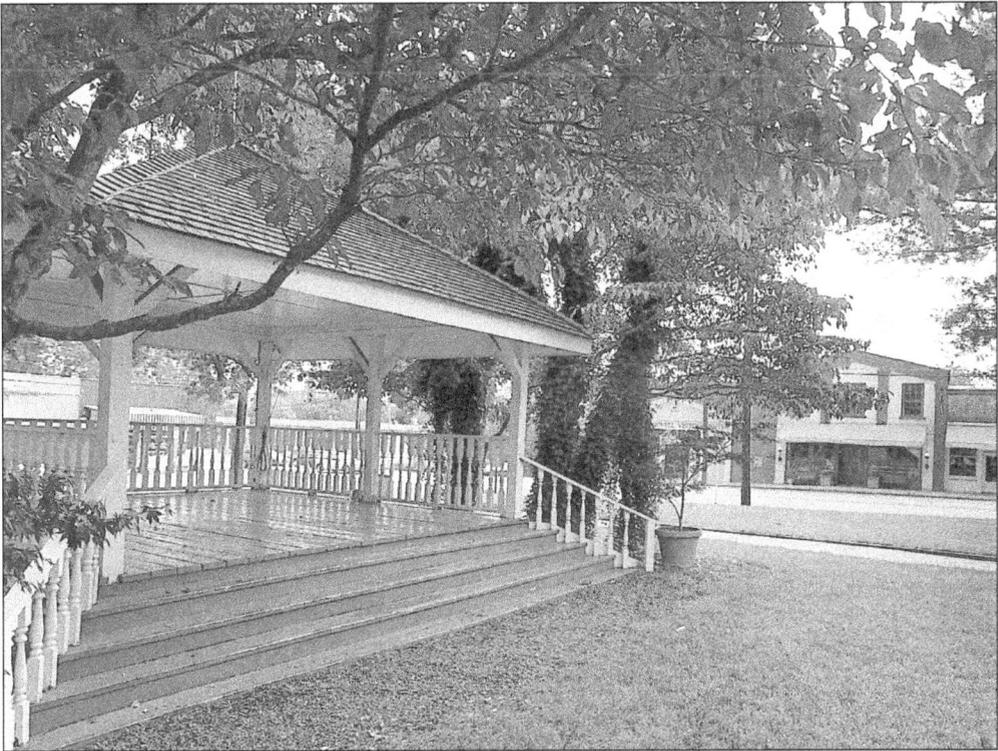

This version of the park bandstand stood until 2000 when it was destroyed by an uprooted tree. A focus for many events, the landmark was rebuilt in early 2001. (Photo by Joe McTyre.)

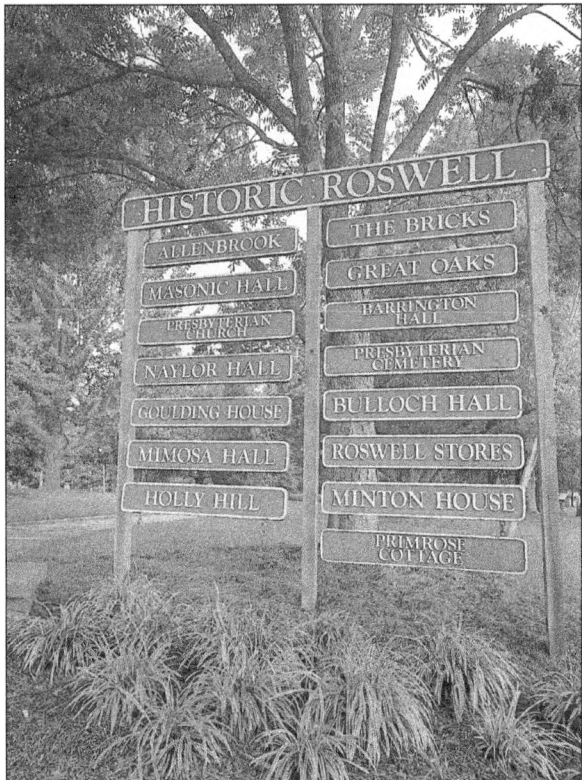

HISTORIC ROSWELL

ALLENBROOK
MASONIC HALL
PRESBYTERIAN CHURCH
NAYLOR HALL
GOULDING HOUSE
MIMOSA HALL
HOLLY HILL

THE BRICKS
GREAT OAKS
BARRINGTON HALL
PRESBYTERIAN CEMETERY
BULLOCH HALL
ROSWELL STORES
MINTON HOUSE
PRIMROSE COTTAGE

Visitors to Roswell are guided to many historic attractions by a sign located on the Square at Atlanta Street and Marietta Highway. (Photo by Joe McTyre.)

123

This recent photo of Canton Street shows stores, including the two-story building (now a restaurant) believed to have been built about 1855 by Charles Dunwody as a shoe shop. Others, including the turn-of-the-century building that was once Stribling's Drug and Soda Co. and Roswell Post Office, are still a vital part of the city's north business district. (Photo by Joe McTyre.)

The Historic Roswell Visitors Center, at the corner of Atlanta and Sloan Streets, and a restaurant next door, anchor the downtown business section. The restaurant is located in the building constructed by the Roswell Manufacturing Co. in 1854 as a commissary. Arthur Smith originally designed the Visitors Center as the Bank of Roswell. (Photo by Joe McTyre.)

124

The Faces of War Memorial, a unique three-dimensional sculpture dedicated to Vietnam veterans, is a feature of the City Hall grounds. The project was planned and financed by the Roswell Vietnam War Memorial Committee Inc. (Photo by Joe McTyre.)

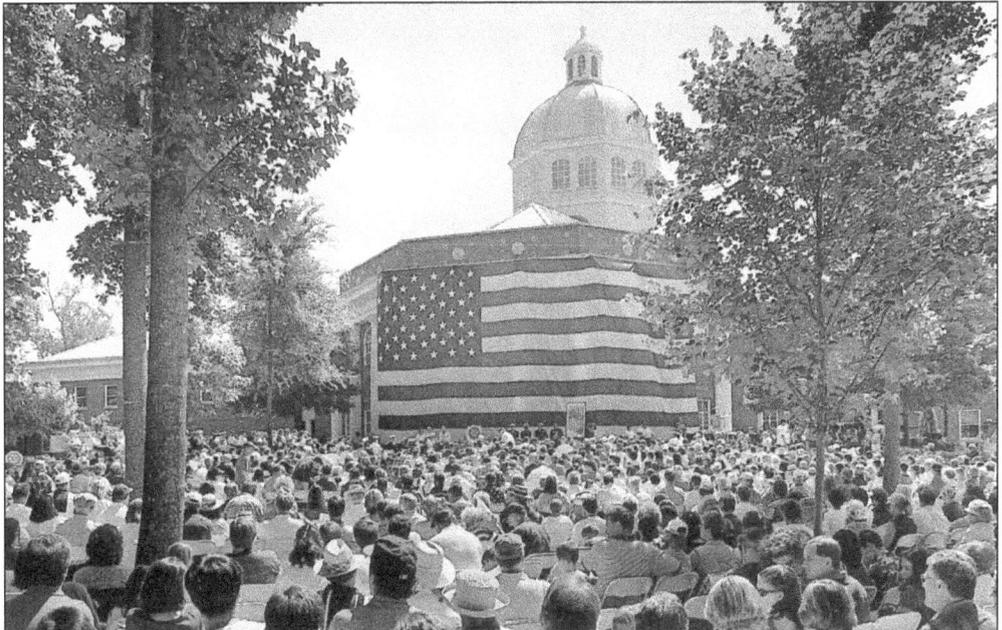

Roswell's Memorial Day program draws hundreds to pay homage to service men and women. The 2000 ceremony at City Hall is pictured above and shows some of the crowd and the large flag draped on the building. (Photo by Joe McTyre.)

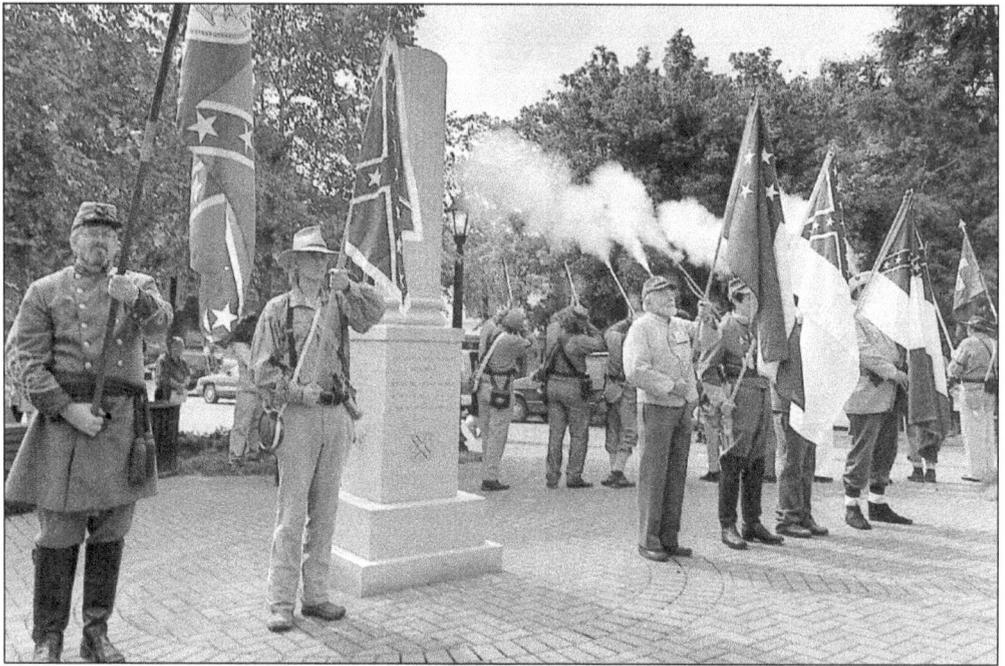

A large crowd gathered in July 2000 to honor "lost" Roswell mill workers at a dedication ceremony at Old Mill Park on Sloan Street. The monument was given to the city by Roswell Mills Camp 1547, Sons of Confederate Veterans (SCV). In this scene, SCV members fire rifles in salute to the men, women, and children who never returned after they were charged with treason and shipped north by Sherman's army in 1864. (Photo by Joe McTyre.)

The Monument of Honor pays tribute to Roswell mill workers exiled by Federal troops. It was dedicated in July 2000. (Photo by Joe McTyre.)

ENDNOTES

1. Cooper, Sarah Joyce King. *King and Allied Families*. Athens, Georgia: Agee Publishers Inc., 1992.
2. Bell, Malcolm Jr. *Major Butler's Legacy*. Athens, Georgia: University of Georgia Press, 1987.
3. Cooper.
4. Negley, Julie. "Roswell King of Darien and Roswell." 1988.
5. Skinner, James Lister III. *The Autobiography of Henry Merrell—Industrial Missionary to the South*. Athens, Georgia: University of Georgia Press, 1991.
6. White, George. *Statistics of the State of Georgia*. Savannah, Georgia: W. Thorne Williams, 1849.
7. Hitt, Michael D. *History of the Roswell Railroad 1853–1921*. Roswell, Georgia: Michael D. Hitt, 1994.
8. Skinner.
9. op.cit.
10. Lane, Mills. *Architecture of the Old South—Georgia*. New York City: Abbeville Press, 1986.
11. Bridges, Herb. *The Filming of Gone With the Wind—A Photographic Essay*. Macon, Georgia: Mercer University Press, 1984.
12. Skinner, James Lister III. "The Smith House of Roswell." Paper. 1991.
13. Myers, Robert Manson, ed. *The Children of Pride: A True Story of Georgia and the Civil War*. New Haven, Connecticut and London: Yale University Press, 1984.
14. Roosevelt, Theodore. *Theodore Roosevelt: An Autobiography*. New York City: Da Capo Press Inc., 1985.
15. Hitt, Michael D. *Charged With Treason: Ordeal of 400 Millworkers During Military Operations in Roswell Georgia 1864-1865*. Monroe, New York: Library Research Associates Inc., 1992.
16. *Minutes of the Roswell Manufacturing Company 1840-1900*. Property of DeKalb Historical Society Library, Decatur, Georgia.
17. Temple, Sarah Blackwell Gober. *The First Hundred Years—A Short History of Cobb County in Georgia*. Marietta, Georgia: Cobb Landmarks and Historical Society Inc., 1989.
18. Myers.
19. Walsh, Darlene M., ed. *Roswell—A Pictorial History*. Roswell, Georgia: The Roswell Historical Society, Inc., 1985.
20. Hitt.
21. Walsh.
22. Martin, Clarece. *A History of Roswell Presbyterian Church*. Dallas, Texas: Taylor Publishing Company, 1984.
23. *Cobb County Times*. May 1932.
24. City of Roswell, Georgia. *Comprehensive Plan 2020*. Roswell, Georgia: City of Roswell, 2000.

REFERENCES

Bowen, L.C. *History and Scenes of Roswell, Georgia, the Historic Town*. Atlanta: Atlanta Public Library, 1962.

Brady, Joseph P. "The Communion Silver of Roswell Presbyterian Church." *Silver Magazine*. September-October 1998.

Cox, Jacob D. *Sherman's Battle for Atlanta*. New York City: DaCapo Press, 1994.

Davis, George B., Leslie J. Perry, and Joseph W. Kirkley, compilers. *The War of the Rebellion: A Compilation of the Official Records of the Union and Confederate Armies*. Ser. 1, Vol. 38, Washington, D.C.: 1891.

Garrett, Franklin M. *Atlanta and Environs—A Chronicle of Its People and Events, Vol. I and Vol. II*. Athens, Georgia: University of Georgia Press, 1988.

Gaissert, Elwyn. Interview.

Groover, Robert Long. *Sweet Land of Liberty—History of Liberty County, Georgia*. Hinesville, Georgia: W.H. Wolfe Associates, 1987.

Hawkins, Mary Wright, Interview.

Hawkins, Mary Wright. ed. *Roswell Area Churches—The First 100 Years*. Roswell, Georgia: Roswell Bicentennial Committee, 1976.

Hitt, Michael. Interview.

Kemble, Frances Anne. *Journal of a Residence on a Georgian Plantation in 1838-1839*. John A. Scott, ed. New York City: Alfred A. Knopf, 1961.

King, William. *Diary of William King, Cobb County, Georgia, July 2–September 9, 1864*. Chapel Hill, North Carolina: University of North Carolina Press.

Martin, Clarece. *A Glimpse of the Past—The History of Bulloch Hall and Roswell, Georgia*. Roswell, Georgia: Historic Roswell, Inc., 1973.

Martin, Clarece. *A History of Roswell Presbyterian Church*. Dallas, Texas: Taylor Publishing Company, 1984.

Nichols, Frederick Doveton. *The Early Architecture of Georgia*. Chapel Hill, North Carolina: University of North Carolina Press, 1957.

Polatty, Rose Jackson. "The Roswell Square." Paper. 1993.

Scott, Thomas A. "Cobb County, Georgia, 1880-1900: A Socioeconomic Study of an Upper Piedmont County." Paper. 1978.

Simpson, Lois King. Interview.

Skinner, James L. III. "The Smith House of Roswell." Paper. 1991.

Sullivan, Buddy. *Early Days on the Georgia Tidewater*. Darien, Georgia: McIntosh County Board of Commissioners, 1992.

Walsh, Darlene M., ed. *Natalie Heath Merrill's Narrative History of Roswell, Georgia*. Roswell, Georgia: Walsh House, 1996.

Visit us at
arcadiapublishing.com

..

www.ingramcontent.com/pod-product-compliance
Lightning Source LLC
Chambersburg PA
CBHW080858100426
42812CB00007B/2074